T0074578

A TRAVELER'S GUIDE TO THE STARS

LES JOHNSON

PRINCETON UNIVERSITY PRESS

PRINCETON AND OXFORD

Published by Princeton University Press
41 William Street, Princeton, New Jersey 08540
99 Banbury Road, Oxford OX2 6JX

press.princeton.edu

All Rights Reserved

Library of Congress Cataloging-in-Publication Data

Names: Johnson, Les (Charles Les), author.
Title: A traveler's guide to the stars / Les Johnson.
Description: Princeton, New Jersey : Princeton University Press, [2022] |
 Includes bibliographical references and index.
Identifiers: LCCN 2021058536 (print) | LCCN 2021058537 (ebook) |
 ISBN 9780691212371 (hardback) | ISBN 9780691240077 (ebook)
Subjects: LCSH: Interstellar travel. | Space vehicles—Propulsion systems.
Classification: LCC TL788.7 .J644 2022 (print) | LCC TL788.7 (ebook) |
 DDC 629.45—dc23/eng/20220121
LC record available at https://lccn.loc.gov/2021058536
LC ebook record available at https://lccn.loc.gov/2021058537

British Library Cataloging-in-Publication Data is available

Editorial: Ingrid Gnerlich and Whitney Rauenhorst
Production Editorial: Natalie Baan
Text and Jacket Design: Karl Spurzem
Production: Jacquie Poirier
Publicity: Kate Farquhar-Thomson and Sara Henning-Stout
Copyeditor: Anne Cherry

Jacket illustration by Karl Spurzem

This book has been composed in Arno

Printed on acid-free paper. ∞

Printed in the United States of America

10 9 8 7 6 5 4 3 2 1

*To Dr. Gregory Matloff, artist C Bangs,
and the late Dr. Robert L. Forward,
with tremendous appreciation*

CONTENTS

LIST OF ILLUSTRATIONS

PREFACE

Life is a journey, and sometimes so is a book. This book's journey began when I was asked to lead NASA's Interstellar Propulsion Research Project in 1999 and began voraciously reading just about every technical book written on the topic of interstellar travel. I was already somewhat prepared for the job. Being a physicist, I knew I could understand the basics and decipher the mathematics that underlies the various propulsion technologies that had been proposed over the forty years or so that scientists had seriously been studying the topic. Having grown up reading at least one science fiction book (novel or anthology) each week from middle school through graduate school, I was mentally prepared to think out of the box—or so I thought.

The Interstellar Propulsion Technology Research Project was funded for about two years before NASA decided to use the funds for other purposes, but not before I became a convert. In my tenure managing the experiments on technologies ranging from solar, laser, and microwave sails to nuclear fission, fusion, and antimatter, I came to believe that going to the stars is something that can actually be done. We may not yet know how to engineer and build the necessary systems, but there is no fundamental scientific reason the systems and technologies described in this book cannot become a reality. With the project's demise, my working on interstellar travel technologies at NASA ended, but not my personal involvement.

Outside of my NASA duties, a close-knit group of my friends and I founded the Tennessee Valley Interstellar Workshop (TVIW), a nonprofit educational organization with the goal of fostering future interstellar travel. TVIW has been far more successful than we ever envisioned and has now sponsored seven symposia, granted thousands of dollars in scholarships to deserving college students who share our common interest, and overseen the publication of multiple original research papers in prestigious science journals. TVIW morphed into the Interstellar Research Group, about which you can learn more on their website, www.irg.space.

That is my journey, but what about this book? It results from my passionate belief that we humans will one day send our descendants to live on a planet orbiting another star, a first step toward taking Earth life to the rest of the universe. It is a goal to which I want to make a contribution and which has consumed a good portion of my personal life these last few years.

My agent and I proposed an earlier version of this book to various publishers ten years ago, but there was little interest. That was before exoplanet discoveries began making headlines, before SpaceX and Blue Origin began revolutionizing access to space, and before the advent of organizations like 100 Year Starship and Breakthrough Initiatives entered the consciousness of the science-literate public. Instead, I coedited (with *New York Times* best-selling author Jack McDevitt) an anthology of original science fiction stories mixed with popular science nonfiction essays called *Going Interstellar: Build Starships Now!*, which was published by Baen Books, a science fiction publisher. The anthology was successful and eventually led to another interstellar-themed science fiction/science fact anthology, also from Baen Books, called *Stellaris: People of the Stars*, which I coedited with Robert Hampson.

On a bit of a lark, and without even my agent being aware, I created and submitted a book proposal, for this book, to Princeton University Press, and to my great surprise they quickly responded with interest. After many telephone discussions with my primary point of contact at Princeton, Jessica Yao, we arrived at what is before you.

The Traveler's Guide to the Stars is intended to be readable, accessible, and understandable by anyone—not just scientists and engineers. There are enough technical books out there on this subject; I did not need to write another. No, this book is intended for the people who will really make the journeys discussed herein a possibility—the people who will have to advocate for the work to be funded and who will participate vicariously, if not personally, when the journeys begin. We will not get to the stars unless society supports going—and that means all of us.

The journey is only beginning. And I want to leave you with what has become my life's vision, thanks to one of those otherwise excruciating management workshops that are fashionable in large organizations. At one of these workshops, I do not recall exactly when, we were asked to articulate in one sentence our professional career goal(s). Mine was simple and I have since quoted it many times: "When future human settlers on an exoplanet write a history book describing how their new world came to be explored and settled, I would like for my technical work to be cited as a footnote."

This book is another step on my journey to becoming that footnote. I hope you enjoy it and learn a few things along the way.

A note to the reader about units of measurement. Throughout the book I will use a mixture of metric and English (now really

just American) units. Why? Because when I am performing my "day job" at NASA, that's how I think—in units of grams and kilograms, meters and millimeters, and so on. But when I am at home, I think and work in inches, pounds, and miles. My choice in any particular instance may to you seem arbitrary, but to me, the units used will reflect how I think about the world and how I suspect many of my readers in the USA do as well.

ACKNOWLEDGMENTS

Early in my career, I won't say how many years ago, I was given the opportunity to lead NASA's Interstellar Propulsion Technology Project (which allowed me to have the best business card ever!), and the first thing I did was reach out to my then-colleague Dr. Robert Forward for advice. Bob Forward, as his surname accurately foreshadowed, was one of the most creative scientists with whom I have ever worked—he published many of the early, groundbreaking technical papers describing how known physics might allow interstellar travel. I was working with Bob on a different technology (space tether propulsion) at the time, and he graciously mentored me as I began to set up the new research project. While I awaited funding for the project to arrive at the beginning of the next US government fiscal year, I had zero funds to work with and could not afford to issue any contracts to get the technical work under way. However, I did have access to an independently funded program that would allow for a university faculty member to spend the summer with me at NASA as a consultant. Bob recommended I work with Dr. Gregory Matloff from the New York City College of Technology (City Tech), whom I had never met.

Bob made introductions, Dr. Matloff (Greg) applied for the summer faculty research opportunity, and a few months later he and his wife, C Bangs, arrived at the NASA Marshall Space Flight Center to begin work. Greg is a coauthor, with Eugene L.

Mallove, of the seminal book in the interstellar field, *The Starflight Handbook: A Pioneer's Guide to Interstellar Travel,* which served as my technical starting point for all things related to traveling to another star. The Interstellar Propulsion Technology Project lasted only about two years before it was canceled and I officially moved on to other work. Greg and C returned to New York and our official NASA collaboration ended.

That pivotal summer began a decades-long friendship with, and many personal collaborations between, Greg, C, and me that includes multiple jointly authored technical papers and books, some of which were beautifully illustrated by C, an internationally known artist. It was through Greg and C that I became involved in the small but passionate interstellar travel community that motivates my technical work to this day, though my engagement with this community is performed almost exclusively outside of my day job—which means evenings and weekends. Greg and C are not only colleagues but true friends. Greg's mentorship was, and continues to be, a blessing upon my life.

The community lost Bob Forward far too early. He died in 2002, shortly after introducing me to Greg and C, and after making contributions to the field that will be cited in technical papers for centuries to come.

Not everyone has mentors such as these; I am grateful that I can count myself so fortunate.

I would like to thank several people who helped review the contents of this book to make sure I got it right and did not leave out anything too significant.

- Jim Beall (retired nuclear engineer)
- Darren Boyd (NASA space communications expert)
- Bill Cooke (lead, NASA Meteoroid Environment Office)

- Eric Davis (The Aerospace Corporation)
- Robert E. Hampson (professor, Wake Forest School of Medicine)
- Andrew Higgins (professor, McGill University)
- Bill Keel (professor, The University of Alabama)
- Ron Litchford (principal technologist, Space Propulsion Systems, NASA MSFC)
- Ken Roy (retired professional engineer)
- John Scott (chief technologist, Space Power and Propulsion, NASA JSC)
- Cathe Smith (Cambridge Technologies)
- Nathan Strange (NASA JPL)
- Angelle Tanner (professor, Mississippi State University)
- Slava Turyshev (senior research scientist, NASA JPL)
- Sonny White (director of Advanced Research and Development, Limitless Space Institute)

I must acknowledge my friends and colleagues at the Interstellar Research Group (formerly the Tennessee Valley Interstellar Workshop). They took a wild idea for holding a southeastern USA regional interstellar technical conference and turned it into a regularly occurring, internationally known and attended technical meeting and an organization that is providing scholarships to college students, publishing groundbreaking research, and keeping the dream alive. The world needs more dreamers such as these.

I would also like to thank the many other visionary scientists, engineers, futurists, and science fiction writers who provided mentoring, inspiration, camaraderie, intellectual sparring, friendship, and support over the years, and without whom my life and career might have gone in a very different, not nearly as interesting, challenging, and fun direction, including:

- NASA colleagues—Joe Bonometti, Carmine DeSanctis, Robert Frisbee, Greg Garbe, Dan Goldin, Andy Heaton, Stephanie Leifer, Sandy Montgomery, Rae Ann Meyer, Chris Rupp, Kirk Sorensen, and all who contributed to the NASA In-Space Propulsion Technology Project; Steve Cook, Leslie Curtis, Gary Lyles, and the NASA Advanced Space Transportation Team; Brian Gilchrist, Joe Carroll, Rob Hoyt, and the NASA space tether propulsion teams; and the NASA Near-Earth Asteroid Scout and Solar Cruiser project and mission teams. (And all the others so numerous that I accidentally omitted, for which I apologize).
- The interstellar research community—Jim Benford, Giancarlo Genta, Paul Gilster, Harold Gerrish, Mae Jemison, Philip Lubin, Claudio Maccone, Rhonda Stevenson, Giovanni Vulpetti, and Pete Worden.
- Science fiction authors who influenced my life—Stephen Baxter, Ben Bova, Arthur C. Clarke, Jim Hogan, Jack McDevitt, Larry Niven, Jerry Pournelle, David Weber, Toni Weisskopf, and all the great writers and editors at Baen Books.
- My very understanding family—Carol, the ever supportive and loving spouse; Carl and Leslie, my attentive and encouraging children; and of course my parents, Charles and June Johnson, who encouraged me to follow my passion.

Many thanks also to Laura Wood, my agent, and Danielle Magley, the student intern technical editor who helped whip the manuscript into shape for submission to the publisher.

ABBREVIATIONS

AU	astronomical unit
ASTP	Advanced Space Transportation Program
bps	bits per second
c	speed of light
CERN	Conseil Européen pour la Recherche Nucléaire
CRISPR	clustered regularly interspaced short palindromic repeats
DSN	Deep Space Network
E	energy
E-sail	electric sail
F	force
g	gram
gbps	billion bits per second
GCR	galactic cosmic rays
GPS	Global Positioning System
IRG	Interstellar Research Group
ISM	interstellar medium
Isp	specific impulse
JPL	Jet Propulsion Laboratory

kg	kilogram
km	kilometer
LEO	low Earth orbit
LY	light-year
m	meter
mbps	million bits per second
MSFC	Marshall Space Flight Center
NASA	National Aeronautics and Space Administration
NEA	near-earth asteroid
r	radial distance from the sun
RPS	Radioisotope Power System
RTG	Radioisotope Thermoelectric Generators
sec	second
SETI	search for extraterrestrial intelligence
SHP	solar and heliospheric physics
TVIW	Tennessee Valley Interstellar Workshop

Introduction

Humans have, since our beginning, looked at the stars and asked the big questions: "Who am I?" "Why am I here?" "What or who is out there?" We are close to being able to answer some of these questions as our species continues its exploration of space and prepares to take the first steps toward the stars. The stars are more than beautiful points of light in the night sky. Far, far away, they harbor new worlds. It is difficult to believe that until the early 1990s the only planets we knew (scientifically) existed in the universe were those orbiting our sun. With the growing list of known exoplanets, some of which appear to lie in the habitability zones of their parent stars, there are many beginning to wonder about how we might someday travel there to explore them. Despite the optimism of the early Space Age, our progress toward this goal has been slower than many anticipated. This is not just for lack of trying; the challenges are daunting.

The nearest star, Proxima Centauri, is about 4.2 light-years away. That is, it takes light, traveling at about 186,000 miles per second (~300,000 km/sec), over four years to make the journey. For most people, this is a meaningless measurement; how many of us can truly relate to the speed of light? To illustrate the difficulty, consider distances much closer and the challenges we face in traversing them. The Voyager spacecraft, launched in 1977, are the most distant emissaries yet launched from Earth.

Voyager 1 is roughly 156 astronomical units (AU) away as of this writing, 156 times the sun-to-earth distance of ~93 million miles, and it has taken it more than forty-four years to get there. For up-to-date information about Voyager's location, check out the NASA website https://voyager.jpl.nasa.gov/mission/status/. If the Voyagers were traveling in the correct direction, then it would take them about 70,000 years to reach Proxima Centauri—and that is the *nearest* star. The duration of a viable interstellar journey must be measured in years, not millennia, for such missions to be undertaken.

Propulsion is not the only challenge. How would such a spacecraft communicate across such vast distances? Far away from any star, how can the craft be powered on its journey through the darkness between the stars? Traveling at the speeds necessary to shorten the trip time will increase the risk of damage to the craft from collision with interstellar dust—a potentially catastrophic event when traveling at a significant fraction of the speed of light.

Fortunately, nature appears to allow rapid interstellar travel without having to invoke new physics. Propulsion technologies based on nuclear fusion, antimatter, and laser-beamed energy all appear to be physically possible—but the engineering of systems of the scale required is well beyond today's capabilities.

If we are to undertake this ultimate voyage, we must first inhabit much of our own solar system. Interstellar travel will require new technologies, a new ethical framework for exploration that will enable us to avoid repeating the mistakes of the past, and a visionary mind-set that is reminiscent of the construction of the great cathedrals of Europe—the notion that a project begun today may not be complete for many generations to come.

And then there is the question of why. Why should we travel to the stars? For that matter, why should we explore space at all?

In the first fifty-plus years of the Space Age, we now have compelling and nearly universally accepted reasons for the exploration and development of space near Earth and in Earth orbit. Weather satellites allow meteorologists to provide fairly accurate weather forecasts days and weeks into the future. They also help us predict the paths of hurricanes and cyclones, saving lives. Communications satellites knit the world together, allowing us to know what's happening all over the world in real time. They relay our television channels and some cell phone conversations, while large constellations of communication satellites are beginning to provide broadband Internet accessible everywhere around the globe. Spy satellites help keep the peace by allowing countries to monitor one another's military activities, nearly removing the possibility of surprise attacks—an important part of strategic safety in our nuclear weapons–armed world. Global Positioning System satellites allow us to navigate to new places and are essential to keeping our highly interdependent world and global economy functioning. Space near Earth is now indispensable to our daily lives and well-being.

Many advocates believe that the next logical step is the development of cis-lunar space, the region between Earth and the moon. With NASA and other countries planning to send people to the moon in the coming years, there is an expectation that new products and services will arise there just as they did in Earth orbit. The argument is then extended out into the solar system and, ultimately, to the stars.

As a scientist, I believe there is a valid reason for exploring space, including space beyond our meager solar system, that has nothing to do with economics or tangible return—to learn more about the universe, what's out there, and how it works. *All* of the engineering we use to keep our twenty-first-century lives functioning stemmed from scientists in earlier eras asking

similar fundamental questions that, at the time, may or may not have had an obvious economic return or application. Expanding human knowledge is as valid a reason as any other.

There are objections to these views and some sticky ethical questions that arise when thinking about our expansion into space and then on to the stars. (Many of these are addressed in chapter 3, "Putting Interstellar Travel into Context.")

Interstellar travel is possible—just extremely difficult. Are we willing to accept the challenge?

1

The Universe Awaits

Space is big. You just won't believe how vastly, hugely, mind-bogglingly big it is. I mean, you may think it's a long way down the road to the chemist's, but that's just peanuts to space.

—DOUGLAS ADAMS, *THE HITCHHIKER'S
GUIDE TO THE GALAXY*

Until the early 1990s, the only people who were sure there were planets circling other stars were science fiction fans who witnessed Captains Kirk, Picard, Janeway, Sisko, and others visit strange, new worlds each week on television or thrilled as Luke Skywalker and Princess Leia restored order in a galaxy far, far away. Okay, not really, but I'm not far off. Until then, astronomers were fairly confident that planets circled other stars, but there was no direct evidence of their existence—only the assumption that our solar system was not unique among the many stars that populated our galaxy, the Milky Way, and the many others that fill the universe.*

*Giordano Bruno (1548–1600), an Italian philosopher, postulated that the sun was but one star among many and that around these other stars were planets. This, and other scientific heresy, got him burned alive in Rome.

The first extrasolar planets, or exoplanets, discovered were found in extremely inhospitable locations orbiting pulsars. Pulsars are rapidly rotating neutron stars that emit regular pulses of radiation, including radio waves, gamma rays, and x-rays, at rates of about one thousand pulses per second. A pulsar's pulse rate is regular and predictable, so much so that they are being considered for use in celestial navigation (see chapter 7, "Designing Interstellar Starships"). Tiny variations in the pulses led to the inference that the observed irregularity was caused by orbiting planets, and *voilà*, the first (indirect) evidence of exoplanets.[1] Optical observers caught up to the accuracy needed for similar feats, and shortly thereafter astronomers were also detecting extrasolar planets around mostly sunlike stars via the Doppler shifts produced by the planets' perturbations of the stars.* Basically, just as a star's gravity tugs on the planets circling it to keep them in orbit, so do the masses of the planets pull on the star. Given the mass differences, the gravitational pull on the star is extremely small compared with the reverse, but it is not zero. Therefore, as a planet orbits a star, the planet will pull on it, causing the star to move slightly toward the planet, inducing it to wobble. Since the star is constantly emitting light, the wobble can be detected as a small Doppler shift in the light's wavelength. These measurements by themselves gave only lower limits to the planets' masses but were an important clue to the abundance of (Jupiter-mass) planets.

*Light emitted or reflected from objects moving away from the observer is stretched out to slightly longer wavelengths due to the object's motion. Light emitted or reflected from an object moving toward the observer is analogously compressed to shorter wavelengths. The amount of elongation or compression depends on the object's speed. This is called a Doppler shift, and it is the reason the radar guns used by police can so quickly determine if you are speeding while driving.

In about 2000, astronomers began finding exoplanets using the transit method. The best way to understand how this works is to think about a solar eclipse. When the moon passes between Earth and the sun along the line of sight, the moon casts a shadow on Earth that you can see. Now imagine looking into our solar system from outside the orbit of Pluto with one of the eight planets crossing your field of view as you stare at the sun. With sensitive instruments, you would see the light from the sun dim slightly as the planet passes between your instrument and the sun, blocking some of the light. If you hold your position long enough, let's say several Earth years, then you could theoretically see the same planet complete multiple orbits around the sun, causing a dimming that regularly repeats. If you were to change your viewing direction to look at a star other than the sun and have even more sensitive instruments, then you would see the dimming of that star caused by any planets that orbit it along your line of sight—the transit method. Of course, given the distances and the relative sizes of planets as compared to the stars they are transiting, the instruments needed to see the dimmed light must be quite sensitive, and the data-processing software required is complex. The analogy I like to use is that of trying to determine the size of a mosquito (the planet) flying in front of your car's headlights (the star) while you stare at it on a dark night.

There are many other methods now used to find and characterize exoplanets, and multiple space missions have flown for just that purpose. As a result, and according to NASA's Exoplanet Exploration website, there are now more than four thousand confirmed exoplanets, and more than five thousand additional potential exoplanets awaiting independent confirmation.[2]

And now the story gets even more interesting. Among these exoplanets, there are several that are near Earth size and orbiting

their parent stars in that star's habitable zone. This means that not only is the planet similar in size to Earth (some larger, like Neptune; some smaller, like Mars), but it is in a region around the star where the temperature is not too hot, nor too cold, for liquid water and the chemistry essential for life as we know it to exist. Scientists have identified about sixty such potentially habitable planets.[3] Given that we have only been able to search among the stars nearest to Earth, and there are about 100 billion stars in the Milky Way alone, using these statistics, the current best estimate for the number of near-Earth-size planets in habitable zones around other stars is . . . drumroll . . . between 11 billion and 40 billion.[4]

Wow. That is a lot of potential real estate waiting to be discovered, mapped, and explored. How soon can we go?

The answer to this question is not something to which a specific date or range of dates can be assigned. At least, not yet. To answer it, we need first to understand how far away these exoplanets are and more about what lies between us and them. Let's start by thinking about the vastness of space and our notions of infinity.

If you want to touch the infinite,* go outside on a cloudless night and look at the stars. You will have to put down your phone, e-book reader, or other gadget and find a spot away from bright lights so your eyes can get adjusted to the darkness. (All right, this will be a challenge for city dwellers, but that is not an excuse.) Once you are there, look up and find as many pinpoints of light in the sky as you can. A few of the lights you see will be planets in our solar system, like Mars or Jupiter, reflecting light from the sun. Others will be stars or collections of stars

*Okay, the universe is not really infinite. But for all practical purposes (note I say "practical"), it is as close to the infinite as we will likely ever see or know.

that, like the sun, emit their own light. Stand or sit quietly and think about the light you see. The particles of light, called photons, that impinge on your eyes have been traveling through space a long time, hundreds, thousands, and perhaps millions of years, and they end their journey through deep space when they reach your eyes and touch *you*.

In the vacuum of space, light travels at about 186,000 miles per *second* (300,000 kilometers per second). On a sunny day, the light that illuminates the world around us traveled through space for about eight minutes, at a speed of 186,000 miles per second, from the time it left the sun until it touched your skin and began giving you a sunburn. Eight minutes. Since you are now outside looking at the night sky, consider the light reflecting from Jupiter, the largest planet in the solar system. Jupiter is typically one of the brightest objects in the night sky because it is so large (eleven Earths can line up across its equator) and therefore reflects a lot of light. At its closest, Jupiter is just over 365 million miles from Earth, and the light you see reflecting from it took about forty-one minutes to get from the sun to the planet and nearly thirty-three minutes to travel from the planet to your eyes—for a total of about seventy-four minutes! The most distant planet, Neptune, is so far away that it takes the light reflecting from it about four hours to touch your eyes. Compared to the stars, these distances to the planets are small.

If you live in a big city, that might be all you can see—even on a clear night. The combination of streetlights, automobiles, and light leaking from the apartments and homes around you, combined with the humidity of the air, might make it nearly impossible to see what those blessed with dark skies can see from more rural areas. Away from the lights of civilization, the average person can see about two thousand stars in the sky. Among the closest, easily visible to those living in the southern

hemisphere, are Alpha Centauri A and B. The light they emit travels through space for more than four years to reach Earth and touch your eyes. Four years! And these stars are relatively close to us. To make discussion of these immense distances easier, astronomers call the distance light travels in a year a light-year. On this scale, Alpha Centauri A and B are 4.35 light-years (LY) away.

If we were limited to seeing the stars using only our eyes, then we would be seeing objects that are many times more distant than Alpha Centauri A and B, but we would be missing the bigger picture—the much bigger picture—that is the universe in which we live. Early telescopes allowed people to look at the reflected light from the planets and see that they were big, round objects like Earth, orbiting the sun at ever greater distances. They also allowed people to see many more stars than are visible to the naked eye, including some fuzzy, spiral-shaped objects, generically called "nebulae," which were so lovingly and systematically categorized by Charles Messier (and are now known as Messier Objects).[5] Until Edwin Hubble came along, astronomers considered what we now know as galaxies to be some of these "nebulae." Exploded stars within our own galaxy were also "nebulae." In fact, given the limitations of those early telescopes, just about anything that looked like a fuzzy cloud of dust or gas was labeled a "nebula." Nebulae were everywhere, and there wasn't much to distinguish between the various types.

In the early 1920s, while using the 100-inch mirror at the Mount Wilson observatory, Hubble took the highest-resolution images to date of the Andromeda Nebula and discovered that it was actually an extremely distant clumping of many stars, like our Milky Way Galaxy.[6] A few years later, he calculated that this new galaxy must be at least ten times more distant than the

most distant stars within our Milky Way. Telescopes improved and many more nebulae were found to be, in fact, distant galaxies. Thanks to modern telescopes, including one named after Edwin Hubble flying in space over 300 miles above in Earth orbit, we now know that there are billions of galaxies in the universe, each containing billions of stars—and we can "see" many of them, thanks to our telescopes here on the ground and in space.

We now know that the multibillion-star cluster that is our own galaxy, the Milky Way, is about 100,000 light-years across. In other words, it takes light about 100,000 years to travel from one side of the Milky Way to the other. One of the nearest galaxies to ours, Andromeda, is nearly 2.5 *million* LY away. If you are stargazing on a clear, dry night, far from city lights, then one of the tiny "stars" you can see is not a star at all—it is the Andromeda Galaxy. Keeping in the theme of touching eternity, consider that the light from Andromeda that touches your eye (touches *you*!) traveled through space more than 2 million years. When you see it, you are truly touching the nearly infinite.

If Alpha Centauri A and B are the nearest stars, and Andromeda is one of the nearest galaxies, what about the farthest? Similar to how our eyes are limited to seeing only about two thousand stars, and the early telescopes were limited to seeing mostly the planets and a few more stars, our current telescopes are limited by current technological abilities. Seen by the Hubble Space Telescope in 2015, EGS8p7 is one of the most distant galaxies ever observed at 13.2 billion light-years.[7]

If you are like me and, I suspect, most people (some astronomers excluded, maybe), then the differences in these distances are almost meaningless and completely outside your everyday experience. How can anyone comprehend the difference

between the distance to the sun (at eight light-minutes) and the distance to Neptune (four light-hours) with the distance to Alpha Centauri A and B, let alone Andromeda? For fun, let's try. First, let's invent our own measuring stick. We start with a scale developed by astronomers, the astronomical unit (AU), which is the sun-to-earth distance of 93 million miles. Using this scale, Earth is 1 AU from the sun. Let's visualize this by creating a scale model of the solar system that will fit into a typical classroom, with 1 AU corresponding to 1 foot (~30 cm) and use this distance to build a mental model of the solar system and beyond.* Earth is 1 AU, 1 foot, from the sun; therefore, on this scale, Mars is ½ foot (AU) away, and Neptune 30 feet (AU). Note that we regularly launch rockets to Mars, and it takes them approximately seven months to cover the Earth-to-Mars distance of ½ foot. Voyager took about twelve years to reach Neptune. On this scale, the nearest stars (Alpha Centauri A and B), would be 268,770 feet, or about 51 miles (~82 km) away. And those are the nearest stars! The best attempt at visualizing the distances involved on a single image can be seen in figure 1.1. Significant solar system objects are specifically labeled, as are the approximate locations of the Voyager spacecraft and the stars in the Centauri system. The part that is a bit difficult to understand, and is also the only way the vast distances involved can be compressed and viewable on the graphic, is the horizontal axis—each distance increment on the axis is ten times farther than the previous one.

I will leave it to you to figure out how far away the Andromeda Galaxy lies on this scale . . . The bottom line: space is big.

*I chose to use the imperial measurement system because my shoe size measures almost exactly 1 foot, which is very convenient. I have walked out this solar system scaling in many classrooms and lecture halls.

Really big. *Unimaginably* big. How, then, can we ever hope to bridge the gap and visit planets circling other stars?

Again, by thinking big, as I will explain. Interstellar travel is not for the timid. We need to consider that there is more than just the distance when we contemplate traveling across the void to visit a planet circling another star. Contrary to what you may think, space is not just a vacuum with a few planets and stars dropped here and there. We need to consider what else lies between us and where we want to go before we can even begin seriously thinking of going there.

First, space is not empty, just *almost* empty. In our solar system, the sun sits at the center and serves as not only the source of heat and light that gives the solar system life, but also as the gravitational anchor around which the eight planets, five known dwarf planets (Pluto is considered a dwarf planet, as are Ceres, Haumea, Makemake, and Eris), as well as hundreds of thousands of asteroids and comets orbit. The sun is, by far, the largest object in the solar system, with a diameter across which you could place more than 109 Earths side to side and more than 1 million Earths in its volume. Almost all of the mass in the solar system—99.8 percent—is in the sun. Jupiter, the largest planet, could contain only a paltry 1,300 Earths in its volume. Of the remaining planets, some are larger than Earth, some smaller. When you combine the masses of all the planets, dwarf planets, asteroids, and comets, you would have most, but not all, of the remaining 0.2 percent of the solar system's mass.

It is this small fraction of a percent that might cause problems for interstellar spacecraft as they exit the solar system and enter another one—and perhaps, to a lesser extent, in the void between the stars. Left over from when the solar system was formed—and created when asteroids, comets, and planets collide (or have collided, many years in the past)—are meteoroids

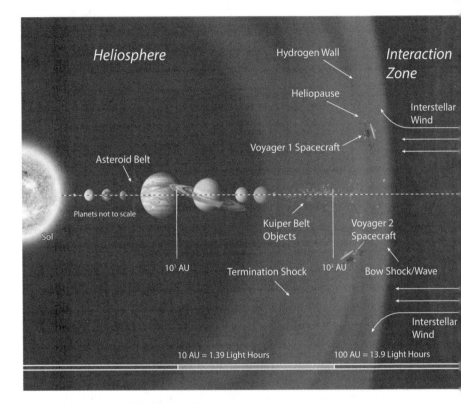

Heliosphere

Hydrogen Wall

Interaction Zone

Heliopause

Interstellar Wind

Voyager 1 Spacecraft

Asteroid Belt

Planets not to scale

Sol

Kuiper Belt Objects

Voyager 2 Spacecraft

10^1 AU

Termination Shock

10^2 AU

Bow Shock/Wave

Interstellar Wind

10 AU = 1.39 Light Hours

100 AU = 13.9 Light Hours

FIGURE 1.1. Interstellar Distances Scale. The distance to the nearest star is extremely difficult to capture in one image, and thankfully the folks at the Keck Institute for Space Studies did it for us in a creative way. Going left to right, the distances from the Sun to various objects are shown in six equal-size increments, with each one shortening the apparent distance by a factor of ten in what is called a logarithmic scale. In other words, the objects in the second increment are ten times farther away than those in the first. Those in the third increment are ten times farther away than those in the second and one hundred times farther away than those in the first. This 10× scaling continues until we reach Alpha Centauri, with the last increment representing distances that are up to one hundred thousand (100,000) times farther away than those in the first increment. Keck Institute for Space Studies / Chuck Carter.

ones, hitting a piece of debris that causes significant damage is ridiculously small and has only happened once, with Mariner 4.[9] Note, however, that the probability of such an impact is a function of distance traveled. And, as noted above, the distances we have so far sent our spacecraft are extremely small when compared to the distances they will traverse in going to another star. Even low-probability events are likely to happen given enough time, and the likelihood of hitting something significant during a light-years-long voyage is high.

And we aren't through discussing what is in the "vacuum" of space yet.

In addition to gravity and light, the sun is pumping tons of hydrogen and helium across the solar system at speeds between about 185 and 500 miles per second in something called the solar wind.[10] If the solar wind radiation reached Earth's surface, it would severely damage the biosphere and life within it. Earth's magnetic field serves as a shield, redirecting the material around the planet so that it streams beyond it. The force of the solar wind changes Earth's magnetic field so that it is compressed inward on the sun-facing side and stretched out on the night side. These fast-moving particles also cause damage to electronics and can completely disable spacecraft over time or quickly, especially during a solar storm (a period of increased radiation emissions from the sun—in other words, when the sun burps and spits out higher-energy, higher-density radiation in clouds larger than Earth that then move outward from the sun and could impact our planet, our spacecraft, or both). Space mission planners design spacecraft electronics to be radiation resistant, but it is not possible to make them immune to the radiation's effects. Given enough time, most spacecraft electronics exposed to solar radiation will fail.

The solar system and interstellar space are filled with magnetic fields. As known physical processes allow Earth's molten

iron core to generate a magnetic field for our compasses to use in pinpointing north, so too do they allow the sun to create an enormous magnetic field that extends far out into space, encircling all the planets in the solar system and beyond. The combined interaction of the solar magnetic field and the solar wind define the heliosphere, the edge of which is called the heliopause (where the sun's outward flowing radiation pressure is balanced by the inward-coming radiation pressure flowing across deep space from all the other stars in the Milky Way). The heliopause is considered by many (but not all!) to define the boundary between the solar system and interstellar space.[11]

These interstellar magnetic fields play a role in the development of another component of the interstellar medium: galactic cosmic rays (GCRs), highly energetic charged particles that permeate space. GCRs were most likely formed when stars elsewhere in the galaxy exploded and sent huge clouds of highly energetic and ionized atoms out into space where they were further accelerated by the interstellar magnetic field to even higher energies. There are not many of them, but over time they can destroy electronics and damage biological life. (GCRs and their impact on interstellar starships will be discussed further in chapter 7.)

And then there is interstellar hydrogen. The heliopause, described above, is where the outward pressure of solar radiation, which is mostly hydrogen, is roughly equal to the inward pressure of the radiation from all the other stars in the Milky Way. This means that the interstellar space surrounding the solar system is filled with hydrogen emitted long ago from other stars and celestial objects. The density is low, with interstellar space averaging about one hydrogen atom per cubic centimeter.[12] If you are traveling very rapidly, these hydrogen atoms become nearly indistinguishable from the high-energy protons flowing

outward from the sun; there is no difference between a slow-moving spacecraft being bombarded by fast-moving hydrogen atoms (as from the sun) and a fast-moving spacecraft plowing through slow-moving hydrogen atoms. This diffuse cloud of atoms might just play a role in the viability of at least one advanced propulsion system that will be discussed in later chapters.

Now that we better understand what's out there, there are many questions that need to be answered. Among them are:

- How will we learn which extrasolar planets we should visit? Which might be like Earth?
- Knowing the vast distances involved and given our current understanding of physics and how nature works, how will we get there from here?
- We understand well the environment of deep space in our own solar system; what about when we cross the heliopause and begin our long journey through interstellar space?
- When and how can we make the trip?

2

Interstellar Precursors

You have to learn to walk before you can run.

—UNKNOWN

At this point you may be thinking, "Okay. When can we go? Are there missions we can launch in our lifetimes?" Unfortunately, we are far from being able to mount a journey to a planet circling another star—even the closest ones.

The pace of human exploration can be summarized as "one step at a time," and so it will likely be as we begin thinking about interstellar travel. When our ancestors ventured out of Africa, they likely did so by foot. Then came the domestication of animals, most notably horses, and the range of exploration increased dramatically. When some ancient innovator conceived of the wheel, the range increased yet again, as did the ability to carry along the goods and supplies that were essential to building early civilization. The innovations kept coming, with wheeled carts evolving into wagons, trains, and eventually modern automobiles. Travel by water also transitioned from being limited by the range of a human swimmer to canoes,

INTERSTELLAR PRECURSORS 21

boats propelled by human labor (oars), sailing ships, and the fossil-fuel- and nuclear-powered ships the size of small cities like those part of modern economic supply chains. The transition to flight was even faster. The first kites were thought to have been flown somewhere in Asia more than eleven thousand years ago. Small balloons followed until finally, in the eighteenth and nineteenth centuries, larger balloons, some capable of carrying people, began to go aloft. Finally, just over a hundred years ago, the first airplanes began to fly, and before long we were launching rockets into space and landing people on the moon. If I were to draw a parallel between these historical transportation milestones and our future interstellar journey, with landing people on the moon being the analogue to sending people to a planet circling another star, I believe that places us firmly at the "canoe" stage. But that's okay; without learning how to navigate the currents of the river in a canoe, our ancestors might not have been able to make the next innovative leap in technology. To understand why I contend that we are still at the canoe stage, we need to think about our efforts in space exploration to date and how we are currently planning to take our first intentional journey beyond the edge of the solar system and into interstellar space.

Before we sent people into space for the first time, the United States and the Soviet Union sent many uncrewed rockets to learn more about the space environment, how our machines might function within it, and its effects on biological life.

Humans being humans, there is not universal agreement of where space begins above Earth. (Are you shocked?) When asked, most people would probably intuit that space begins where Earth's atmosphere ends. A widely used definition is that space begins at 100 kilometers (~62 miles) above sea level, at what is called the Kármán Line. That's a nice, round, even

number in metric units and almost totally arbitrary. NASA uses a different definition and considers someone an astronaut if they reach altitudes above 50 miles (in English units, of course). If you truly want to consider space to begin where the atmosphere ends, then you would have an ever-changing altitude that reaches as high as about 375 miles, which is due to day/night and seasonal differences in upper atmospheric density. For our purposes, since we are soon to be talking about traveling tens or hundreds of trillions of miles, these numbers are all about the same—and ridiculously small.

Crossing that first few hundred miles was a challenge not met until the mid-twentieth century with the development of modern rockets. And, if you have been following the news, it is still a difficult boundary to cross all these years later. Hardly a year goes by without at least one rocket failing to reach its destination in space for some reason or another. The year 2020 was a particularly difficult one for rocket launches, with some spectacular failures making the news, including the loss of Virgin Orbit's LauncherOne, China's Kuaizhou and Long March, Rocket Lab's Electron, Arianespace's Vega, and others.[1] In the early years of space exploration, when large rockets were being developed and flown for the first time, failure was as common as success, if not more so. Driven by the competition of the Cold War, most of the problems were quickly overcome and ever more capable rockets were developed to send payloads into space.

In 1957, the USSR launched Sputnik, the world's first orbiting satellite, which triggered the now famous space race. That race can be separated into two segments: sending the first person into space and the successful landing of astronauts on the moon. But there were hundreds of rocket launches that preceded these milestones. *Hundreds.* It is important to note that

in this time period, both the USA and USSR were working toward sending people into space and were developing intercontinental ballistic missiles (ICBMs) as part of the other "race," the arms race. Though we like to separate the use of rockets for defense from their use in peaceful space exploration, the truth of the matter is that the technologies required for each are basically the same and neutral regarding their end goal. Each racer learned from the other, and this duality is what contributed to the large number of rocket launch precursor flights flown. Many of these launches, quite a few flown even before Sputnik, were not intended to reach orbit and instead flew ballistic trajectories (what goes up must come down) from one place on Earth to another, building up to sending a spacecraft into orbit. The first rocket to reach space ballistically, flying to an altitude of 118 miles before coming back down, was a V-2 launched from Peenemünde, an island off Germany's Baltic coast, in 1942.[2]

Among the precursor missions to sending a human into space were the launch of the first spacecraft to leave Earth orbit (Luna 1, 1959, USSR);[3] the first flight of primates into space, monkeys Able and Baker (1959, USA);[4] and the first photographs of Earth from space (Explorer 6, 1959, USA).[5] Finally, in 1961, the USSR launched Vostok 1 carrying cosmonaut Yuri Gagarin into Earth orbit with an apogee (or highest point in the orbit) of 203 miles (327 km) above Earth.[6] Several Earth orbital flights followed, and many were precursors to the next goal of sending people to the moon.

In the USA, the most famous series of prelunar test flights were the Gemini series. Between 1961 and 1966, the two-person Gemini spacecraft carried ten crews and sixteen individual astronauts into low Earth orbit (LEO), where they developed the techniques that would be later used in the

Apollo missions to the moon. Gemini's precursor missions had crews spending up to two weeks in space (to encompass the round-trip time to and from the moon), performing extra-vehicular activities (EVA) and perfecting orbital maneuvering, rendezvous, and docking procedures. The precursor missions continued in the Apollo series of missions, which included the orbiting of the moon by the crew of Apollo 8 and the almost–lunar landing of Apollo 10. Neil Armstrong and Buzz Aldrin were the beneficiaries of these test flights when they walked on the moon in 1969.

A similar approach will likely be used during our interstellar exploration. The first series of precursor missions have already been taken, and these are our modern canoes. These missions are the many robotic missions launched to explore and study the solar system, its planets, and its environment. There are too many to list here, but the nations of the world have successfully sent spacecraft to fly by or orbit all of the solar system's planets, some of the dwarf planets, the sun, and quite a few asteroids and comets. We can consider these amazing feats of engineering and science to be the interstellar equivalent of the early space race's ballistic rocket launches. They are necessary, but insufficient, first steps toward exploring interstellar space. Among these missions, there are five that future historians might collectively consider to be Sputnik-equivalent milestones—Pioneer 10, Pioneer 11, Voyager 1, Voyager 2, and New Horizons.

Pioneer 10, launched in 1972, was the first mission to fly by and study Jupiter.[7] Why is this mission on the list of Sputnik-like milestones? Because it was the first human-made object to achieve solar system escape velocity. The sun's gravity, like Earth's, can be overcome if an object has enough velocity to not be pulled back toward the source of the gravitational force. For an object to escape Earth's gravity, it needs to exceed 6.9 miles

per second (11 km/sec). This speed is not, however, enough to escape the sun's gravity, and almost everything we launch into space will remain in orbit around the sun because solar system escape velocity is not required to reach Venus, Mars, or any of the other planets. The sun's escape velocity (when launching from Earth)* is ~26 miles per second (~42 km/sec), and Pioneer 10 was the first to exceed it. Pioneer 11, launched one year later, became the first spacecraft to fly by and study Saturn. It, too, achieved solar system escape velocity and will never return to the solar system.

The most famous of the interstellar precursors flown so far, Voyagers 1 and 2, were launched in 1977, with Voyager 2 launching a few days before Voyager 1. Their primary missions were not to study interstellar space but to fly by the gas giants Jupiter and Saturn. Voyager 2 went one step further by visiting Uranus and Neptune, providing the first-ever close-up views of these majestic outer planet gems. Using the Voyagers for interstellar exploration was on the minds of their creators when they were in development, as evidenced by the records they carried. Each spacecraft bore a gold-plated audiovisual disc filled with photographs of Earth and varieties of life found here, spoken greetings from various people, a collection of music, including works by Mozart and Chuck Berry, as well as a host of scientific information and a map that shows the spacecraft's planet of origin.[8]

*Yes, I had to put in the caveat of "when launching from Earth," because the force of gravity between any two objects drops off with the square of the distance ($1/r^2$). If we were inhabitants of Mars, the job of launching rockets out of the planetary gravity well would be easier, because Mars is less massive than Earth and therefore exerts less pull on our rocket and its payload. It would also be easier to achieve solar system escape velocity, since Mars orbits the sun at a distance farther than Earth. We would, of course, have other problems—like staying alive in the harsh Martian environment—but that can be the topic of another book.

Why was this included? In case "someone out there" encounters the craft and is curious about its creators. Of course, and as we discussed in chapter 2, neither of the Voyagers will encounter another solar system for many tens to hundreds of thousands of years. They are simply traveling too slowly to reach anything significant any sooner, and they are not traveling in the correct direction. If Voyager 1 were pointed toward Proxima Centauri, the nearest star to Earth, it would take more than 73,000 years to get there. Don't hold your breath.

More recently, in 2006, NASA sent the New Horizons mission to fly by and provide the first-ever high-resolution images of Pluto. Taking nine years to reach Pluto, the spacecraft is on a solar system escape trajectory that included the post-Pluto flyby of the Kuiper Belt object known as Arrokoth, or (486958) 2014 MU69, as it continued its outward journey. As of this writing, the spacecraft is still operational and may provide views of additional Kuiper Belt objects should any be in range of its limited onboard ability to adjust its trajectory before its radioactive power supply dies. Like the Voyagers, the New Horizons spacecraft will not encounter any stellar systems for many tens of thousands of years or more.

Solid design and good engineering practices have allowed the Voyagers and New Horizons to continue operating beyond their primary mission lifetimes, providing a serendipitous opportunity to study the outermost edges of our solar system and into nearby interstellar space. Voyager 1 crossed the heliopause (see chapter 1) and officially entered interstellar space, 122 AU from Earth, in 2012. Voyager 2 should reach the heliopause anytime now. New Horizons will join them in interstellar space around the year 2038. The nuclear power sources that keep the Voyagers functioning and communicating with Earth will run out of power in the mid-2020s. New

Horizons will suffer a similar fate in the late 2030s. At best, they will be able to send limited scientific data back to Earth to a distance less than 200 AU.

Taken together, Pioneer 10, Pioneer 11, Voyager 1, Voyager 2, and New Horizons are the interstellar exploration equivalent of Sputnik. None were specifically designed to study the interstellar medium or to serve as a precursor for future interstellar travel—a feature they share with the German V-2 rocket reaching space for the first time during World War II.* To say that none was designed to study the interstellar medium is an important point. These missions were designed to study planets, dwarf planets, and Kuiper Belt objects. Their instruments included optical cameras to take photographs (and they provided amazing photographs) and instruments specifically tuned to study planetary environments. In nearby interstellar space, there are no large objects to photograph, and the instruments needed to study the radiation there are different. In other words, using the instruments on Voyager is somewhat like looking at a photograph of your great-grandmother in a black-and-white photo. You can tell she is human, what type of clothes she is wearing, and her general appearance, but you would not be able to determine with any degree of certainty what colors the clothes were that she was wearing. Another analogy might be that you are given a black-and-white photograph of a large body of water, with only the water visible against the horizon, and asked to determine the characteristics of the water (acidity, salinity,

*The V-2 flight into space was part of a test series to develop a military rocket that could be used to carry bombs and attack Germany's opponents during World War II— the point being that the rocket was designed for one purpose and then used for another. The analogy to the flights of these purely peaceful scientific missions breaks down at this point.

mineral content, degree of pollutants, etc.) using only the black-and-white image. The science teams have done the best they can, using the instruments available, to characterize the nearby interstellar medium, but many important scientific questions remain unanswered.

The data collected by these missions as they depart the solar system, combined with remote observations of interstellar space by telescopes and instruments back on or near Earth, have piqued the interest of scientists around the world who are clamoring for a new mission that will be dedicated to studying space beyond the solar system and getting a better understanding of what's out there.

All of our space exploration efforts so far are nothing more than the modern equivalent of putting a canoe in the river and seeing where the current will take us. Think about it. Our rockets launch a spacecraft into space, giving it sufficient velocity and energy to escape the pull of Earth's gravity and perhaps even the sun's, but then the thrusting stops and they coast the rest of the way to their destination(s). True, we creatively push them into directions that will allow them to fly by some large planets and use their interactions with that planet's mass to change direction or accelerate in what is called a "gravity assist" maneuver, but it is really nothing more than allowing the current to carry our canoe past a rock in the middle of the river or over some rapids that make it go a little faster. So, too, will it be with our first attempt to explore nearby interstellar space in a mission called Interstellar Probe.

The idea of missions designed specifically to study the interstellar medium out to about 1,000 AU is not new. Scientists have been wanting to launch such a probe since the dawn of the Space Age.

Before the Voyager spacecraft crossed the heliopause and into interstellar space, scientists predicted a different shape for the heliosphere than was found by the limited instruments on the Voyager spacecraft (refer back to page 18 for a discussion of the heliosphere). Studying complex physical interactions that are far away, and for which there are few or no experimental or measured data, relies on complex models. For these models to be accurate, they need to be benchmarked, or confirmed, by the very data they are trying to predict. In some cases, and as we learned from Voyager, the models were sometimes wrong.*

Perhaps the most compelling reason to send such a probe is discovery. Before Explorer 1 orbited Earth in 1958, scientists did not know much about what are now called the Van Allen Radiation Belts.† Before sending the Cassini spacecraft to orbit Saturn, we did not know that the moon Methone existed (discovered in 2004), nor did we know of the hexagonal storms raging at Saturn's pole.[9] Before sending New Horizons, Pluto was merely a dwarf planet barely discernible in the best of telescopes. Now we know that Pluto is the home of a heart-shaped nitrogen-ice glacier, the largest known glacier in the solar system.[10] These were discovered by going there. By sending a properly instrumented spacecraft beyond the edge of the solar

*This is a really important point in science. Models are only as good as their predictions. Many scientists build models to predict the behavior of nature under specific circumstances or at specific locations, and most of them turn out to be incorrect. The best way to know if the model is accurate is to use it to make a prediction and then take a measurement or make an observation to see if the prediction was correct.

†The person who built the science instruments carried into space by Explorer 1 discovered them. His name: Dr. James Van Allen.

system, scientists will learn more not only about the interstellar medium but also about the solar system itself.

By sending a spacecraft into interstellar space and looking back toward Earth, we will see our solar system as hypothetical aliens might see it from another star elsewhere in the galaxy. We will be able to see how the sun interacts with the gas and dust between stars, and how other stars interact with it as well. Scientists will be able to view our home star and compare its features with those of other stars to further understand our place in the larger galaxy.

Interstellar Probe will be expensive, and because of that, it is likely to be the only one of its kind for a generation. Since it will be paid for by taxpayers, the mission will need to carry instruments to answer science questions in many disciplines, not just those studying the sun and its influence. What else is out there? A great deal.

New Horizons's primary mission was to study the dwarf planet Pluto and Charon, Pluto's moon. Once the flyby was completed, the fully functional spacecraft with some remaining propellant was available to go elsewhere and study something else—but what? To answer that question, recall Pluto's demotion from being the ninth planet to merely a "dwarf planet." Why was it demoted? One of the reasons, and not the most scientifically compelling of them, was that there are likely hundreds of small bodies like Pluto that inhabit the solar system, mostly in the Kuiper Belt.* The scientists behind New Horizons knew there were likely to be other dwarf planets out there to

*The Kuiper Belt, named for astronomer Gerard Kuiper (who had no direct contribution to its discovery other than being a prominent and productive astronomer), is a region of the solar system beyond the orbit of Neptune wherein there are many comets, asteroids, and other small bodies like dwarf planets.

visit, so they designed the spacecraft to be flexible after its encounter with Pluto, giving it enough propellant to perform a modest course change to visit one of them if possible. When the spacecraft launched, they had no idea what their next destination might be. With a flight time of almost ten years (from Earth to Pluto), the science team had plenty of time to use the best telescopes and find their next target. They did, and after flying by Pluto and Charon, New Horizons was retargeted to visit Arrokoth, which it did in January 2019. Arrokoth was discovered in 2014, eight years after New Horizons was launched. There are likely hundreds more dwarf planets to study in the Kuiper Belt, and for this reason the Interstellar Probe will likely have its trajectory selected for it to fly by one or more of them on its way out of the solar system, targeting them for scientific study.

The technology to allow such a mission is finally catching up to the scientists' ambitions in one important way: until today, launching a probe that would reach over 200 AU in the lifetime of the scientists who engineered and built it would have been impossible. Recall that Voyager 1, launched in 1977, took until 2012 to reach the heliopause and forty-four years to reach its current location at 156 AU,[11] giving it an average velocity of about 3.5 AU/year. Now, let's say you're a mid-career scientist who has the experience and pedigree to lead such a mission. Chances are you will be at least in your mid-forties by the time you have the experience and expertise to propose, design, and get someone to fund the work. It will take another five years to build the spacecraft, get it tested, and ready for launch—taking you to age fifty. Then it launches. Traveling at 3.5 AU/year, like Voyager, it will take twenty-eight years to reach 100 AU (you will be seventy-eight) and another 114 years to reach 500 AU, taking you to the ripe old age of 192. With luck, your grandchildren

might be able to review the data, more likely your great-grandchildren. You can see the dilemma.

There is another enormous challenge associated with mission durations of decades to centuries. How do you design a spacecraft to remain functional that long? Voyager was not designed to last as long as it has; we are just benefiting from exceptionally good engineering and more than a bit of luck. Believe it or not, the Voyagers' design life was only five years, long enough for them to fly by and study Jupiter and Saturn.

The possible methods for implementing an Interstellar Probe mission have evolved considerably since I first became involved in the effort in about 1999. (Yes, I've been in the space business a long time. Look at my photo and that fact will become obvious!) At the time, I worked in the Advanced Space Transportation Program (ASTP) at the NASA Marshall Space Flight Center and was the principal investigator for a recently approved space demonstration of a new type of propulsion system called an electrodynamic tether.* When that was selected, I was recruited to work in ASTP because, well, moving spacecraft around in space using a long, thin wire is at the heart of what "advanced space transportation" should be. Most of my colleagues were true rocket scientists working on improvements in the development and manufacturing of chemical rockets. I was, quite literally, the "odd man" in the group. Naturally, when the Jet Propulsion Laboratory (JPL) called and asked for an advanced propulsion expert to come to Pasadena and work with their team in looking at sending a robotic probe to 250 AU and beyond, I got the job. (In truth, no one else in the office

*The project was called the Propulsive Small Expendable Deployer System (ProSEDS) and was to fly in 2003. Sadly, it was canceled as a direct result of the Columbia tragedy and never flew.

wanted to go. These experienced, seasoned rocket scientists scoffed at the idea of launching such a mission because they knew the limits of chemical rockets. They gave the job to me, thankfully.)

At JPL, I was immersed in a team of scientists who were eager to observe the interstellar medium (ISM) in situ, not from afar as we were then (and still are) mostly limited to doing. Unlike planetary missions, taking picture of interstellar space at these distances would not be terribly informative. However, measuring the composition and energies of the atoms (charged and neutral), electrons, electric and magnetic fields, dust, and interactions among them is of keen interest for scientists trying to understand the transition of the environment surrounding our sun to the interstellar environment just outside the sun's sphere of influence.

To give you an idea of how difficult it may be to study the denizens of deep space at those distances, consider the estimated particle density there: less than 1 atom (of anything) per cubic centimeter. By comparison, the density of the air we breathe is about 10^{19} molecules per cubic centimeter.* The magnetic fields they want to measure there are thought to have a strength of 6 microgauss. For comparison, Earth's magnetic field can be as high as 0.6 gauss, which is over 100,000 times stronger. In other words, the stuff they want to measure is very weak and very, very far between. But, taken together across the immense volume that is interstellar space, it matters. The interplanetary particle densities and field strengths are much smaller and weaker than Earth's, but still far more numerous and

*For those who get confused by scientific notation, 10^{19} = 10,000,000,000,000, 000,000. This means that for every 1 atom in interstellar space, there are 10,000, 000,000,000,000,000 atoms in the air.

stronger than that in interstellar space, and we are currently limited to looking through this stuff in the solar system to see what is outside it—not an easy task. Clearly, we must go there to take the measurements needed.

The positive news is that NASA is currently considering doing just that and has chartered a team led by the Johns Hopkins Applied Physics Laboratory (APL) to perform "a trade study of a realistic mission architecture that includes available (or soon-to-be available) launch vehicles, kick stages, operations concepts and reliability standards" to enable the mission within the next two decades.[12] To this end, the APL team has approximately two hundred scientists and engineers identifying the science to be performed and promising approaches for making it happen.

Based on the distances to be covered and the need to reduce the time taken to cover that distance so the scientists who launch the mission have a chance to be still alive when it reaches its destination, and with the explicit goal of launching Interstellar Probe sooner rather than later, the APL team is narrowing the list of possible propulsion and power options to those that are available today. Their stated goal? Reach a solar system escape velocity of 15–20 AU/year. Recall that Voyager is traveling at 3.5 AU/year. That is a big difference. A *huge* difference.

Over the years, various in-space propulsion technologies have been considered, and they all have their pluses and minuses, as will be described in chapters 5 and 6. Suffice to say that for most of the time this mission has been studied, the assumption has been that one of the new, low-thrust propulsion systems with science-fictional names like electric propulsion, solar sails, or magnetic sails would provide the speed required. None of these advanced technology options have matured fast enough

to allow the mission to proceed anytime soon, and the science community is impatient. There has to be another way.

The leading approach for propelling Interstellar Probe is the use of NASA's new monster rocket, the Space Launch System (SLS), to launch the probe and two attached conventional solid propellant rocket engines behind a thermal sunshield that will allow the probe/rocket motor combination to pass extremely close to the sun—within five solar radii ~2 million miles (~3.5 million kilometers). Mercury orbits the sun at ~36 million miles. This would be the closest any spacecraft has ever flown to the sun. While at closest approach, called perihelion, the solid rocket motors would fire, giving the probe a speed boost at the optimum time in its trajectory, accelerating it to a velocity of 15 AU/year, allowing it to go screaming out of the solar system at almost the desired velocity.[13] The close solar approach is called an Oberth Maneuver, named after Herrmann Oberth, the first person to work out its feasibility (mathematically).* Those who regularly follow interplanetary missions might recognize this approach as being a variation of the standard planetary flyby maneuver that engineers regularly use to accelerate spacecraft in deep space. The Voyager spacecraft used it multiple times to attain their current velocities. Using the massive sun provides quite a speed boost. This is a philosophically different approach than those considered from when I first became involved in Interstellar Probe back in the 1990s. At that time, it was assumed that a new propulsion technology would be needed to achieve the necessary velocity. What we did not consider was the advent of

*To illustrate my degree of space geekiness, I recently planned a vacation to Germany to allow a visit to Oberth Museum in Feucht, Germany. I highly recommend visiting it.

truly large launch vehicles and what can be done with a brute force approach.

Unfortunately, there is a big issue with using this approach.* It is a technological dead end. Using the largest rocket in the world and passing as close as possible to the sun to perform a boost using rockets will allow Interstellar Probe to reach its velocity goal. But then that is it. Based on our physics and engineering knowledge, this is the limit of performance that can ever be achieved with chemical rockets. It cannot get any better (faster)—*after all, it is a canoe.* This approach may allow the Interstellar Probe to be launched, but from a propulsion point of view, it will do almost nothing technologically that can be used to enable future, more ambitious missions requiring yet faster solar system escape velocities.

Before discussing these more ambitious deep space missions, it is worth mentioning that a great deal of precursor science and reconnaissance can be performed remotely using space telescopes that never leave Earth's vicinity. With our eyes we can see nearby stars. Our telescopes allow us to see more distant stars, and space-based telescopes those still farther away. We are able to build large space-based telescopes with the optical capability to resolve planets circling some of these nearby stars. But there is a problem. The star around which the planet is circling is much, much brighter than the reflected light from the planet, and the two are so close together, relatively speaking and from our distant perspective, that we cannot see the planet because of the starlight. (Recall the problem of seeing a mosquito

*There are actually many possible issues associated with planning on using the SLS. To start with, it is a new rocket that (as of this writing) has not yet flown—will it work? Will the SLS still be available and affordable for the mission?

in the glare of a car headlight discussed in chapter 1.) Now recall the discussion of solar eclipses causing the dimming of the starlight, thus allowing the existence of exoplanets to be inferred. What if we can leverage the physics that allows an eclipse to happen and use that to help us distinguish and image an exoplanet?

If you have ever experienced a total solar eclipse, you will never forget it. As the moon passes directly in front of the sun and completely blocks the sunlight, day becomes night, the crickets begin to chirp, the air rapidly cools, and you can suddenly see the sun's corona, which looks like long streamers coming from the surface of the moon-blocked sun—previously lost in the glare of the sunlight. With our space-based telescopes, can we create an artificial eclipse to block the light of the distant star and allow the dim planet to be seen? First proposed in 1962,[14] the idea of using an "occulting dish" to accomplish an artificial eclipse has fresh life thanks to the efforts of astronomers like Webster Cash and Sara Seager, an MIT exoplanet scientist. Seager and her team were funded by NASA to study the feasibility of a space telescope that would include an occulter, or star shade, flying on a separate spacecraft and positioned between the telescope and the target star system where it could block the star's light. Her study, and others, concluded that the approach should work, leaving open the possibility that the next generation of space telescopes might be accompanied into space with their own star shades.

There is also a precursor mission proposal to image an exoplanet and not require a star shade: the Solar Gravity Lens (SGL).

To understand the importance of the SGL mission, we need to discuss our favorite physicist, Albert Einstein, and his other relativity theory, General Relativity (GR). In the Theory of Special Relativity, Einstein described how the constant speed of light

from all points of view affects the flow of time in reference frames that are accelerated to velocities approaching c. Simply stated, the faster you move, the slower the rate at which time passes relative to observers not moving with you at that speed. GR takes the link between moving through space and the passing of time to another level, one that includes the effects of mass and the nature of space and time themselves. Einstein postulated, and has been proven correct in every observation and test devised thus far, that space and time are inseparable and are coupled together in such a way that it is better to describe them as one, or space-time. Space cannot exist without time nor can there have been time "before" there was space.*

Once you make this assumption about how the universe works, you can then think about the role mass or matter plays within it. In our everyday lives, we observe that light travels straight through space from its source to where it is detected. In the absence of gravity, this holds true with space-time as well. But when matter is included, space-time bends. The more massive the object, the more bent space-time becomes. My favorite visualization of this is to consider a mattress. If the surface of the mattress is the shape of normal space-time where no mass is present—that is, flat and straight—then light will go from one side of the mattress to the other in a straight line. If, however, a bowling ball is placed on it, then the surface of the mattress becomes indented. In this case, to reach the other side of the mattress, light will follow a path that is curved around the ball; the closer to the ball the light gets, the bigger that curvature is (figure 2.1). Likewise, as space-time is bent, and since

*This is why scientists cannot talk about what existed before the Big Bang. Since both space and time were created in the Big Bang, there cannot have been a time "before" because, well, time did not yet exist!

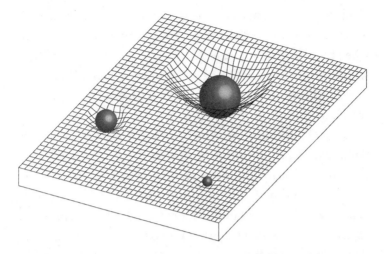

FIGURE 2.1. The Bending of Space-time. Space-time is bent near any object with mass; the more massive the object, the greater the curvature. For example, the sun bends space-time far more than Earth. Image created by Danielle Magley.

light is constrained to move along space-time, the light traveling through space-time near the bowling ball will be forced to follow the surface of the mattress and subsequently its path will be bent as well.

But, in practical terms, what does this mean? So what?

To answer that question, let's divert to everyday life again and talk about optical lenses, like those in the eyeglasses or contact lenses that many of you reading this may be wearing or might have worn at some time. In a lens, light is refracted, or bent, so that the light rays passing through it seem to come from a point that is closer or farther away from where they actually originate—making objects seen through the lens seem either bigger or smaller than they really are. Convex lenses bend light to form a focus. In space-time, recalling our mattress analogy, massive objects bend light much like a convex lens (though through an entirely different physical process), with a similar

result—they can magnify more distant objects and bring *them* into focus.* Astronomers frequently observe this aspect of GR when they observe a so-called Einstein Cross or Einstein Ring, which is simply a very distant object gravitationally lensed by a closer, massive object that just happens to form its focus in our region of space.

Hmm. What happens to be nearby and massive enough to bend space-time? It turns out that all of the planets bend space-time to some degree and form subsequent gravity lensing focus regions extending far out into space beyond the edge of the solar system—the less massive the planet, the further away its focus. The sun, with its enormous mass, bends space-time to a degree that it creates a line of focus near 550 AU (figure 2.2). Physicist Slava Turyshev is studying this effect for NASA and has proposed a mission to send a modest-size telescope, 1 to 2 meters in diameter, to the solar gravity focal region for the purpose of imaging potentially habitable exoplanet(s) otherwise impossible to see with conventional optical telescopes.[15] It is possible that scientists will be able to reconstruct the image of that exoplanet as if it were being observed from nearby, and see if anyone there has the lights on at night!

There are other compelling scientific missions proposed that will slowly increase our understanding of nearby interstellar space, each requiring that we travel farther and faster. These will be difficult (perhaps impossible) to accomplish without new propulsion technologies, and they are not the only technologies needed to enable these missions.

*A note for the scientists who might be reading this book. Strictly speaking, the solar gravity lens does not produce a simple focus like a convex lens, but rather an Einstein Ring, which is much too complicated to describe fully here. But the effect is the same, and a convex lens focus is the most easily understood analogy.

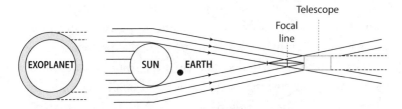

FIGURE 2.2. The Solar Gravity Lens. The light reflected from an exoplanet will travel across light-years of space to arrive at our sun, following a straight-line path through space-time. Near the massive sun, space-time is bent. Light, following this bent path, will converge and form a line of focus near 550 AU. A telescope placed there with appropriate image processing technology should be able to see an exoplanet in great detail—so much so that if there were a civilization like ours present, they would be detectable. From "Image Recovery with the Solar Gravitational Lens" by Viktor T. Toth and Slava Turyshev (*Phys. Rev.* D 103, 124038. June 2021).

What about power? How will the spacecraft be kept warm and have power to both run its instruments and send the data back home?

Our current fleet of robotic spacecraft are mostly powered by sunlight because they are operating in the inner solar system near the sun. As our canoes move farther from the sun, the light grows dim, with the sun eventually becoming virtually indistinguishable from any other star in the sky. As this happens, the ability of a spacecraft's solar arrays to generate electrical power diminishes, eventually to a point where no power is generated. This problem is even worse than it intuitively appears, due to a property of sunlight called the inverse square law.

This law applies to any point source of light, like the sun. Simply put, if you double the distance from the sun (for example, from that of Earth's orbital distance to two times that distance), then the amount of light falling on any given surface is not halved (as intuition might lead you think) but rather is decreased by a factor of four $(\frac{1}{2}^2 = \frac{1}{4})$. This means that the

amount of light falling on that surface is only one-quarter the amount of light that fell on that same surface when it was at Earth and closer to the sun. If you increase the distance to three times the sun-to-earth distance, then the resulting amount of light falling on the array is nine times (3^2) smaller. Conversely, if you decrease the distance to one-third that of the sun-to-earth distance, then the sunlight doesn't triple, it goes up by a factor of nine!

When sunlight is plentiful, deploying large area solar arrays to generate power from it is the most cost effective and simplest method to use. As spacecraft travel farther from the sun, sunlight intensity decreases rapidly, causing an associated rapid decrease in the power that can be generated. Some missions are more ambitious than others, and the range of electrical power required is large. For example, the Juno spacecraft,* launched in 2011 to study Jupiter, generates only 435 watts at Jupiter (and would have been able to generate many times that if it were in Earth orbit, thanks to the inverse square law).

For missions bound for Jupiter and further out, spacecraft use plutonium power packs called Radioisotope Thermoelectric Generators (RTGs), each typically producing enough power to run the scientific instruments, keep the spacecraft warm in the cold of deep space, and drive the communications system to send the collected data back to Earth. Single RTGs, like the one on New Horizons when it flew by Pluto, can generate only about 202 watts—the bare minimum to allow meaningful science return.

*Juno is the Roman name for Hera, and Jupiter is the Roman name for Zeus. Juno/Hera and Jupiter/Zeus are married. It is amusing that they sent "Juno" to check on "Jupiter" (to see if he was up to no good, perhaps?).

Solar cells only work when close to the sun, and there are no batteries capable of storing the power needed for a decades-long journey to 200 AU and beyond. RTG technology is based on the radioactive decay of plutonium (figure 2.3). Some of the decay products are absorbed in the material surrounding the plutonium, generating heat, which is then turned into electricity by thermocouples.* Thermocouples generate electricity passively, meaning they have no moving parts. RTGs are perfect for using on spacecraft that are far from home since there is really nothing about them that can easily break or stop working. The life-limiting factor for an RTG is the eighty-seven-year half-life of plutonium.† Unfortunately, since the output power is dependent upon the amount of plutonium, the power output will decline similarly. The Voyager spacecraft, launched in 1977, are projected to have their RTGs stop producing power sufficient to continue operating and call home between 2025 and 2030. NASA is developing the next generation of radioactive decay power systems, now called Radioisotope Power Systems (RPS), with a variety of power outputs and mission-specific configurations (i.e., deep space versus the surface of Mars). The next generation systems will be capable of providing up to about 500 watts of power.[16]

What are the other options?

*I must point out that *thermo-* means "related to heat," and *couple* means "to join." Being a fan of wordplay and etymology, I am fascinated by many words we use, their origins, and how they sound as we speak them. (Just ask my family; I sometimes blurt out words that may nor may not have anything to do with the topic at hand, but are synonyms, homonyms, or just nonsensical sounding.)

†Plutonium produces electrical power through the heat generated as it decays into uranium and emits alpha particles. The half-life of a substance is the time it takes for half of the substance to decay into its daughter products.

Pu-238
Neutrons: 144
Protons: 94

U-234
Neutrons: 142
Protons: 92

α-particle
Neutrons: 2
Protons: 2

FIGURE 2.3. The Radioactive Decay of Plutonium. Plutonium-238 is unstable and decays naturally into uranium-234 with a half-life of eight-seven years. As the plutonium decays, it emits helium atoms (often referred to as alpha particles), which interact with the material surrounding the radioactive elements, warming them. This generated heat is then used to keep a spacecraft warm and/or to generate a small amount of electricity, which can be used to power a spacecraft when it is far from the sun and solar panels are impractical.

NASA is also developing Kilopower, a new fission-based power system (which operates similarly to the nuclear reactors used to generate electrical power) that would produce about four times as much power as an RTG but with a significant drawback—lifetime.[17] The design life for Kilopower is less than twenty years. In principle, the Kilopower reactor could serve as a pathfinder for a new generation of fission-powered reactors designed to operate and produce electrical power for a hundred years or more, making fission an option for Interstellar Probe, SGL, and perhaps even missions bound for another star. Given the relatively modest power requirement for a robotic spacecraft in its launch and deep space transit phase, enough nuclear fuel could be carried aboard the ship to see it through a journey

spanning twenty-five to fifty years, or more. If only it were that simple. Instead of passively (meaning no moving parts) converting the heat from radioactive decay into electricity, as does an RTG, a fission reactor uses the heat generated by the nuclear reaction to expand a working fluid or gas, which then cools and contracts, often causing the movement of conducing wires relative to a magnet to generate electrical power. This process produces more electricity than simple radioactive decay, but it has many more steps, requires more mass, and is more complicated. (Fission > heat > expands/contracts a gas > moves wires relative to magnets > creates electricity.) As most engineers will testify, machines with that many moving parts tend to wear out or break over time, and designing a system that can operate continuously for half a century will be a challenge. But it can be done.

Another option is power beaming. It should be possible to send power to spacecraft in deep space using lasers or microwaves, and the key figure of merit for its viability is, like rockets, efficiency. Here are the steps required to get usable microwave beamed energy from where it is generated to the electrical power needed by the spacecraft: 1) ground- or space-based power generation, 2) power to microwave conversion, 3) broadcast, 4) transmission across space, 5) reception, and 6) conversion back to electrical power. The overall efficiency of the system is the product of the efficiency of each step. For the system to be viable, each step needs to be highly efficient. The good news is that we humans are pretty good at creating and manipulating microwaves.

From their first widespread adoption as radar during World War II to the introduction of the miraculous, fast-cooking microwave oven into kitchens around the world in the 1960s, people have been creating and using microwaves for all sorts of creative applications. The most germane are probably the

modern cell phone networks (think of all the cell phone towers that dot roadsides across the world) and satellite communications. In the former, every watt of power wasted at a cell phone tower adds up to huge money lost for the big cell phone companies that operate hundreds of thousands of them in the US alone. There is a huge incentive to develop technologies and systems to increase their efficiency and decrease cost, and it has quite literally paid off. Each step in the efficiency chain described above has a relatively high value except for one: transmission across space. Like sunlight and the solar wind, any microwave beam sent outward to cross millions or billions of kilometers in space will diverge over time, reducing the amount of power that can be received onboard the spacecraft, driving it to larger and larger receiving antennas to capture as much of the energy as possible, increasing its weight and complexity at the same time.

And then there are lasers. Unlike sunlight, which emits light of many colors across the electromagnetic spectrum, lasers have a narrow frequency spectrum, or color. This really matters when it comes to converting the received laser light into electrical power at the spacecraft. Solar cells are good at converting light of many colors (like that emitted by the sun) to electrical power, but that means they are not the most efficient overall, with measured efficiencies at or below about 40 percent. This means that only 40 percent of the energy contained in the incident sunlight is converted to electrical power. The rest is lost, mostly as waste heat. On the other hand, solar cells designed to maximize power conversion at only one frequency, the same at which the laser is beaming, can attain conversion efficiencies well above 55 percent. The practical side of this increase in efficiency is that smaller receiver arrays may be used, reducing the spacecraft mass.

Laser beams, too, diverge when traveling across space, but they have the advantage of being able to begin their journey in

a much more focused beam than is possible with microwaves, reducing the losses—but with distances so vast, the energy lost to the divergence is still considerable.

Now that we have the propulsion and power options identified, next is communication. Sending a spaceship anywhere is a technological achievement, but if it cannot send the data from its instruments home, then what is the point? The two Voyager spacecraft are so far away that it takes over twenty-one hours for the radio signals to travel from the spacecraft to Earth or vice versa. While their 23-watt radios are more powerful than your average cell phone, which uses about 3 watts, it is far less powerful than my local public radio station transmitter's 100,000-watt transmitter. When the Voyager signal reaches Earth, its power has dropped to about 10^{-18} watts. How is it possible to receive and understand this signal? To understand the challenges of interstellar communications, we first need to define some terms and list the challenges that must be overcome.

Bits are the smallest unit of data and usually have a single binary value, either 0 or 1. This is the fundamental data unit in digital communications to convey simple information, such as the answer to the question "Are you there?" If the answer is "yes," then you reply with "1," and if you are not wherever "there" is or do not reply, then the response is "0." This type of data can be sent at a rate measured in bits per second (bps). Typically, however, bits are grouped together in "bytes," each containing 8 bits. Think of a byte as a combination of bits that describes a particular letter of the alphabet, which cannot be distinguished from the other letters in the English alphabet by a simple "1" or "0" alone. Music is even more complex. Stored on my computer is the song "Walk the Line" by Johnny Cash, which requires 38,081,616 bytes. Video requires even more, with a typical high-definition movie needing about 3,000,000,000 bytes.

In the context an interstellar precursor or a true interstellar mission, it would be far easier for a spacecraft to send home the simple message "I arrived," which would consume bits of data at most, than to send back high-resolution video or imagery of the destination being visited, but that would be far from satisfying for those that went to all the trouble to send the spacecraft.

Bandwidth is the volume of information that can be sent in a measured amount of time, usually in units of bps. Modern terrestrial communications networks routinely handle millions of users, each transferring data at rates ranging from thousands of bits per second (kilobits per second, or kbps) to millions (mbps) and billions of bits per second (gbps). Transmitting this much data requires a lot of power, thousands of regularly spaced towers to relay the signals and boost their signal strength, and an extensive network of copper and fiber optic cables that span the globe. Obviously, there is not a similar infrastructure available in deep space.

Link margin is a measure of how well a communications system can perform based on its power and distance. As with sunlight, solar wind, lasers, and microwaves, the strength of a radio transmission drops quickly with distance, obeying the inverse square law. Again, the most relevant examples are the Voyager spacecraft. To receive Voyager's weak radio signal, NASA uses a network of Earth-based radio dish antennas with apertures of 70 meters (230 feet)! As it continues to fly into deep space, Voyager's radio signal will soon be undetectable from Earth.

There are three good ways to boost the amount of signal sent and detected across vast distances: 1) increase the power of the broadcast, 2) increase the sizes of the broadcast and/or receiver antennas, 3) use "quiet" radio frequencies—those in which there are few other users and therefore little or no noise or interference. The obvious benefit of using a higher-power

transmitter is that you have more strength at the start; when it inevitably decreases during transit, there is more headroom from which to fall. The other approach, building a bigger antenna, makes sense if you think about the "how" part of the inverse square loss problem. The beam spreads out, making it weaker across any given area for its collection. If you increase the collection area, then you capture more of the weakened signal. Building multiple antennas in space with extremely large aperture (miles long in scale, which might not be as difficult as you think—more on that later) would increase the signal collection area.

On the spacecraft side, both options translate into a more massive spacecraft, making the propulsion problem more difficult. For precursor missions, recent advances in fission and, maybe, fusion power can provide enough additional output power to increase the distance across which useful data may be transmitted. This increased power, coupled with innovative, lightweight antennas, many of which are deployable (meaning that they can be packaged into small volume for launch and then unfurled after they arrive in space to make them operational), can realistically increase our reach into the interstellar medium to several hundred AU or more—still far short of what will be needed to send signals between the stars, but good enough for precursor missions.

Artificial radio noise near Earth is a huge problem (thanks to 100,000-watt transmitters like the one mentioned above and to the billions of 3-watt cell phones out there), which is further complicated by radio noise generated by the sun and planetary magnetospheres, especially Jupiter.* For this reason, scientists

*Believe it not, you can hear radio noise from Jupiter right here on Earth if you have a sensitive radio tuned to either 18 MHz or 24 MHz and know when to listen.

use frequencies that are relatively "quiet"—that is, not used by terrestrial radio transmitters and seldom interrupted by nature. Voyager calls home on one of two possible frequencies (2.3 GHz or 8.4 GHz); DSN sends signals to Voyager at 2.1 GHz.

What about optical communication? Many cities are clamoring to swap their copper cable-based Internet systems with fiber optics to increase the rate at which data can be transferred. Instead of using radio frequencies to send information through the air, optical communications systems use laser light, which has the potential to carry much more information. Optical fibers can transmit data at rates of gbps or terabits (trillion) bps per second (tbps) versus the mbps of much heavier copper wire. A similar increase in data rate transmission should be possible wirelessly, but not without some drawbacks.

For one, optical communication does not work well in planetary atmospheres due to the absorption and dispersion of light by the often humid atmosphere, including clouds, and the many dust particles and aerosols that are between the light source and the receiver. (Just think about the tiny particles you see in your living room when the sunlight is streaming through the windows.) In deep space, these problems mostly go away. For this reason, the world's space agencies are embracing optical communications to send large amounts of data across millions of miles, making near-real-time streaming of high-resolution video from places like Mars a near-future reality (as opposed to taking months for the video to download and then watching it). Laser optical communication can begin with high power and with the transmitted data sent highly directionally toward the intended destination, but with distance the beam spreads, the energy density drops, and the link margin drops. And there is the pointing problem. With laser optical communication, the line-of-sight problems get much more stringent

than with a directional radio transmitter. Any jitter of the beam could make a difference in the signal being received—or not. For example, go outside after dark and try to hold a flashlight beam steady as it shines on a building or tree on the next block. Inevitably, the slight motion of your hand will cause the spot of light to jump around quite a bit. Imagine trying to hold a laser beam very still so that a small spacecraft billions or trillions of miles away can see the signal and not have the effects of jitter at these distances render useful communication impossible. Keep in mind that an Earth-based beam is constantly moving due to Earth's rotation, the movement of the planet around the sun, and the sun's motion as it orbits the center of the galaxy. All of these motions must be calculated and compensated for in the pointing or receiving of the beamed information.

The preceding discussion is all about sending information from Earth to the spacecraft. The spacecraft must know where to point its radio antenna or communication will be lost. The verdict is still out on using optical communication across distances measured in the hundreds of AU.

Propulsion, power, communications, reliable systems—all are necessary components of a successful interstellar precursor mission, but none is sufficient. The missing pieces are the reason to go and finding someone or some organization willing to pay for it. Fortunately, the National Research Council report "Solar and Space Physics: A Science for a Technological Society," otherwise known as the Heliophysics Decadal Survey— one of the science documents that guides NASA's investments in space science—gives us the reason to go:[18]

Advanced scientific instrumentation for an interstellar probe does not require new technology, as the principal technical hurdle is propulsion. (Also required are electric power from

a low-specific-mass radioactive power source and reliable, sensitive, deep-space Ka-band communications.) Advanced propulsion options, which could be pursued with international cooperation, should aim to reach the heliopause considerably faster than Voyager 1 (3.6 AU/year). Possibilities include solar sails and solar electric propulsion alone or in conjunction with radioisotope electric propulsion. The panel did not find either the ballistic or the nuclear electric power approach to currently be credible. In summary, to enable achievement of this decadal survey's key science goals in the coming decades, the SHP [Solar and Heliospheric Physics] panel believes high priority should be given by NASA toward developing the necessary propulsion technology for visionary missions like SPI and interstellar probe.

Clearly, the ability to enable even the most rudimentary missions into interstellar space will require technological advances to get us out of the "canoe stage" and to the next level. In the immortal words of a famous (unfortunately fictional) starship captain: "Make it so!"

3

Putting Interstellar Travel into Context

In the past century, there were more changes than in the
previous thousand years. The new century will see changes
that will dwarf those of the last.[1]

—H. G. WELLS, SCIENCE FICTION AUTHOR

Now it is time to pause, catch our breath, set realistic expecta-
tions, and dispel some misconceptions. In chapter 1, we dis-
cussed the amazing things in the universe that we want to visit,
explore, and perhaps make our future home(s). We also out-
lined the enormity of the challenge posed by the distances in-
volved. In chapter 2, I discussed where we are today in deep
space exploration, exploration beyond the bounds of the eight
planets that make up the innermost portions of our solar sys-
tem, and I described missions that we can conceivably launch
within the next few years to explore nearby interstellar space.
Also discussed was the stark realization that with current tech-
nologies, sending even a small robotic probe to another star

would require tens of thousands of years. Reaching the stars will not be for the timid.

Before describing the different technologies that need to be developed to allow such trips, it would be useful to restate the challenge of crossing the immense distances between the stars in terms of the energy required to accelerate a spacecraft to the velocities needed to make the trip in a reasonable amount of time. We will also need to redefine what we mean by "a reasonable amount of time"—it is not what you might think—and address a few of the ethical questions that sometimes arise.

Even if a spacecraft were 100 percent efficient in converting an energy source into propulsion, which would not be achieved in practice, the energy required to accelerate even one kilogram (2.2 pounds)—about the mass of the smallest spacecraft flown today—to one-tenth of the speed of light (0.1 c, or about 186,000 miles per second) is about 450 trillion joules. That is a big number, and with numbers this size, most people's eyes begin to glaze over. What does this mean in units we can really understand? Consider the coal burned in electrical power plants. Under ideal conditions, which almost certainly never happen, 1 kg of coal can produce about 23 million joules of energy. That means that our 1 kg spacecraft would require burning and capturing all the energy released from about 19 million kg (~42 million pounds) of coal with 100 percent efficiency to accelerate it to 0.1 c.* Accelerating a spacecraft the size of the 720-kilogram Voyager probes to 0.1 c would require 720 times more energy, *an amount equivalent to an appreciable fraction (about 0.06 percent) of the entire world energy output for one year.*

*Considering that a train car can carry about 150,000 pounds of coal, the energy needed to accelerate our spacecraft to 10 percent the speed of light would require 168 train cars fully loaded with coal.

The demands of decelerating prior to reaching the intended target would increase the energy requirement by as much as a factor of two. When considering the energy required to accelerate a ship carrying humans on a long journey to another star, the numbers become even more mind-boggling. A review of human-scale starship studies (yes, these are a thing) indicates that such a ship would have a mass somewhere between 10^7 and 10^{10} kg. A ship with a mass of 10^7 kg would require a staggering 4.5×10^{21} joules of energy to accelerate to 0.1 c with perfect efficiency.*

Adding to the kinetic energy requirement, making the job of reaching high velocities that much more difficult, are the efficiency by which a particular propulsion system converts its propellant into useful thrust (which are almost always much, much less than 100 percent) and the inherent energy density of the propellant used by the propulsion system. Anything less than converting a high-energy-density propellant into thrust highly efficiently is simply not practical.

To put energy conversion into perspective, consider a typical gasoline-powered car and the efficiency with which it converts gasoline into motion. In the car's engine, the gasoline is ignited to burn and create an expanding cloud of gas. The kinetic energy of the expanding gas is converted into the movement of a piston, which is then converted into the rotational motion of the crankshaft. The rotating crankshaft turns the wheels, converting its rotational motion into linear motion of the automobile. When the inefficiencies of each step are added together,

*If anyone is interested, that's four sextillion, five hundred twenty-seven quintillion, seven hundred sixty-two quadrillion, five hundred fifty-three trillion, seven hundred thirty-six billion, two hundred sixteen million, one hundred ninety-six thousand, two hundred fifty joules, in not-so-plain English.

the final overall efficiency at which the gasoline is converted into the car's motion is less than 50 percent.

But wait, in the above example we started with gasoline. Gasoline is made from oil, and there are inefficiencies in the processes by which gasoline is made from oil. For the purposes of considering a particular propellant for space travel, the inefficiencies in producing the propellant or making the propulsion system are not usually considered relevant since they do not affect the overall trip time or size of the spacecraft. They do matter, however, when we begin discussing the costs and required infrastructure required to produce the propellant. These processes are also inefficient, making the overall task of mounting an interstellar mission that much more difficult.

Developing a propulsion system that allows rapid travel is the key to covering the immense distances between the stars in a realistic amount of time. Traveling that fast potentially creates a big problem. Recall that the smallest interstellar spacecraft we can realistically conceive will have a mass of 1 kg and, when traveling at just 0.1 c, have 450 trillion joules of kinetic energy (the energy associated with its motion). If this small probe were to collide accidentally with a planet, which could happen if our targeting or navigation technology takes it slightly off course, then it would impact and release all that energy in the form of an explosion with the equivalent explosive capability of seven Hiroshima-size atomic bombs, ~15 kilotons each. And this is for a spacecraft that weighs the same as an average cantaloupe. A Voyager-class spacecraft traveling at 0.1 c would impact with an energy of 79,000 kilotons—the equivalent of well over 5,000 Hiroshima bombs! And this is for the ships traveling at only 10 percent of the speed of light. If we ever achieve rapid interstellar travel, we'll need to be sending ships outward with speeds in excess of 50 percent the speed of light. In this faster

case, our cantaloupe-size spacecraft would have the energy equivalent of more than 220 Hiroshima bombs. We'd better make sure our first emissaries to the stars don't miss and cause our first contact with alien life (if there is any at our destination) to be perceived as an act of war!

Now let's talk about how long it will take to make the trip. This topic may be challenging for readers of this book who reside in North or South America because, based on my personal experience, we have a vastly different perception of time from that of our counterparts elsewhere in the world. The reason is simple: almost every building or structure on our continents was made quite recently. Yes, there are ceremonial burial mounds created by Native Americans, some of which date back more than two thousand years, but most structures we encounter in our everyday lives, especially in North America and Canada, were built within the last fifty to a hundred years, with really old homes, buildings, and churches going back to perhaps the 1600s. These "old" structures are often set aside for preservation and are popular tourist destinations. Now, consider Europe.

In college, I had a good friend from the United Kingdom. After I began my career, I traveled to visit him at his "flat" (apartment) located in London. It was a wonderful trip, and during the course of it I asked him when his flat was built. His answer? "It is fairly new, built in the early 1800s or so." "Fairly new???" I was staying in an apartment, one of thousands in or around London, built when my country, the USA, was barely twenty-five years old. Many still-occupied, everyday buildings in much of Europe are hundreds of years old and the locals think nothing of it. When I visited Italy and Greece, the same laissez-faire attitude toward the ages of the buildings and landmarks surrounding them expanded to an even larger period of time. My

wife and I toured Delphi (built around 800 BCE), Olympia (with remains dating back to 2000 BCE), the Parthenon, and so on. You get the picture. Many Europeans have a view of history that is quite different than mine. For me, something that happened two hundred years ago is ancient history. For them, it would be a recent event.

And then there are the beautiful cathedrals and churches. Built to honor God, the majestic structures reside in many European cities and are ongoing examples of a "long view" that, again, most North and South Americans lack. From start to finish, building Canterbury Cathedral, one of the most famous churches in the world, took 343 years.[2] I cannot imagine the construction committee at my local church, which took less than two years to construct, signing up for new building that would take more than three hundred years to complete. Can you? In the USA, many companies' strategic and long-range plans look five years into the future. If we are going to mount expeditions to the stars, then we need to take a much longer view, one reminiscent of the thinking that was required to construct Europe's churches. Not only will our spaceships have to cross deep space and travel extremely fast, but they will also have to have a commitment from those back on Earth that spans centuries.

Let's think back to our small robotic spacecraft traveling from Earth to a planet circling Alpha Centauri A, B, or C. They are all at about the same distance from here (on a galactic scale): ~4.3 light years. Our intrepid interstellar craft, traveling at 0.1 c, will require more than forty-three years to get there. I say "more than" because the ship will presumably spend some time accelerating to 0.1 c at the beginning of the trip and decelerating at the end, bringing the total trip time to at least fifty years. Once it arrives, the data that it captures will be sent back home at the speed of light, requiring 4.3 years to reach our

earthbound radio receivers, making the total time from launch through first data fifty-five years minimum—and this is for the nearest star! Given the energy required, it is likely that a larger ship, one sized to carry human crew, will have to travel much slower than 0.1 c, making the travel times longer still. Our starship makers, travelers, and mission controllers will need to be thinking more like Europe's cathedral makers than today's church building committees—without the forced labor that was so often used in their construction.

Believe it or not, within the US government there are those who try to take the long view to solving problems and, in the case of interstellar travel, briefly put some serious money toward enabling an interstellar-capable society. Begun as a study and series of conferences under the US Defense Advanced Research Projects Agency (DARPA), the 100 Year Starship Study had among its goals the funding of a private group that would take the next century to foster the ideas, technologies, and societal changes necessary for mounting an interstellar voyage. To that end, a $500,000 contract was awarded to a group led by retired NASA astronaut, physician, and futurist Dr. Mae Jemison. Her 100 Year Starship organization, with the DARPA funding, energized the space community to think about taking such audacious voyages, bringing what was once a small subset of space advocates and technologists into the mainstream of space research and thinking.[3] The idea is no longer "fringe."

Which brings us to a few of the ethical questions and criticisms surrounding space exploration in general and interstellar travel in particular.

Wouldn't the money be better spent here on Earth? The short answer is that all the money *is* spent here on Earth, paying the companies and people who are the designers, developers,

managers, and technicians who make plans, build, and construct spacecraft and control them during flight. I suspect the real question is: *Why not spend the money to provide food, shelter, and health care and improve the lives of everyday people?* This is a tough question and one that can only be answered by again taking a longer view.

The US government budget as I'm writing, in 2021, is approximately $4.829 trillion. Putting in the zeros and rounding a bit, that's $4,829,000,000. Of that, NASA gets about $23.3 billion, or 0.4 percent, of the total. For comparison, in the heyday of the Apollo Program, NASA accounted for about 4 percent of the budget. As you will learn by reading this book, such big numbers become almost meaningless, so I use this visualization when I am giving a lecture and discussing the budget: Using a penny to represent 1 billion dollars ($1B), the US budget would be a pile consisting of 4,829 pennies, or about $48 worth. If I remove NASA's budget, all 23 pennies of it, there is no noticeable change in the size of the pile, which accounts for the rest of the budget. Money currently spent on space exploration is, for many programs, a rounding error.

Apart from the salaries of those who work in the space field, money spent on science and exploration does not provide an immediate monetary return on investment to a government or society, but it does return a highly valuable intangible return—the increase in knowledge about the way the universe works and about the world around us. Before there could be all of the modern technological benefits we take for granted today, there had to be the fundamental research and science that forms the basis of all technologies. Technology is the application of science. If our predecessors had not conducted science for the sake of science, then we would not have electricity, refrigeration, air travel, cell phones, computers, and so on. The return

on investment in science conducted one hundred years ago is still accruing. Our investments today may not pay off for another hundred years.

We have messed up the biosphere on Earth; why go someplace else and mess it up there too? Human expansion beyond Earth used to be a given, a cultural assumption shared by just about everyone on the planet, whether or not they lived in a country with spacefaring capabilities. This might be changing, though. In a 2020 interview, the noted German filmmaker Werner Herzog called visions of permanent settlements on Mars "an obscenity," and said that we should "not be like the locusts" in our efforts to explore and settle in space. He is not alone. There have been a rash of opinion articles, books, and white papers, mostly produced by astrobiologists, in which they advocate that the whole idea of spreading life to locations beyond Earth should be avoided if not outright banned. While some concern is certainly justifiable—it would be a disaster if humanity significantly contaminated the Martian environment before scientists ascertain whether life exists there—in the case of the moon, asteroids, and other airless bodies, there is no compelling reason to not explore and settle. These are lifeless worlds and always will be.

To the best of our knowledge, we live on the only place in the universe harboring sentient, biological life. If there are other forms of life out there among the stars, which many experts believe is highly likely, then it is in places that are few and far between. Most of the universe is almost certainly devoid of life and, for the most part, a decidedly hostile environment for it. To explain the varying degrees of hostility posed by nature in space, let's discuss a few examples in our solar system, beginning with the relatively benign environment on the moon. Aside from having essentially no atmosphere (making simple

tasks, like breathing, impossible), the lunar surface is also unprotected by Earth's magnetic field, exposing anyone visiting there to radiation doses about 200 times higher than on Earth. In the short term, this is not a significant risk, but over time, such relatively high radiation exposure can lead to a much-increased risk of cancer. Astronauts will also be at risk from inhaling lunar dust that will find its way into any habitats there, potentially causing all sort of lung diseases and respiratory side effects that remind this former resident of Eastern Kentucky of the black lung disease that devastates coal miners in that region.

Perhaps the most extreme radiation environment in our solar system is found around the planet Jupiter. Thanks to its massive magnetic field's ability to trap and then energize the trapped solar wind, any spacecraft sent there have to be thoroughly shielded to prevent their electronics from failing or to protect the crew from lethal doses of radiation. The rest of the planets, dwarf planets, asteroids, and comets have environments somewhere in between. Looking beyond our solar system and into the galaxy at large, there are some significant threats looming that could potentially wipe out all life on Earth and anywhere nearby. The chief risk is that caused by a supernova, a star that explodes. These spectacular events occur fairly frequently in the universe, with our Milky Way Galaxy seeing one every fifty years or so. Fortunately, the galaxy is so large that the likelihood of one happening nearby is small, occurring only about every 240 million years. That said, if one were to occur within about 25 light-years of Earth, the radiation pouring into the solar system would destroy more than half of Earth's ozone layer, allowing more of the sun's damaging UV radiation to reach the surface of Earth, dramatically altering the biosphere and almost assuredly leading to another extinction event.

Many, myself included, believe that life is good and every effort should be made to assure that it survives and thrives. If

there is one thing we've learned by looking at the history of life on Earth, it is that events happen that imperil its existence. Science tells us that there have been at least five mass extinction events in the last 500 million years in which large percentages of the species on Earth became extinct. As an example, in the Permian Extinction some 250 million years ago, 75 percent of the species living on land and 96 percent of those in the ocean died.[4] Fortunately, over time—lots of it—life on Earth recovered. Many of those who advocate interstellar travel and settlement are motived because we want to preserve life and our intelligent, tool-using species. As the Russian rocket scientist Konstantin E. Tsiolkovsky said, "Earth is the cradle of humanity, but one cannot remain in the cradle forever."

Then there is the question of the lifetime of our technological civilization. As any student of history will tell you, human civilizations have a lifetime. They are created, thrive, decay, and then die—often leaving long periods of chaos in their wake. We are living in what is perhaps the first worldwide civilization and, as the COVID-19 pandemic taught us, it is complex and heavily interconnected. There are many plausible scenarios that could end civilization, including nuclear war, plague, and climate change. Will it even be possible to pick up the pieces when, not if, it falls? We dare not take the risk and should make every possible effort to extend life and civilization's reach beyond the cradle into which they were born.

Finally, humans are not perfect and never will be, no matter hard we try, so our lives will always impact the environment in which we live. This characteristic is not unique to humanity; just go look at a dam built by beavers or a field decimated by a swarm of locusts. The difference is that we can choose how much we want to impact the environment. Much of the damage we've done to Earth's biosphere was inflicted before we became aware of what we were doing, and much is being accomplished

today to assure that future impacts are minimized. When we arrive at a new world, out there somewhere, we will not be starting from scratch. Those who go will be taking the cumulative knowledge of the species and have the tools to begin living on their new world in a more environmentally aware, renewable-focused manner.

Interstellar colonization sounds too much like "manifest destiny" and would continue to perpetrate the injustices that occurred on Earth in the colonial era and still occur now, in our postcolonial era. The first way to address this concern is to disavow all notions that establishing a settlement on a planet circling another star would involve subjugating any life found there. I would like to think we can establish something akin to the *Star Trek* Prime Directive, in which interstellar explorers are prohibited from interfering with the internal and natural development of alien civilizations and—my addition—any extant life found there, no matter how primitive. Our settlements, not colonies, should only be established to take life where it is otherwise absent. Harking back to my core philosophical premise that life is good, to me it would be immoral to have the capability to export life beyond Earth and then not do so. Such an act of omission would be immoral and unethical.

As I mentioned in chapter 1 and have reaffirmed in the discussions above, if we are to go to the stars, then we need to think BIG: big distances (to be traversed), big energy (for our spacecraft to travel quickly), big infrastructure (to develop, build, and perhaps propel our ships), big time (commitments to a goal much longer than a human lifetime for both our travelers and those at home who support them), big cost (such undertakings will be expensive), and big aspirations (thinking about the future and not just of ourselves).

4

Send the Robots, People, or Both?

Our flight must be not only to the stars but into the nature of
our own beings. Because it is not merely where we go, to
Alpha Centauri or Betelgeuse, but what we are as we make our
pilgrimage there. Our natures will be going there, too.[1]

—PHILIP K. DICK

A few years ago, I attended a Mars exploration conference
hosted by the Lunar and Planetary Institute in Houston, Texas.
In one of the plenary sessions, the topic, a perennial favorite,
was closely related to the topic of this chapter: Should we con-
tinue our exploration of Mars with robots or send people? This
was a technical meeting populated almost entirely by space sci-
entists and engineers who, over the course of the multiday
meeting, presented highly detailed papers describing the tech-
nologies and systems applicable for human and/or robotic
Mars exploration. There were more than three hundred people
attending this particular plenary.

The panelists debating the topic were in the front of the room,
and the discussion had become impassioned, with members on

both sides of the debate providing evidence supporting their views, seemingly not comprehending how anyone from the other side could possibly misunderstand the data and disagree with them. As a longtime member of the space community, I was somewhat inured to the discussion since I had heard the arguments and read articles and papers on the topic throughout my career.

Sitting in front of the auditorium, facing the stage and the panelists, was a single, empty chair with a white sign on its back saying that the seat was reserved for someone with a four-letter name—Buzz.

About twenty minutes into the panel, the person for whom the seat was reserved entered the room and took his seat. That person was, of course, Buzz Aldrin, the second man to walk on the moon. Since I was not fully engaged in the debate, and because of who he was, I was distracted from what was being said and watched him instead. I am sure I was not the only one there doing so. Aldrin sat there listening to the debate for no more than five minutes before he rose from his chair.

When Buzz Aldrin stands to speak, he gets people's attention. Without being asked, the panelists stopped speaking, all eyes went to this aging lunar explorer—one of the few people to experience what everyone in the room was talking about—and all waited with a palpable sense of bated breath for what he had to contribute. I was not recording, but I was paying close attention, and this is my recollection of what he had to say.

"I've been part of this discussion since I was selected for the astronaut program back in the early sixties. I've heard both sides of the debate make their case, but I want to ask a question. I want to ask the audience, not the panelists," Aldrin said as he pivoted to face those of us in the audience. An audience, I might add, that was split pretty evenly on both sides of the humans

versus robots debate. Aldrin paused for a few moments, no doubt to raise a sense of expectation and for the dramatic effect. Then he asked a question.

"If it were possible, how many of you would sign up for a one-way trip to Mars?"

To my amazement, in this room of scientists and engineers who fully understood the risks of space travel and the extremely hostile environment that is present on Mars, and who undoubtedly had networks of close friends and family at various places across Earth, about 70 percent raised their hands. Among them were those who had, just moments before, been adamantly on the side of robotic-only exploration. Seventy percent (give or take).*

From that moment, the tenor of the debate changed from an "either/or" proposition to "both, at the proper time." As has been the pattern established since the beginning of space exploration, this trend is likely to continue as we begin leaving our solar system to explore what lies beyond. We will first perform remote reconnaissance, next we will send our robotic explorers, and then the people will follow. Sounding rockets that flew to space and back again were flown with scientific instruments to prove their relative safety before attempting orbital flight. Two robotic spacecraft, Sputnik and Explorer 1, orbited Earth before the flights of Yuri Gagarin and Valentina Tereshkova. The Ranger series of robotic landers went to the moon before Neil Armstrong and Buzz Aldrin. Our many robotic missions at Mars are slowly leading the way for humans to follow. So, too, will it likely be in interstellar exploration. Perhaps the first

*I did not raise my hand. Though I might eagerly sign up for a three-year round trip to Mars, I would not want to go there and live out my life away from family, friends, open skies, trees, and the wondrous beauty that is Earth.

missions will be robotic spacecraft that fly by the target stellar system at 10 percent of the speed of light (that's moving really fast), not bothering with carrying all the propulsion required to slow down once they arrive. Then there may be the robotic spacecraft that do slow down, circle, and perhaps land on planets that look promising for human settlement, beaming their collected scientific information back to Earth prior to the launch of the first settlers to that destination. Only then will the ships with human crews begin such a journey.

When compared to robotic exploration, taking people to the stars is much more complicated, requires much larger ships, will cost considerably more money, takes longer, and is filled with risk. These are not reasons to abandon the thought of sending people; far from it! Rather, they reinforce the idea that we should first dispatch robotic explorers who will send the results of their explorations back home. Our machines are becoming much more capable and autonomous with their capabilities increasing each year. It only makes sense to begin here, but we must also realize this approach has its limitations.

We are in the midst of a "robots first, then people" strategy with our robotic exploration of Mars. In 1965, the USA's Mariner 4 spacecraft successfully flew by Mars, sending home the first-ever close-up pictures of the red planet, changing planetary astronomy forever. The Soviet Union was the first to place a spacecraft into orbit around Mars in 1971 with their Mars 2 mission, which also attempted to be the first to land a probe on the planet's surface. Unfortunately, the lander failed on descent and crashed. Later that year, they tried again and were successful, though the lander's communication system failed after only fourteen seconds.

In 1976, NASA sent the twin Viking spacecraft to Mars. Once they arrived, each split into two parts: a lander, and an orbiter

that remained in space to circle the planet to act as a radio relay back to Earth. The landers carried various science experiments, some of which were designed to look for signs of life in the Martian soil. They were beasts; each lander weighed 1,300 pounds (not including propellant), and the data they sent home rewrote our understanding of the Red Planet. The USA's next lander, Pathfinder (weighing 800 pounds when it landed), did not arrive until 1996, when it not only landed but carried and sent on its way the first Mars rover—a six-wheeled mobile science laboratory that expanded the area of the surface that could be explored from a single landing site to a circle with a radius of 100 meters (~325 feet), the range limited only by the ability of the rover to communicate with the lander. Since then, a series of orbiters has arrived at Mars with operational lifetimes measured in decades, not days, months, or even single-digit years. Multiple landers and rovers have begun exploring the surface, carrying much more sophisticated science instruments, and with ranges of twenty-five to thirty miles from the landing site. This surface exploration range is dramatically increasing as the first robotic airships and helicopters arrive.

Similar stories of robotic planetary exploration, displaying ever-increasing capabilities with systems of lower and lower mass, can be seen with virtually every planet in the solar system. NASA is testing new space communication systems that will soon allow near-real-time, high-definition video from its robotic emissaries, allowing Earth-based scientists, explorers, and adventurers to go along for the ride—virtually. It is easy to envision spacecraft getting smaller and smaller, growing more and more capable, and soon availing themselves of the propulsion systems that could carry them to the nearest stars.

But there are problems that still must be overcome. Our robotic explorers are not yet fully autonomous and capable of

on-the-fly problem solving. The Mars rovers are painstakingly controlled by teams on Earth who send short-term commands to the rovers and then wait for feedback before telling the rover what to do next. The speed of light limits the back-and-forth commanding by as much as three to twenty-one minutes, depending on where Earth and Mars are located relative to each other as they independently orbit the sun. The latest rovers have more autonomy than their predecessors, but there is still a long way to go before we reach 100 percent independent operation.

And then there is the problem of intuition. Malcolm Gladwell does an excellent job describing professional intuition in his book *Blink*.[2] The blurb on the book describes best what Gladwell means by the ability to blink: "*Blink* is a book about how we think without thinking, about choices that seem to be made in an instant—in the blink of an eye—that actually aren't as simple as they seem."

The most salient example relevant to the topic at hand is a story I heard relayed by Apollo astronaut Harrison Schmitt during a technical conference. Schmitt walked on the moon in 1972 during Apollo 17 and, as a geologist, has the distinction of being the only professional scientist to visit there. When astronauts walked on the moon, their time outside the lunar lander was heavily scripted and guided by controllers back on Earth who used video feeds and input from the astronauts to guide their decision making. As you might suspect, time outside was limited and every minute counted when it came to collecting samples for return to Earth. The urgency was compounded for the crew of Apollo 17 since it was the last lunar mission, and whatever they collected would be the last to come back to Earth for quite some time. While collecting, Schmitt was directed by Mission Control to pick up samples from a specific location. While he was walking toward it, he noticed a rock formation

that looked far more relevant and interesting—he *blinked*—and decided to collect a sample from there instead. This particular sample, which caught the eye of the experienced geologist who was on-site, there, just a few feet from it, had been missed by the mission team viewing the scene remotely. It ended up being one of the most scientifically important samples returned from any of the trips to the moon. For the foreseeable future, the human mind, with its intuition and "blink" abilities, is likely unmatched by any computer for making this type of decision.

Finally, there is the experiential aspect of exploration. Even though we can take a virtual, high-definition tour of the Louvre and see the *Mona Lisa*, people still spend the money and fight the crowds in order to go to the Louvre and see the exhibits there in person. Seeing the Twelve Apostles (a spectacular coastal rock formation) at sunset was an emotional experience for my wife and me when we visited Australia a few years ago. Seeing someone else's photographs of them would not be an adequate substitute—not even close. Many people will not be satisfied with the future equivalent of a nice picture sent by text with the caption "Wish you were here!" No, they will want to go and see the destinations for themselves.

Unless there is a breakthrough in extending the human life span, the settlers who board an interstellar starship when it departs Earth will not be alive when it reaches its destination. Pause and think about this. Those who get aboard an interstellar exploration ship will be resigning themselves to life inside an artificially created, failure-prone (because anything built by humans has the potential to fail) ship that will be traveling through the most dangerous environments in the universe to a destination that no one has physically seen and that may or may not be suitable for sustaining Earth life. That said, there are compelling reasons to send people. So, assuming the technology

challenges are met, and we have the capability to build a world-ship, what else needs to be considered?

Someone will be deciding how many people to send and selecting who goes. Surprisingly, many papers have been published discussing the minimum number of people required to provide the required genetic diversity and to overcome unforeseen in-transit catastrophic events. As might be expected, different studies that focus on different aspects come up with widely different answers.

Population geneticists look at the problem through the lens of our current understanding of genetics, developing mathematical models of genetic inheritance and coming up with estimates of future variation based on characteristics of the starting population. Much can also be learned by looking at the world around us and at history. Conservation organizations and biologists look at wild-animal populations to determine which might be at risk of extinction and, over many years, through continuous observation, assess their predictions against current populations. Anthropologists look at human history, migrations, and historical analogues of known isolated populations to determine which were successful and why.

For a worldship, the numbers range from a few hundred to hundreds of thousands, with many studies concluding that ten thousand settlers is reasonable.[3] Of course, modern biological science provides other options for increasing genetic diversity, such as sending thousands of frozen human embryos as cargo which could then be gestated across many generations after arrival to ensure diversity.*

*While this option most certainly had to be included for completeness, this author would not support it on religious and moral grounds.

The traditional worldship aesthetic favors a long and cylindrical ship, slowly rotating around its long axis to provide acceleration that mimics the acceleration of gravity. This would allow the passengers to have an open sky above their heads when "outdoors," relieving somewhat any sense of claustrophobia that might develop in ships that look and feel more like today's spaceships, with their small compartments and tightly confined spaces. The ultimate size of the habitat will depend on crew size, but current thinking has its diameter being ~½ mile, with cylinder lengths of a few miles.

Others believe that building these giant ships would be more easily accomplished by hollowing out an asteroid for living space and adding a propulsion system to slowly send it out of the solar system and toward its destination. This would certainly help solve the radiation shielding problem, with most, if not all, of the cosmic rays being stopped in the asteroid material before reaching the crew contained within.

Regardless of the geometry, these ships will be enormous. When you factor in the living space per individual, the supplies necessary to keep them alive and healthy, the shielding to protect them from radiation and cosmic rays, the power to keep the lights on, the propulsion system and required propellant, plus the structures necessary to hold the whole thing together, it begins to appear overwhelming. Note that overwhelming does not mean impossible—just difficult.

Any ship that will carry people to the stars (who are awake for the journey) will have many necessary and desired attributes such as Earth similar gravity; breathable air; drinkable water; places to live, work, eat, socialize, and play; and all the systems necessary to keep the crew alive for the duration of the journey. As you might imagine, taken together, these requirements lead toward an exceptionally large vehicle.

It is in the discussion of life aboard the worldship that we need to shift our thinking from the realistic futures of various technologies based on physics, biology, and engineering to the social sciences of psychology, sociology, and political science— with a bit of ethics and philosophy thrown in.

To understand the psychological effects of prolonged isolation on small populations as it relates to space travel, one might be tempted to refer to the NASA data of the last twenty years during which the International Space Station has been occupied by crews staying there for up to a year at a time. NASA has also funded studies looking at how a three-year round trip to and from Mars would psychologically affect the crew. While this data is certainly useful, it may not be the most applicable since the worldship population will be much larger than the nominal five-person crew of the ISS.

Many turn to the navy, where larger groups of people are placed in close quarters on a mostly self-sufficient ship and isolated from the rest of humanity for many months at a time. With its 6,000+ crew, a US Navy aircraft carrier might be the best analogue to our 10,000+ crew worldship. While they are not at sea and isolated for a lifetime, for many young people, being away at sea for over a year at a time might *seem* like a lifetime. Volumes have been written on this topic in journals unrelated to space travel that worldship designers will undoubtedly have to study in the design process.

Speaking of the navy, what will the shipboard culture be like? It is difficult to imagine the ship being sent by the military under military-style rules. The people who are selected to make the journey will be as diverse as the human population in general and therefore not likely predisposed to be under strict military discipline for the rest of their lives. Even if this worked for the initial crew, what of their children? Would the daughter of

the captain be trained to be the next captain? Would the son of a cook be destined to make food for the crew during his entire adult life? Perhaps there will be a competitive process to fill these roles after whatever education system the settlers adopt has completed its course with future generations. There will have to be some sort of hierarchy, but what would it look like?

Whatever form it takes, there will have to be an emphasis on security. Like it or not, people are unpredictable and, with the significant psychological stress the crew will undergo, some might snap. Others might react negatively to the shipboard culture, whatever it is, for moral, religious, political, or philosophical reasons and take actions detrimental to the health and safety of the ship and its passengers. Remember, if someone becomes disaffected, unlike on Earth, they have nowhere to go. And no matter how robust the ship's design, it cannot be made impervious to a human being determined to do damage. One person with ill intent could destroy the entire ship.

Consider air travel. In its early years, people could buy a ticket and get onboard, with family and friends walking them across the tarmac to the stairs leading up to the plane. Then came the wave of hijackings in the 1960s and 1970s that led to a bit more security at the airport and the use of metal detectors to screen for obvious weapons like guns. This worked well until a group of determined people intent on causing destruction perpetrated the events of 9/11. Airline travelers now undergo multiple identity checks, pass through full-body imagers and metal detectors, have their bags inspected, and in some cases endure full-body searches before they can board the plane. Hardly a week passes without hearing of an airplane being diverted due to an unruly passenger or a perceived threat during the flight. We are willing to accept significant inconvenience and a voluntary surrender of our personal liberties to ensure the

safety of our fellow airline passengers for several hours in order to reach our relatively close destinations. But would people be willing to make similar sacrifices *for a lifetime*? Such a culture sounds more like a police state than a space journey to a new home.[4]

What about the children born during the journey? If the trip time is much longer than a human lifetime, then there may be multiple generations living their entire life span aboard ship. It is entirely likely that some of them may not want to be settlers on a new world, especially after they learn of the massive oceans, blue skies, and verdant land of Earth. Is forcing them to fulfill the dreams of their parents or grandparents ethical?*

What if the descendants of our intrepid interstellar settlers arrive at the planet Proxima Centauri B only to find that there are alien microbes, just microbes, living in the soil? Do they proceed with landing and establishing a settlement there, introducing not only human life and bacteria but presumably plants and animals brought with them from Earth? The ethics gets even more sticky if they were to arrive and find extant animal life, not sentient life, but animal life that some would argue could potentially become sentient in the future. Who decides what they do next? The settlers? Or perhaps some guideline created before their departure, like the Prime Directive, to which the original settlers agreed, but not their biological descendants who had no choice in the matter?

*Personally, I do not believe there are clear black-and-white answers to the ethics of raising children aboard ship. I was born and have lived my life in the USA. Did I ask to be born here? Would I have chosen life in the USA over life in England or Japan? It is a moot point, and, if we ever send people to the stars in worldships, it will be a moot point also for children born along the way.

These are big questions, with many challenges that will not be easily answered or solved. And all of them, including the notion of sending robots first, are moot if we don't first solve some of the technological challenges facing us. First and most important is that of propulsion. How do we move from the canoe stage and build our first sailing or motorized boats and ships?

5

Getting There with Rockets

In the van, we can see the rocket in the distance, lit up and shining, an obelisk. In reality, of course, it's a 4.5-megaton bomb loaded with explosive fuel, which is why everyone else is driving away from it.[1]

—CHRIS HADFIELD, ASTRONAUT

There are many challenges associated with mounting an interstellar mission; first among them is propulsion. Unless you can get a spacecraft, crewed or not, to another star system in a reasonable amount of time, why bother developing the other technologies that will be required? For this reason, there will be two chapters discussing candidate propulsion technologies, describing why some might work and why others cannot. This chapter will focus on spacecraft that create their thrust through rocket propulsion.

A rocket is something that provides propulsion by using some sort of propellant that is expelled in one direction to get the spacecraft or vehicle to move in the opposite direction. If you stand on a skateboard and throw a basketball in one

direction, then you will roll slightly in the direction opposite of the thrown ball and experience simple rocket propulsion. Another example would be something most of us remember doing as children—blowing up a balloon and then letting it go, untied, to fly around the room (and hopefully not break something fragile). The air coming from the balloon is this simple rocket's exhaust, and the balloon itself is the rocket being propelled. Scientists boil this down mathematically to the notion that momentum and energy of the rocket *system*, which includes everything (for example, the balloon and the air within it before it is let go and the air expelled from it after it flies) is unchanged when added all together. In the skateboard case above, the mass times velocity of the thrown basketball must equal the mass times velocity of you + skateboard, not considering the friction between the skateboard's wheels and the ground. Since you + skateboard are more massive than the basketball, your resulting velocity will be small compared with that of the ball, which moves away much more rapidly. A rocket is no different. The balloon illustration of rocket propulsion can be found in figure 5.1.

The force accelerating a spacecraft depends on the mass of the propellant expended and the velocity with which it is exhausted from the engine. There is another factor to consider, which is that the mass of the rocket decreases as the propellant is expended, making the resulting spacecraft momentum calculation a bit more difficult, requiring calculus. This is captured in something called the rocket equation, and it governs nearly every element of our current space exploration endeavors. Don't worry about my use of the word *equation*; I'm not going to give you nightmares about high school algebra! The important thing to note about the rocket equation is how it dramatically affects the amount of propellant required to achieve high

Action force: air rushes out Reaction force: balloon goes forward

←———————————— ————————————→

FIGURE 5.1. A Simple Rocket. One of the earliest examples of rocket propulsion people encounter is when, as children, they blow up a balloon and realize that if they simply release the open end instead of tying it off, the balloon will fly around and perform random acrobatics. In the figure, we see an illustration of a balloon as the air escapes. The force generated by the outflowing air, moving to the left (this simple rocket's exhaust), is balanced by the balloon itself moving to the right, resulting in no net change in momentum (action and reaction balancing each other). Image created by Danielle Magley.

speeds. The amount of propellant required to achieve a specific change in velocity (otherwise known as acceleration) increases dramatically unless the exhaust velocity is high. The higher the exhaust velocity of the propellant, the greater acceleration that can be achieved for a given amount of propellant. Pay attention here. The rocket equation tells you how the propellant (mostly its mass) and exhaust velocity relate to thrust. Thrust is what gets the rocket moving at some velocity and that velocity, coupled with the mass of the spacecraft, tells you how much kinetic energy the spacecraft has while it is moving.* The key takeaway

*The concept of kinetic energy, or energy of motion, is one we all readily intuit— without even realizing we are doing physics. Consider a bullet. When shot out of a gun, the bullet is moving very fast and can do a lot of damage to whatever it hits. Now

is this: *For a given mission, like an interstellar mission, we want to find the type of rocket that attains its final velocity in the way that most efficiently converts the energy of the propulsion system into the ship's kinetic energy to minimize the travel time.*

Who is not awed by the sheer power and majesty of a rocket launch? The first one I viewed in person was a night launch, which made it even more spectacular. The Space Shuttle Endeavor left the Kennedy Space Center the night of December 1, 2000, for a ten-day mission in low Earth orbit (LEO). I was a launch honoree, which means I was able to watch from a VIP area about as close as spectators (for obvious safety concerns) were allowed. I had a camera, but the hosts told us not to use them. They said there would be pictures and videos of the launch available and that we should just watch and experience the event. As the main engines started and the solid rocket motors fired, the space shuttle rose ever faster into the sky, arcing out over the Atlantic. I cried. (Many of us were in tears; the experience is an emotional one.)

The numbers are impressive. At launch, the space shuttle, external tank, solid rocket boosters, and all the propellant combined had a total weight of about 4.4 million pounds.[2] In order to get off the ground, a rocket has to have high thrust, which can be thought of as the force being applied by the rocket's exhaust. Remember, to get a rocket to go one direction, you need to have the rocket exhaust go in the opposite direction. In this case, to get the rocket to go up, the exhaust had to push against the

consider the same bullet, and instead of shooting it using your gun (which ignites the gunpowder in the cartridge, turning the bullet into a rocket), you simply throw it at the same target. There will be a world of difference in the effect the impacting bullet has on at whatever it was thrown. A person simply cannot propel the bullet as fast as the exploding cartridge/gun can, and therefore the thrown bullet has less energy associated with its motion, which means it does much less damage.

rocket and be aimed down. To escape the pull of Earth's gravity, the rocket's thrust has to be greater than its weight (mass in Earth's gravity), and rocket scientists use this ratio, thrust/weight, to characterize the performance of a rocket. The higher the ratio, the better the rocket is able to get off the ground and escape the pull of Earth's gravity. The main engines of the shuttle did not have the thrust/weight necessary to get off the launchpad, so the designers included two solid rocket motors to provide the extra push required. Each solid rocket motor was capable of applying 12.5 million newtons of thrust. When the thrust of the two solid rocket motors was added to that of the main engines, the shuttle had no choice but to lift off and head for space. After the solid rockets were jettisoned, about two minutes into the flight (because they ran out of propellant), the shuttle's main engines then provided the thrust that accelerated the shuttle from about 3,000 miles per hour to over 17,000 mph in just minutes, placing it safely into orbit.

Think about this for a minute. The shuttle took only about eight minutes to reach orbit beginning from a dead stop.

As impressive as this is, chemical rockets, like those used to launch the Space Shuttle, the Saturn V, and SpaceX's Falcon 9 (among all others) are woefully inadequate for accelerating spacecraft to the velocities required for reaching another star system and barely adequate even for taking the first steps beyond our own solar system. Why? Though chemical rockets are capable of achieving high thrust and breaking the bonds of gravity, even when operating at peak performance they are not very efficient. There is only so much energy you can extract from making chemical bonds, which is all that really happens in a rocket's combustion chamber to get thrust. For example, the Space Shuttle's main engines burned liquid hydrogen and

oxygen to produce thrust. The big external tank to which the Space Shuttle orbiter was attached held ~390,000 gallons of liquid hydrogen and ~145,000 gallons of liquid oxygen. All this propellant was used to get the vehicle to orbit with the external tank being jettisoned just before arriving there. *Poof.* Over 500,000 gallons of liquid propellant gone in eight minutes. Add to this the almost 1,100,000 pounds of solid rocket propellant burned in the solid rocket motors, and you begin to see what I mean by an inefficient system. Don't get me wrong; rockets, with their high thrust/weight, are the best way we have to get from Earth's surface to space, but once there, we need something else, something much more efficient, with a higher energy density (available energy/kg of propellant) to get us the next million, billion, or even trillion miles.

Space propulsion experts* use the term *specific impulse* (I_{sp}) to compare the efficiency of rocket-based propulsion systems. The acceleration of a rocket depends on thrust (determined by the amount of propellant thrown out of the back of the rocket and the speed at which that propellant is thrown out) compared to the rocket's weight. The faster the speed at which propellant is expelled, the faster the rocket can travel or the more cargo it can carry. (If you add up the momentum contained in all the exhaust gas and subtract the spacecraft's resultant momentum, you get zero. Momentum is conserved, and Sir Isaac Newton is kept

*Notice that I do not call them "rocket scientists." That term, which in popular culture has achieved a status near the top of the perceived intellectual scale, implies that those who work in the field of advanced space propulsion are experts in rockets—which may or may not be true. Many advanced space propulsion technologies can accelerate a spacecraft without expelling any propellant, which means they are not really rockets. Thus, many advanced space propulsion engineers are not, technically, rocket scientists.

happy.)* For chemical and most other rockets, the exhaust is accelerated to high speeds through heating, and such can generically be considered chemical thermal rockets. The added "thermal" is a qualifier that will be best understood later when other forms of thermal rockets are discussed and compared with other, nonthermal ones. A rocket's I_{sp}, therefore, is a rough measure of how fast the propellant is ejected out of the back of the rocket. A rocket with a high specific impulse doesn't need as much propellant as a rocket with low specific impulse. The higher the specific impulse, the more push you get for the amount of propellant used. A propulsion system with a higher specific impulse uses the mass of the propellant more efficiently. I realize it may not make sense unless you go through the math,† but I_{sp} is measured in seconds.

In the case of the Space Shuttle, the I_{sp} of the main engines was ~366 seconds and the solid rocket motors were only 242 seconds. SpaceX's Merlin engines, used to propel the Falcon 9, have an I_{sp} 282 seconds. Such high-performance rocket engines have an I_{sp} in the hundreds of seconds. Most rocket engines have I_{sp} values less than 500 seconds. (*Remember that.*) Why is that their upper limit? Simply, the reason is chemistry. To release the energy to create thrust from the propellants requires making chemical bonds, and there is only so much energy that can be gleaned from chemical reactions and the making or breaking of chemical bonds between the elements and molecules. It is unlikely that any chemical rocket propellant will be found that produces an I_{sp} above 600 seconds.

*Remember Newton's Second Law of Motion, F = ma. This law of nature says that exerting a force (F) on an object of mass (m) will result in that object being accelerated at rate (a). In the context of rockets, think of the thrust as being analogous to the force that a rocket experiences when it is accelerated.

†Using a phrase I came to detest as a graduate student, "the interested reader" can better understand the derivation of I_{sp} by going through a bit of the math, which I will leave, of course, to the interested reader.

Even when you are operating in space, not trying to get off Earth, a chemical rocket is limited in its performance by its I_{sp}. Think of it as the rocket science equivalent of fuel economy in a car (miles per gallon). We will be using I_{sp} as a figure of merit to compare the performance of the various forms of rocket propulsion and their suitability for interstellar missions.

How can we get better efficiency in a rocket? Once you've reached the theoretical maximum that chemical reactions can provide, you have to look elsewhere for ways of adding energy to the propellant. Performance and efficiency are all about energy and energy density. What about nuclear power? The energy released in the fissioning (splitting) of uranium atoms is far more than is possible chemically, as is obvious when you are reminded of the impetus behind the development of nuclear weapons. The nuclear energy to which I refer here is not that associated with bombs (more on that later when I discuss Project Orion), but with the processes used every day to produce electricity in nuclear power plants all over the world.* In a nuclear power plant, the energy is produced not by altering the chemical bonds between atoms, but by altering the way the particles which make up an atom are bonded together at their center, breaking the nucleus apart in a process physicists term fission. When this happens, the broken parts, or fission fragments, have a lot of kinetic energy that is converted to thermal energy through collisions and interactions with other atoms, which makes the atoms absorbing the fission fragments hot. This is then used to heat water, turning it into steam, which then spins the turbines that produce electricity.

In our nuclear rocket, instead of superheating water to make electricity, the propellant, typically hydrogen, flows across or

*Fun facts: In 2019, nuclear power provided about 20 percent of the electricity generated in the USA and 75 percent in France.

through the hot reactor, heating it to temperatures as high as 3,000 K (or approximately 4,940°F), limited only by the requirement to keep the system from melting (!!). The superheated gas is then expelled through the engine nozzle, producing thrust. Why is this attractive? Due in large part to these high temperatures, nuclear thermal systems are much more efficient at heating propellant, producing an I_{sp} of between 700 seconds and 1,100 seconds; that's two to almost three times higher efficiency than chemical thermal rockets. This allows them to provide a rocket with more than twice the amount of propulsive capability per pound of propellant than their chemical counterparts.

When considering trip times and reasonable fission reactor masses, the amounts of propellant required, and all the other practical aspects of building and flying a nuclear thermal rocket, they look good for use in the solar system. For sending people to Mars, nuclear thermal rockets can get reasonable round-trip times (two to three years in duration) and use about half the propellant required for the same trip if using chemical rockets. If we build and fly them, they might even enable human travel to and from Jupiter and its moons and robotic missions out to Pluto and slightly beyond. Unfortunately, that appears to be their limit.

There is simply not enough energy released in fission (the available energy density) to allow an I_{sp} sufficient for practical interstellar travel.* The propellant loading would be enormous, to the point of being so heavy that the craft would not be able to accelerate to begin its journey. In short, there is a limit to the amount of weight (in propellant, payload, structure, etc.) that the rocket can carry, as adding more propellant increases the

*In my thinking, any trip that takes thousands of years or more is impractical.

overall weight, and thus also increases the propellant needed to accelerate it, requiring yet more propellant, which adds more weight, and so on and so on. This is often called "the tyranny of the rocket equation" and is why I_{sp}, efficiency, is so important. The higher the I_{sp}, the less propellant required, hence less added weight.

There is another nuclear process that can provide the energy needed to drive a rocket, and it is the same process that powers the sun—nuclear fusion. As the name implies, this process in concept is simple: two or more atoms are forced to merge and form a new element, releasing energy in the process. We experience the direct benefits of nuclear fusion every day when we enjoy life on Earth as our planet is kept warm and lit by our star, the sun—which is powered by nuclear fusion occurring at its core.

The sun, in its glory, is huge. And this is an understatement. More than 109 Earths could be placed side by side along its diameter, and if it were a hollow sphere, more than 1 million Earths could be placed inside. It is made primarily of hydrogen, the individual atoms of which, thanks to its gravity, are squeezed close together at its core. They are squeezed so tightly together that a significant fraction of them merge together to form helium, releasing energy.

Hydrogen is the simplest atom to understand. Its nucleus contains one proton orbited by one electron and makes up >99.9 percent of the universe's hydrogen.* The energy released in the sun's fusion reaction produces an outward pressure that balances

*There are forms of hydrogen that are slightly different than what I describe above. These are known as its isotopes. Deuterium is a hydrogen atom containing one proton and one neutron. Tritium, the other isotope, with one proton and two neutrons, is unstable and does not live long.

the gravitational forces relentlessly pressing against the central core and is what keeps gravity from compressing the atoms further together. This released energy eventually makes its way to the solar surface, where it can escape into space and provide the light and heat needed by those of us on Earth. To put the energy released in a fusion reaction in context, we should look to one of the most famous equations in the history of modern science:

$$E = mc^2$$

Thanks to Dr. Einstein, we know that mass (m) is related to energy (E) via the speed of light (c). This is how we can understand and calculate the amount of energy that can be gleaned from a fusion reaction like that occurring in the sun. The nucleus of a helium atom, which contains its two protons and two neutrons, weighs only 99.3 percent as much as the protons and neutrons that go into making it. Where did this mass go when the hydrogen atoms were fused to make helium? It was converted to energy, as predicted by Einstein's equation, and 0.7 percent of the mass became energy. By comparison, combusting chemical propellant releases only about one-billionth of its rest mass energy, and it does so by reshuffling the chemical bonds between atoms, forming new connections (hence compounds) but leaving the protons and neutrons making up the atoms unchanged. Harnessing this 0.7 percent might give us the energy-dense heat source we need to efficiently travel to the stars.

Unfortunately, re-creating what nature does spontaneously in the sun's core is not so simple to reproduce in the laboratory. After all, to achieve nuclear fusion in the sun, 1.989×10^{30} kg of hydrogen are used to compress the atoms together, initiating

fusion.* On Earth, we don't have access to that amount of mass, so other approaches, which do not require the mass of the sun to work, are being tested.

How would a fusion reactor be used for interstellar travel? First, it could serve as a large power source that could be used to power an electric propulsion system (see the discussion of electric rockets below). Alternatively, it could be used in more of a direct mode, where the fusion reaction is also the thrust-generation mechanism. It might be possible to design the reactor to expel some of the fusion byproducts out one end of the spacecraft to provide thrust.

Since this is not a book about the development of fusion power but a book about interstellar travel, let's just say that scientists have been trying to replicate nuclear fusion reactions in the laboratory with some success and that we should, someday, be able to miniaturize fusion reactors to the point where they can be placed on spacecraft and used to explore space.

Even for fusion, the tyranny of the rocket equation still rears its ugly head, but not until you get to the propellant required to travel beyond the nearest stars. In other words, a fusion-powered and -propelled starship might be able to take a spacecraft to Alpha Centauri with a trip time of less than a few hundred years. When compared to chemical and nuclear (fission) thermal rockets, this sounds really good. Unfortunately, if our goal is exploring not just the nearest star but also the nearby stellar neighborhood, the trip times and propellant required become unwieldy.

What if we can create a fusion propulsion system that does not require carrying all that propellant, in the process bypassing

*1.989×10^{30} kg = 1,989,000,000,000,000,000,000,000,000,000 kg. A typical car weighs <2,000 kg, or about a ton.

the limiting part of the rocket equation? The Bussard ramjet does just that. First proposed by Dr. Robert Bussard in 1960, the concept is simple: build a spacecraft with a fusion propulsion engine, and instead of carrying all the hydrogen propellant needed for the trip, collect it on the way through the interstellar medium. Recall from chapters 1 and 2 that the density of interstellar hydrogen is roughly 1 atom per cubic centimeter. This isn't much, but if you build a large enough collector, or scoop, and you are moving rapidly enough (perhaps initially accelerated by propellant carried on board), then it just might work. The collected hydrogen would then be the propellant for the fusion propulsion system. There are issues. The first is that the isotope of hydrogen in interstellar space is not the easiest to use in the fusion process unless you have the mass of a star and its associated gravity to do the compression leading to fusion. Another is the sheer scale. Like with all other aspects of interstellar travel, the scoop must be big. Really *big*. (Think hundreds or perhaps thousands of miles big.)

In a 2017 paper with a wonderful title, "Tau Zero: In the Cockpit of a Bussard Ramjet," authors Blatter and Greber examined in detail what it might take to build a functional ramjet.* They envision a starship approximately the mass discussed in this paper that has a scoop made from single-atomic-layer graphene the size of Earth. (Graphene is a form of carbon that is extremely strong—three hundred times the strength of steel by weight. The material is so amazing that I wrote a book about it.[3]) The collected hydrogen then feeds the fusion reactor to

*The paper not only discusses the physics of a Bussard ramjet but also pays homage to the classic science fiction novel *Tau Zero* by Poul Anderson, that describes a voyage through the galaxy on board just such a starship. I highly recommend both the technical paper and the novel.

produce power and/or thrust. Unfortunately, like most inter-stellar propulsion system options, the devil is in the details. Just like ships that run out of gas will eventually come to a stop due to friction as they pass through water, so, too will the Bussard ramjet experience friction collecting all that hydrogen as it rams its way through space. To produce net thrust, the friction caused by collecting each hydrogen atom must be overcome by the exhaust of the propellant, driving up the efficiency at which the overall system must operate. Physics says it is possible and it therefore stays on our list of viable options.

An interesting additional application that would not require overcoming the hydrogen-induced drag would be using the Bussard ramjet as a brake, allowing the friction obtained in collecting the hydrogen propellant to be added to "reverse thrust," produced by the fusion engine itself, to slow down at the end of the journey, reducing the required propellant load. Slowing down is just as difficult as accelerating, and any scheme that might allow offloading propellant should be considered.

And now for something completely different,* rockets that use electromagnetic energy to accelerate propellant instead of heat. Consider that we humans are particularly good at manipulating nature using electricity. Lighting, air conditioning, radio, television, and computers are but a few examples of the creative applications built on the fundamental properties of protons and electrons and the electric and magnetic fields associated with them. You may recall that protons carry a positive electric

*I've always wanted to reference *Monty Python's Flying Circus* in one of my books. If you aren't familiar with the phrase "And now for something completely different," then you should immediately go to YouTube or another streaming service and begin watching this classic series of British television humor—and remember, "Nobody expects the Spanish Inquisition!"

charge (+) and electrons have an equal, opposite negative (−) charge. This "field" occupies the region of space around the charged particle in which it can affect other charged particles; they need not be "touching" to interact with each other. In our daily lives, since we are made of atoms that contain protons and electrons, we usually do not see their affects because we and our world are mostly charge neutral—the positive and negative charges are present in roughly equal numbers and cancel each other out. However, we can create experiments and circumstances where we have an excess of either, and that is where it begins to get interesting from a propulsion point of view. Charged particles have three characteristics that make them useful for space propulsion:

1. Opposites attract and like charges repel each other. Electrons repel other electrons and positively charged atoms do likewise. Conversely, protons and electrons are attracted to each other.

2. A charged particle placed in an electric field will experience a force, attractive or repulsive, depending on the charge(s) creating the field, whether positive or negative, and the charge on the particle (+ or −). The field will cause an unconstrained charged particle placed within it to move because of the force acting upon it.

3. A charged particle placed in a magnetic field will also experience a force, causing it to move. Physicists call this the Lorentz force, named for the man who first explicitly worked out the physics behind it, Hendrik Lorentz.

Scientists have been taking advantage of these facts to study the fundamental aspects of nature at the atomic level in the big particle accelerators like Europe's CERN in Switzerland, where

scientists accelerate atoms to velocities near the speed of light and crash them into each other, observing the by-products and learning more about what makes up the matter from which our everyday world is made. Similar techniques are used to accelerate propellants to extremely high-exhaust velocities, and thus to high I_{sp}, in electric rockets (sometimes referred to as plasma rockets), of which there are many types.

In an ion thruster, atoms in a neutral gas (typically a heavy one, like argon, xenon, or krypton) are stripped of electrons and then accelerated by an applied electric field toward one end of the chamber in which these interactions take place, and then out of it, creating the rocket exhaust. As the fast-moving gas is ejected from one end, momentum is conserved, and the rocket moves in the opposite direction just like in the thermal rockets described previously. As the charged propellant ions emerge from the ship, a cloud of oppositely charged electrons is injected into it so that it can become charge neutral and not be attracted back toward the spacecraft (figure 5.2). *Voilà!* We now have a rocket that doesn't rely on extreme heat to function.

Ion thrusters are highly efficient, with an I_{sp} of about 3,000 seconds. In other words, ion thrusters are about ten times more efficient than chemical rockets. But there is a drawback. Ion thrusters, and all electric propulsion systems, have extremely low thrust. This means that when they begin operating, no one is going to feel the acceleration pushing them back into their seats like astronauts experience when a high-thrust, but inefficient, chemical rocket launches them to orbit. Rather, the ion thruster provides a small, gentle, and efficient push and, in space, keeps up this gentle push for hours, days, weeks, or even years to add up to high final velocities, far higher than are possible with high-thrust, less efficient thermal rockets that use up

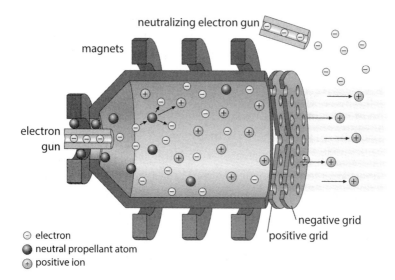

neutralizing electron gun

magnets

electron gun

electron

neutral propellant atom

positive ion

negative grid

positive grid

FIGURE 5.2. Ion (Rocket) Propulsion. Electric rockets seem more complicated, and they can be, but in principle they are the same as any other rocket. Exhaust expelled from one side results in a net force pushing the rocket in the opposite direction. In this example, high-energy electrons are fired into a chamber filled with a charge-neutral gas. The incoming electrons strip away electrons from the neutral gas atoms, giving some a net positive electrical charge. An externally applied magnetic field then accelerates these positively charged atoms (to the right in the drawing), expelling them as exhaust. To keep the charged atoms moving away from the spacecraft, additional electrons are injected into the exhaust, which, if the energy levels are appropriate, can attach to the positively charged ions and again make them charge neutral. Oona Räisänen, Wikimedia Commons (CC BY-SA 3.0).

all their propellant in seconds, minutes, or hours. If you are already out of the gravity well, you don't need high thrust, just thrust, and the more efficient the better.

Ion thrusters, powered by sunlight, are in use today. The most notable example is NASA's Dawn mission, which used it to study the main belt asteroids Ceres and Vesta, moving from one to the other using the spacecraft's ion thruster—a feat that would have been nearly impossible with a chemical rocket due

to the amount of propellant required. They are also used commercially to help Earth orbiting communications satellites remain in position for extremely long periods of time.

Ion thrusters are not the most efficient electric propulsion system, far from it. When engineers begin using all three of the charged particle characteristics listed above, they can create electromagnetic rockets that can attain an I_{sp} of more than 10,000 seconds. An example is one with a rather intimidating name, the magnetoplasmadynamic (MPD) thruster. (Use that in a conversation with friends. If you pronounce it correctly, they will think your IQ jumped at least fifteen points.) In an MPD thruster, the ionized propellant flows into the chamber where a magnetic field creates most of the acceleration, sending the accelerated propellant out the exhaust chamber, providing thrust. The addition of the Lorentz force from the magnetic field provides a different mix of thrust and efficiency, allowing (theoretically) an MPD thruster to get particularly good thrust and up to 6,000 seconds I_{sp}.[4]

There are other variations of the electric rocket, each with its own unique and individualized approach to orienting electric and magnetic fields in order to achieve thrust. Among these are the variable specific impulse magnetoplasma rocket (VASIMR), Hall effect thrusters, colloid thrusters, and so on. They all have their pros and cons but retain one common limitation with regard to true interstellar travel: electric rockets, despite being ten to a hundred times more efficient than chemical or nuclear thermal rockets, are not efficient enough to take us to the stars. That darned rocket equation still applies . . .

Electric rockets are, however, good candidates for robotic interstellar precursor missions into nearby interstellar space. Studies have shown that they are efficient enough to attain the required velocities with a reasonable propellant load

provided they have the power to operate. To attain the high speeds necessary to leave the solar system will require them to operate for long periods of time at ever-increasing distances from the sun. Solar power is simply not feasible, and they must either bring their own power source or have the power beamed to them from somewhere else. Refer to chapter 7, "Designing Interstellar Starships," to learn more about how interstellar starships might get their power.

Nature's speed limit is the speed of light. What if we had a rocket with that as its exhaust velocity? Going back to our introduction to rockets, the faster the exhaust velocity of our rocket, the better. What could be better than the speed of light? Nothing, but there is a catch. The only thing the universe allows to go that fast is light, and photons have no rest mass. Classically,* then, the momentum of a rocket that expels light should be zero. (Any velocity, including the phenomenally high speed of light, times zero is still equal to zero.) Classical physics begins to diverge from the reality of how nature works when we start traveling at speeds close to the speed of light. Photons, by definition, travel at the speed of light—and guess what? Scientists have measured the momentum of light and found that it is small, but greater than zero. Instead of having no momentum, light, therefore, can carry momentum and should be able to be used as a rocket exhaust to propel a spacecraft. Alas, a photon's momentum, which depends on its energy, is still extremely small but, as noted, is not zero. Nothing could be more elegant than simply turning on a light to accelerate our way to the stars.

*"Classical physics" is a term to describe our understanding of the world at the macro level (not at the scale of atoms and molecules, where quantum mechanics is required) and at speeds substantially less than the speed of light (where the theories of relativity are needed).

A simple photon rocket concept would use some sort of on-board power system to generate energy that is then efficiently converted into the beam of light used for providing thrust. (*Efficiency* rears its head a lot; such is the translation of physics to practical engineering—almost nothing can ever be 100 percent efficient; most processes we use don't even come close.) In the best case, there is no propellant heated or accelerated, only the light generated by the onboard power source. Doesn't that sound great? It would be if photons carried more momentum, but they don't. Assuming a nearly 100 percent efficient conversion of generated energy into photons, every single newton of thrust will require 300 MW of power.[5] For comparison, the power generated by the typical coal-fired electrical power plant found the world over is about 500 MW, which would generate only 2 N of thrust if it were miniaturized to fly on a rocket. The amount of energy required to produce 1 N of thrust is woefully insufficient to move a spacecraft that would weigh well over 10 tons.* Doing the math, and assuming our spacecraft uses nuclear fission as its power source with the best efficiency we can envision, which is not even close to 100 percent, we find that to accelerate our ~10-ton spacecraft to 0.1c, the mass of the nuclear fuel required would be astronomical.

What about a more efficient power system than that old fission stuff? What about fusion? Fusion releases about four times more energy than fission for a given fuel mass.[6] While that certainly helps, reducing the nuclear fuel mass to one-fourth of an astronomical number is still unimaginable. Recall that these calculations are for accelerating a 10-ton spacecraft. But there may be another way. Earlier we discussed the Bussard ramjet,

*For comparison, the Space Shuttle's main engine produced about 2 *million* newtons.

which collected interstellar hydrogen to use as fuel for the fusion reaction and as its rocket exhaust. What if the collected hydrogen were used only for the fusion part of the photon rocket and the thrust was produced by the photon emission? Again, referencing the paper by Blatter and Greber, this just might be possible. Of course, now you again have to add an Earth-size, one-atom-thick hydrogen scoop and consider all the friction and other side effects, but the numbers say it might work. If not, then adding even a small fraction of the required fuel to the spacecraft's mass makes the problem that much harder because the ship would require even more nuclear fuel to accelerate the mass of the additional nuclear fuel added, etc., etc., etc.

There is another option. What if nature provided a way to convert all of the mass of nuclear fuel into energy with 100 percent (theoretical) efficiency? Then we would only have to deal with how that energy is used—to drive a photon rocket, a more conventional rocket that uses some sort of reaction mass (like a chemical or electric rocket), or a hybrid approach. Thankfully, nature does provide such an option—antimatter.

The reactions to produce the energy to drive our starships that we have discussed so far have been in the realm of the chemistry and nuclear physics with chemical and electric rockets, concerned primarily with the rearrangement of electrons on or between atoms and molecules; fission and fusion rockets producing energy through interactions between protons, neutrons, and atomic nuclei; and photon rockets emitting light, also through the manipulation of electrons. Physics now provides a curious form of matter, also on the atomic scale, that allows us to work with the most energetic reaction of all: a form of matter whose name sounds like it is straight from science fiction that can provide, at least in theory, nearly 100 percent mass-to-energy conversion for propelling our starship—antimatter.

Antimatter is that magical-sounding word for a state of matter often thrown into a space movie or science fiction novel to make readers think the author is erudite. But antimatter is real, and nature produces it all over the world on a daily basis, albeit in small amounts.

What is this antimatter, and how can we use it to propel our starships? To answer this, a brief digression into particle physics is required.

Particle physics is the study of the smallest detectable particles that make up everything in the universe and the fundamental interactions between them. Just like how the proton, neutron, and electron make up the atoms that constitute everything we can touch, so too are they made of even smaller stuff. As an example, protons are composed of three quarks—two "up" quarks (each with a two-thirds positive charge) and one "down" quark (with a one-third negative charge), held together by gluons. In the soup of elementary particles that constitute matter, there are particles called muons, neutrinos, and mesons, which consist primarily of positive, negative, and neutral pions, and more, mixing and matching to make our material world. When the multitude of subatomic particles were first discovered, so many were found that scientists began calling them members of a particle zoo.

Ratcheting our view back up to the atomic level, there exist in nature antiprotons, with the same mass but opposite charge (− instead of +) of a proton, and positrons, which are electrons with positive charge instead of negative. These, in turn, are made of smaller particles like antiquarks, into which we won't delve too deeply. What is so special about antimatter that we can consider it a power source? As shown in figure 5.3, when an electron and a positron collide, they annihilate and convert all of the energy contained in their mass into energy. (Remember

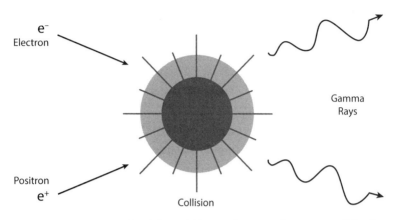

FIGURE 5.3. Antimatter Annihilation. When an electron and a positron collide, all of their rest mass energy is converted into energy in the form of gamma rays. Image created by Danielle Magley.

$E = mc^2$? In this case, all of the mass is instantly converted into energy.) The same is true of a proton and antiproton, but they release even more energy due to their larger masses; each proton (antiproton) is about 1,836 times more massive than an electron (positron).

Let's put this energy release into a scale with which we can relate, hopefully. Matter/antimatter annihilation converts exactly equal masses of antimatter and matter into energy. Consider a raisin, which weighs about 1 gram. Split it in half and consider one half to be made of normal matter and the other of antimatter. Bringing the two raisin pieces together would release about 9×10^{13} joules of energy. One kiloton of TNT releases ~4×10^{12} joules. That means that combining our matter-antimatter raisin will produce an explosion releasing an energy equivalent of ~21.5 kilotons—roughly the same as the atomic bomb dropped on Hiroshima, Japan, during World War II, though it is unfortunate that to understand how much energy this is we need to put it in terms of weapons of war.

Could it be simpler? Well, unfortunately, it is not that simple. The very thing that makes antimatter so attractive is also what makes it so difficult. How do you safely capture or manufacture antimatter and store it until you need it?

Antiparticles are produced all around us as cosmic rays interact with the atoms in the atmosphere, smashing them apart into their constituent subatomic particles that subsequently recombine into other atoms, some of which are antiprotons and positrons. Some cosmic rays are antimatter particles themselves, created in some high-energy event elsewhere in space and eventually reaching our atmosphere. They are also produced closer to home, like in your kitchen. Some people eat bananas for their potassium, and mixed in the dominant form of potassium are a few atoms of potassium-40, a naturally occurring isotope of potassium that spontaneously decays, releasing one positron just about every hour. But don't worry, the positron will immediately encounter a normal electron and be annihilated, with the minute amount of energy released being quickly and imperceptibly converted to heat.

Antimatter is also created by humans in high-energy particle accelerators like the one at CERN in Europe. When protons collide at speeds approaching the speed of light, they break down into their constituent subatomic particles and, in the process, some antimatter is created. They can be created in other ways as well, all involving high-energy collisions or other interactions with normal non-antimatter that subsequently produce antimatter particles. As you might imagine, storing the antimatter you produce until it's needed can be quite a challenge. After all, most of the universe is made of normal matter, and as soon as an antiparticle finds a normal particle, they annihilate. Fortunately, positrons and antiprotons carry an electrical charge, which means they can be manipulated and directed by electric

and magnetic fields, much like the electrons and ions used in electric rockets. This allows them to be directed into magnetic traps set up in a vacuum, allowing them to be stored for long periods of time where they won't encounter any normal matter to annihilate. This assumes, of course, that we will be able to create perfect vacuums in the chambers where we store antimatter. Any residual atoms in the vacuum will be an annihilation source for the antimatter, resulting in premature matter-antimatter reactions, reducing the supply of antimatter available for use when it is needed. Making a perfect vacuum will not be easy and currently requires monstrously large pumps, extremely cold temperatures that "freeze out" residual gases in the vacuum chamber, and methods to get the frozen atoms out of the chamber.

Scientists have manipulated positrons and antiprotons into combining and forming antihydrogen, which might be easier to store long-term than gaseous or ionized antimatter.[7]

The matter-antimatter interaction releases energy, but what does that mean? Energy is not some mystical blue glow but rather, in this case, a mixture of fast-moving particles, light at various wavelengths, and heat. Proton-antiproton annihilation produces a mixture of mesons that quickly decay into electrons or positrons, muons, gamma rays, and neutrinos. Neutrinos are nearly massless, which means they hardly interact in any way we find useful and cannot be manipulated to produce useful thrust. The mesons, muons, and electrons or positrons are either charged or electrically neutral and are moving at or near the speed of light. The charged particles can be directed by electric and magnetic fields, as is done with electric rockets, to produce thrust with high-exhaust velocities. Alternatively, if the desire is to produce a photon rocket using antimatter as its power source, electron-positron fuel is used because their annihilation product is gamma rays, which are simply short-wavelength light.

Assuming we solve the engineering challenges for safely storing antimatter on board our starship, annihilating it in such a way that we can use the myriad of charged and neutral atoms produced, plus the light and heat, to create thrust, then one obstacle remains. How much antimatter do we need, and how can it be manufactured in bulk?

To propel our starship while making no assumptions about how efficiently we can convert the energy released in the antimatter reaction into useful thrust (in other words, assuming we are 100 percent efficient at using the energy produced, which we won't be), the result comes to many tons. (Depending upon the size of the spaceship and its destination, this could be as low as a few tens of tons up to more than a thousand.) When compared to the millions of tons of chemical, fission, and fusion propellant required, it sounds like a small and reasonable number until you consider how much antimatter we produce in the world today—on the order of a few nanograms. That's about 0.000000001 grams or 0.000000000001 kg. And this is where it gets difficult. We know that antimatter is the best possible way to store energy from a mass point of view ($E = mc^2$), but the engineering knowledge of how to produce, store, and efficiently use the amounts needed has eluded us.

I saved one of the most interesting rocket ideas to be the last. Interesting because it is audacious, has many adverse (*unbelievably bad*) side effects, violates international treaties, and would be considered unacceptable to >99 percent of the world's population—and it just might work.

In the early days of the Nuclear Age, as scientists and engineers were learning to tap the power of the atom and before they fully understood the dangers (from radiation, fallout from aboveground nuclear tests, managing the waste, etc.), many exciting and fanciful ideas based on harnessing the power of the atom were proposed. People began designing nuclear-powered

submarines,[8] which are real and still safely in use today, nuclear-powered airplanes,[9] trains,[10] automobiles,[11] and, yes, nuclear rockets. It was in this era that nuclear thermal rockets and fusion rockets were first conceived, and we are still seriously considering them today. And then there was Project Orion. In 1958, two scientists, Ted Taylor and Freeman Dyson, began working on a way to use miniature nuclear bombs exploding just next to one side of a heavily shielded space vehicle as a means of propelling it through space. The principle is the same as what I, and many young people of my generation, did with firecrackers—place objects on top of the firecracker to see how far the exploding firecracker would carry them.* Instead of firecrackers, Taylor and Dyson envisioned multiple nuclear bombs lofting a large spacecraft (think battleship size), protected from the blast by large pusher plates, and connected to the spacecraft through some massive shock absorbers. With small nuclear bombs ejected from the business end of the ship every three seconds—Boom! Boom! Boom! The ship would be not-so-gently nudged upward out of Earth's gravity well and into space. *Boom! Boom! Boom!* The explosions would continue as the ship accelerated out of the solar system and up to a cruise velocity of 0.1 c.[12]

A great deal would have to be optimized to make this work. The bombs would have to be designed so that their energy is not dissipated isotropically (the same in all directions), but rather has more energy focused in one direction, toward the spacecraft's shock absorbers, so that as much of the nuclear

*Confession time. With some friends in high school, we did the same "experiment" with far more than firecrackers and when the shards of rock began pelting us from high in the air where the explosion carried the remains of the rock we tried to loft, we decided it was time to move on to other, safer things.

energy as possible can be used. High yield (equivalent to mega-tons of TNT) might produce a bigger bang and stronger push, but it might be too strong for the ship to survive or produce an acceleration larger than a human crew can withstand. Limiting the accelerations less than three or four times Earth's gravitational acceleration in which we all live quite comfortably and limiting the explosions to a yield that won't vaporize the ship, points toward bombs having yields considerably less powerful than the one used on Hiroshima during World War II. Various designs have been considered with spacecraft of varying size, and the common theme is that several hundred small nuclear bombs would be required to accelerate the ship toward its destination and then to decelerate once it arrives.

If you consider the bombs to be fuel, then Orion is really just another rocket and subject to the same limitations of the rocket equation. One might then wonder, appropriately enough, how Orion manages to beat the rocket equation to get a high I_{sp} when the basic physical processes that make it work, fission and/or fusion (in the bombs), cannot (fission) or may not (fusion), on their own, get the needed efficiency. The answer lies 1) in the ability to direct the majority of the energy released during the explosion toward the spacecraft, 2) the very short amount of time the blast energy interacts with the pusher plate, causing minimal ablation of it, 3) the use of magnetic fields around the plate to optimize the thrust provided by the explosion's by-products. Taken together, the equivalent I_{sp} of an Orion spacecraft is between 100,000 and 1,000,000 seconds. High enough to "beat" the rocket equation for missions to nearby stars.

When discussing this technology, it is important to remember that the spacecraft being propelled by the exploding nuclear weapons is enormous, and one of the key features of the

approach is that it is both high thrust and high I_{sp}. This means it has the thrust necessary to lift the spacecraft from the surface of Earth into space and then continue boosting it. The primary objection to its use within Earth's gravity well, where the biosphere also resides, should be obvious—detonating all those atomic bombs would poison the nest. What if we could launch the system to space using more conventional rockets and then accelerate with the nuclear detonations once there? While this approach would certainly work in theory, it would be extremely difficult in practice due to the weight of the craft and the problems associated with assembling it in space. First, there is the number of launches required to loft the ship in pieces—it would be a lot of launches. Second is the matter of assembly. Usually, spacecraft assembled in space don't have to withstand high accelerations. Assembling a ship that would be boosting at up to four times Earth's gravity would be a challenge, but doable. Third is the small matter of the existing international treaties that prohibit placing nuclear weapons in space.[13]

The bottom line: it ought to work, but we will probably never build it. Rockets will most likely be the workhorse of space travel into the foreseeable future, with technological advances enabling many of the rocket types discussed in this chapter to be built and used as we explore and settle the solar system. Because of the tyranny of the rocket equation, if we want to use rockets to reach the stars, then we have to either resign ourselves to a very long journey (using chemical, nuclear fission, or electric rockets); engineer giant vehicles, capable of carrying enormous amounts of propellant or hardware (nuclear fusion and photon rockets); or learn how to build dauntingly complex and dangerous systems (antimatter rockets).

6

Getting There with Light

... ships and sails proper for heavenly air should be
fashioned ... [1]

—GERMAN ASTRONOMER JOHANNES KEPLER AFTER
OBSERVING COMET TAILS BEING BLOWN BY WHAT
HE THOUGHT TO BE A SOLAR "BREEZE"

A reasonable question at this point might be: "Can we travel to
the stars in ways that eliminate the 'tyranny of the rocket' equa-
tion?" Yes, as a matter of fact, we can. The keys are to find a way
to accelerate our spacecraft without having to carry the energy
required to do so on board the ship itself, and to throw away the
notion of I_{sp}. If you don't use propellant, then your I_{sp} is, in
theory anyway, infinite. But if you are on a ship bound for the
stars and you need an enormous input of energy in order to
accelerate to 0.1 c, then how can you get it when you are moving
through the emptiness of deep space and not using a rocket? To
begin with, space is not "empty."

Let's return to the center of the solar system and consider the
sun. In addition to being a giant fusion furnace and massive

anchor around which Earth and other planets revolve, it is the source of light that warms Earth and allows life to flourish here. Wait a minute. The light from the sun fills the space between Earth and the sun; can we somehow use that or some other form of offboard energy to propel or power a spaceship? The answer to both is yes.

Spacecraft regularly use the energy contained in sunlight to provide their electrical power (see chapter 7). As long as they remain near the sun where the intensity of light is comparatively large, modern solar panels can generate enough electrical power for just about any robotic and human mission we can envision. In chapter 5's discussion of photon rockets, we learned that light particles, or photons, may have no rest mass, but they do carry momentum. When a photon rocket emits a beam of light, the momentum of the expelled light, through the principle of action-reaction, causes the rocket to move in the other direction, conserving the total momentum of the system in the process. Instead of emitting the photons, solar sails reflect incoming solar photons to derive thrust and do this with twice the efficiency of a photon rocket. One increment of momentum is provided when the photon impinges the sail; the other when the light is reflected backward in the direction opposite to which it arrived.*

The "free" use of solar photons for providing thrust requires that the spacecraft being pushed by the sunlight be extremely lightweight and reflect a lot of light in order to get meaningful

*One might ask, "What about conservation of energy? Where does the energy that accelerates the sail craft come from in this process?" The answer is the photon of light. Light carries energy and momentum, and when it is reflected from a surface, the energy imparted is seen as an energy loss in the photon, increasing its wavelength and decreasing its energy.

acceleration or thrust. This all goes back, again, to Sir Isaac Newton:

$$F = ma \ (Force = mass \ times \ acceleration)$$

In this case, the force represents the constant force of sunlight at a given distance from the sun, which can only be turned into a large acceleration if the mass of what is being accelerated is small. Since, at this distance from the sun, the force from sunlight does not change, then the product of the mass and acceleration cannot change. In order for one to be large (a, the acceleration) then the other (m, the mass of the spacecraft) must be small. This drives the object reflecting the light to be as large as possible (to capture as much force per area as it can) and as lightweight as possible (realizing that as the area of the reflector gets larger, it unavoidably gets more massive, reducing the resulting acceleration). Just as our ancestors learned to maximize the use of the energy contained in the wind to propel oceangoing ships with large, lightweight sails, we, too, can build solar sails to reflect light and sail on sunshine.*

When propelling a spacecraft, solar sails do not have the gutpounding excitement of a rocket; instead they evoke a sense of elegance, with their reflective sails showing the glint of reflected sunlight as they accelerate to faster and faster speeds.

Intuition leads many to think that a solar sail is good for moving radially outward from the sun but not much else. In this

*There is an unfortunate naming convention here that often confuses people. Solar sails do not sail on the solar wind, which is another, very real stream of particles emitted by the sun. Using the analogy of wind sailing to describe solar sailing makes a lot of sense, but it often makes people think solar sails are sailing the solar wind, which is not the case. There are sails that reflect the solar wind, like in wind sailing, but they are called either electric or magnetic sails, and are described later in the book.

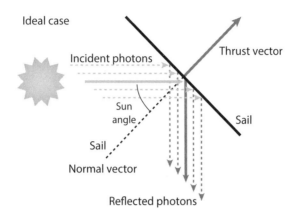

FIGURE 6.1. How Solar Sails Work. Solar sails are not rockets, but they, too, operate under the same basic physical principle of rocketry—the conservation of momentum—and they do this in a really interesting way. Consider the solar sail as a perfectly reflective flat plate, with the sun to the left. No matter what angle the sail is tilted, the incident particles of light (photons) will reflect from it, producing a net thrust on the sail that depends upon that angle and the energy of the incident photons. As the photons reflect from the sail, they lose a little energy (and actually change color in the process). The energy lost by the photons is transferred to the sail as momentum, accelerating it.

case, and as is often the case when it comes to the science of spacecraft orbital dynamics (the study of how to move objects around in space and get them to go where you want them to go), intuition can steer you in the wrong direction. Solar sails are good for moving outward away from the sun, but their path need not be in a straight line. They can be steered to go in just about any direction desired—outward, inward, upward, or downward—by simply changing the angle that the sun reflects from the sail (figure 6.1). First of all, remember that Earth orbits the sun with a velocity of 67,000 mph. Anything we send into space from Earth will begin with the same velocity; add to it

whatever energy the rocket that launched it provides, and you will have the starting orbit of the sail craft around the sun. Nothing in space stands still!

By accelerating along the existing velocity vector (in the orbital direction the ship is already going), the orbital energy of the sail craft is increased, thereby spiraling it away from the sun. If you tip the sail to get thrust in a direction opposite to the velocity vector, the orbital energy decreases, allowing the sun's gravity to pull it inward, spiraling toward the sun. Since the force of sunlight increases when you get closer to the sun and weaker as you get farther away, the net acceleration on the sail craft increases as it falls toward the sun, making it easier to keep moving closer. Conversely, as the sail craft sails away from the sun, the force from sunlight gets weaker, reducing the acceleration until it gets so low as to be negligible. By tipping the sail upward or downward, you can accelerate out of the orbital plane and allow the ship to get above or below the ecliptic plane.*

It is important to note that the force of sunlight not only goes up as you decrease the distance between your sail craft and the sun, but it also goes up nonlinearly according to the inverse square law, or as $1/r^2$, where r is the radial distance from the sun. Simply put, if you double the distance from the sun from that of Earth's orbital distance to two times that distance, the force is not halved (as intuition might lead you to think) but is rather decreased by a factor of four ($\frac{1}{2}^2 = \frac{1}{4}$, therefore providing only

*The ecliptic is the flat plane of Earth's orbit around the sun and is the primary reference plane when describing the position of objects in the solar system. Most of the planets, asteroids, and comets in the solar system lie in or near the ecliptic, give or take a few degrees.

¼ the amount of thrust as was experienced by the sail near Earth). Conversely, if you decrease the distance to ½ that of Earth, the force on the sail doesn't double; it goes up by a factor of four! If you decrease the distance to ⅓ that of Earth, then the resulting forces are nine times (3^2) larger. It is this force increase that makes sails attractive for interstellar travel. A large, extremely lightweight solar sail deployed close to the sun would experience the force required to rapidly escape from the solar system and travel to another star.

Professor Gregory Matloff, a pioneer in the field of solar sailing, calculated that a sail made from one-atomic-layer and very strong material, with diameters measured in kilometers, could attain velocities of 0.003 c or better, arriving at Alpha Centauri in 1,400 years.[2] When he did his initial calculations, building a sail that large required materials not yet known, and they could have been called *unobtainium*. However, in 2004, graphene (there it is again) was discovered, which has the properties that would be required to build such a large sail. Unfortunately, as of today, making graphene on the scale required to build even the simplest solar sails is beyond current technological capabilities. *But it is physically possible.*

How far away are sails such as those required to enable an interstellar voyage in a reasonable amount of time? To answer that question, consider the recent spate of successful solar sail demonstration missions: NanoSail-D,[3] LightSail 1 and 2,[4] and IKAROS,[5] all flown in the 2010s. There are more coming soon. NASA's Near Earth Asteroid (NEA) Scout is a NASA mission that will use an 86 m^2 (925 ft^2) solar sail to propel a small science spacecraft in a slow flyby of an asteroid about two years after its launch, in 2022.[6] Solar Cruiser is the most ambitious solar sail mission planned to date. It will use a 1,653 m^2 (~18,000 ft^2) sail

to demonstrate its capability to reach previously unreachable orbits and solar system locations achievable only through the continuous thrust provided by solar sailing.[7]

All of these missions have either successfully flown or are in development for flight within the next few years. There is a noticeable trend in the sizes of the sails flown over time: NanoSail-D and LightSail 1 and 2 (10–32 m^2), NEA Scout ($\sim 10^2$ m^2), and Solar Cruiser ($\sim 10^3$ m^2). Will a 10^4 m^2 sail be next? How long will it be until we are able to build the 10^6 m^2 sails envisioned by Matloff? Today's and, admittedly, tomorrow's solar sails are far from the scale needed to mount an interstellar voyage, but they are steps toward it.

A solar sail really doesn't care about the origin of the light that illuminates it to provide thrust. Would it be possible to help overcome the rapidly diminishing thrust experienced by a solar sail as it leaves the vicinity of the sun by illuminating it with artificial light from a laser? The answer is yes, but with some important caveats.

First, a laser can produce an intense beam of light at a specific wavelength, perhaps at a wavelength tuned to match the color of light at which the sail material is most reflective in order to get the biggest possible boost. Despite how it looks in science fiction, beams of laser light are subject to the same natural laws as sunlight, and the beam size will therefore get progressively larger, and less intense, with distance. If a laser system has an appropriate lens attached, it is possible to avoid inverse-square decay until you are past the focal point of the lens—and then the beam begins to diverge and get weaker. Most proposals for laser-driven light sails propose to use the laser in the near-field regime where the beam is still focused or collimated and does not suffer inverse-square drop-off in the beam intensity. In both

cases, laser light has an advantage over sunlight in that it begins compact and intense (powerful), potentially providing a thrust that dwarfs anything possible using sunlight alone.

What is the status of high-power laser development, and how far are we from the sizes needed to mount an interstellar voyage?*

Like many technologies, lasers and masers (the microwave equivalent of a laser) have grown from a theoretical possibility enabled by Albert Einstein's discovery and quantification of the photoelectric effect—which showed that light delivers its energy in discrete bits, photons—for which he was awarded the Nobel Prize. It wasn't until the 1950s that pioneers Charles Townes and Theodore Maiman built and demonstrated lasers in the laboratory.[8] Since then, lasers have grown in power level, wavelength tunability, overall beam quality, and, importantly, continuous operation. Extremely powerful lasers with power levels as high as 2,000 trillion watts have been demonstrated, though for vanishingly small periods of time—on the order of a trillionth of a second.[9] What is needed are high-power, tightly focused, continuously operating lasers with output powers in the hundreds of millions or billions of watts. A place to look for the development of lasers approaching the power levels that will be needed for in-space laser propulsion is the military, who have their own reasons for developing them.

*I continue to reveal my age. When I began my career, I worked on Ronald Reagan's Strategic Defense Initiative, otherwise known as Star Wars. One of the areas I worked in was that of using high-power lasers for blowing up incoming nuclear warheads. In that era, when laser powers of tens of kilowatts or more were discussed, the facilities used to produce them were enormous (school building size) and required mixing many toxic and caustic chemicals like hydrogen fluoride and deuterium fluoride. Today, lasers with yet higher power levels can be powered by diesel generators and fit on the back of trucks. Such is the pace of technological progress.

The US Army is planning to build and test the Indirect Fires Protection Capability—High Energy Laser (IFPC-HEL), which has an advertised continuous power level between 250 and 300 kilowatts.[10] Published studies show that previously tested US Army lasers, with power levels in the tens of kilowatts, had a sufficient pointing ability to place and hold a beam on an orbiting sail the size of the LightSail.[11] There are other promising techniques being developed that could boost the laser power on the target without necessarily requiring an initial beam power of megawatts to gigawatts, and photon recycling is one of them. In conventional laser propulsion, the photons in the laser beam strike the sail, impart their momentum, and are then reflected and lost forever. Realizing that such losses are a waste of energy, Drs. Philip Lubin, Young Bae, and others propose methods by which many of these photons can be reused.[12] In photon recycling, the laser light repeatedly reflects between the laser and the sail in order to maximize the energy transfer to the spacecraft. If the laser and the sail act as retroreflectors, meaning that the incident light is reflected back along the path it took from the source, and then reflected back again, along with the addition of freshly generated photons, much more of the power in the beam can be transferred to the sail, increasing its acceleration and velocity.

There are other innovative approaches to create the high-power laser systems required to launch an interstellar probe. Instead of designing a single laser system with the output power required, it might be easier to build hundreds to thousands of relatively small, lower-power lasers and combine their output in something called a phased array. Not only would this make the technology development easier, presuming that it will be expensive to go from where we are today in a linear development fashion to a single laser system with the power and other

attributes required, but this approach would also probably be less expensive. In any new product, the development of the first unit produced is expensive. For a commercial product, companies make their profit not by charging a fortune for the first unit but by selling many copies of the product, since making the second through n^{th} unit is inherently less expensive as the cost of development has already been paid for the first one. A good example is new car design. Across the automobile industry, the research and development costs for a new model of any car is well over $1 billion. If the company were to make only one car, then they would have to charge the customer over $1 billion in order to make a profit. Instead, by making and selling many thousands of copies, the combined profit from each vehicle adds together to recover the development costs.

Next, where you place the laser will make a big difference in its performance. If you locate it on Earth, where there is an established power system that could provide the electrical power necessary to run it, then you will most likely require more than one due to Earth's rotation. In this case, and from the point of view of the sail, the laser source will be in view for a while and then drop below the horizon and be inaccessible until the planet rotates enough for it to be visible again. This can be solved by having more than one laser-beaming station on the planet so that one or more of them are in view at any given time. Another option would be to have relay stations in orbit that would reflect or redirect the laser beam to keep it on the sail craft as Earth rotates below it. Then there is the problem of the laser losing energy as it passes through the relatively dense, moisture-laden atmosphere, where light will be scattered, reducing the amount of laser light actually falling on the sail. For this reason, high-altitude locations above the densest part of the atmosphere are being considered. There is another important

issue that must be considered—accidentally illuminating someone else's Earth-orbiting satellite while you are aiming at the sail might be considered an act of war.

If you locate the laser in space orbiting the sun instead of orbiting Earth, then the whole "keeping the sail in view for a long time" problem is mostly solved. But where will the power come from? Solar arrays? That's certainly possible, but at the power levels required, they would be enormous. With any high-power laser system based on Earth or in space, there is a potential legal problem in that when the laser is not sending a spacecraft on an interstellar voyage, it could certainly be used as a weapon, and there are treaties against that sort of thing.

Finally, in the approach of using a rather large sail that is first accelerated by sunlight and then boosted by laser, the intensity of the light producing the thrust falls off with distance, as mentioned previously. This can be solved by placing several lasers in space, each progressively farther from the sun, so that as the beam from one gets weak, the outgoing sail falls into the line of sight of the next one, allowing the closest one to pick up the job and to continue rapidly accelerating the sail craft. Alternatively, and as initially proposed by Dr. Robert Forward in his seminal paper on the topic, "Roundtrip Interstellar Travel Using Laser-pushed LightSail," published in 1984, a large Fresnel lens (think of it as a huge magnifying glass) could be placed near the orbit of Jupiter to capture the now-diffuse laser beam and refocus it to allow continued outward acceleration of the sail.[13]

There is another approach to laser sailing that is receiving some significant attention lately thanks to Breakthrough Starshot, a philanthropic organization developing technologies that might one day take us to the stars.[14] Instead of starting with an extremely large solar sail that transitions to laser sailing or even beginning with a large sail that is optimized for laser acceleration,

the alternate approach envisions a rather small sail, perhaps as small as 1 m², that is rapidly accelerated to >0.1 c by an extremely powerful Earth-based laser. From a performance point of view, this approach has some very obvious advantages. For example, with a small spacecraft, perhaps weighing less than 1 kg (the "m" in Newton's Law) with the goal of as small as 1 g (a raisin!), and a high-power laser that provides a large force (F), the acceleration (a) could be rather large. The acceleration could be so large as to achieve the goal of reaching 0.1 c in a few tens of minutes, sending the spacecraft rapidly out of the solar system and on its way. This approach, like all the others discussed thus far, has its pros and cons.

As mentioned above, the biggest "pro" is the small size of the spacecraft. If the trends in spacecraft miniaturization continue, or perhaps accelerate, then what was once possible only on heavy spacecraft like the Voyagers (which are about the size and weight of a typical car) might be able to fit on a raisin-size spacecraft in the future. Today, governments, industries, and universities are flying CubeSats, small spacecraft measuring only tens of inches in length, width, and depth and weighing less than a few tens of pounds. Many are performing missions that twenty years ago would have required spacecraft ten to one hundred times larger and more massive. The trend is definitely toward small, more capable spacecraft, so a Starshot-class spacecraft, which they sometimes call a "chipsat," is not unbelievable.

Next, the sail size must be kept small and low in mass. Materials science advances of the last few years are encouraging. From graphene to diffractive metamaterials, robust, highly reflective, and thermally tolerant materials are being discovered and created on a regular basis. Finding one that can reflect light with an efficiency of >99.9 percent, without becoming

prohibitively massive (remember that low-mass sails are essential), would be ideal, but it is not necessarily the best solution. What is needed is a sail that remains low mass, reflects enough light to get sufficient thrust, *and does not absorb much of the energy from the incident light.* It turns out that an ultra-light-weight material with reflectivity as low as 30 percent might be sufficient—if the remaining light can pass through it without being absorbed.[15] Absorbing too much energy during such a short boost period could result in the destruction of the sail before it has achieved the desired speed.

Like all interstellar missions, the Starshot sail craft, though very small, will still have a chance of hitting meteoroids and dust during its journey across space, potentially ending the mission.

Finally, on the sail side, there is the problem of steering. With a solar sail and the low accelerations they experience, it is possible to reorient the sail to correct for thrust errors in a matter of minutes or hours without significant impact on the mission or causing the spacecraft not to reach its intended destination. (Remember that we don't want our spacecraft, traveling at 0.1 c, to accidentally hit another planet!) For a large solar sail being boosted by laser, the maneuvering requirement becomes more constrained, perhaps requiring precision adjustments every few seconds or minutes. Given that it will take days, weeks, or even months, depending on the design, laser power levels, and so on, for the sail to accelerate to 0.1c, there is plenty of time to correct for misalignments and pointing errors. With the small spacecraft approach envisioned by Starshot, there is not much time to correct for targeting errors. The entire acceleration phase will be over in a matter of minutes, with any misalignment causing the spacecraft to completely miss its intended target. Analysis shows that the sail can be shaped in such a way as to be self-correcting

for misalignments, allowing it to "ride the beam" and maintain course. Preliminary experiments with a microwave-levitated sail show that this approach just might work.[16] With all these caveats considered, the Starshot approach is considered by many to be the only viable one for near-term interstellar missions, and it might allow them to meet their goal to "demonstrate proof of concept for a new technology, enabling ultra-light uncrewed space flight at 20% of the speed of light; and to lay the foundations for a flyby mission to Alpha Centauri within a generation."[17] One can only wish them success.

Another type of sail that derives thrust by reflecting photons is the microwave sail. The electromagnetic spectrum covers all wavelengths of light, from the longest (extremely low frequency, thousands of kilometers long) to those a fraction of a nanometer (gamma rays). The part of the spectrum used by solar sails is in the small range that humans can see and is therefore called "the visible" part of the spectrum, 400–700 nanometers (nm), which is, understandably enough, a dominant part of the solar spectrum. What other parts of the spectrum might we consider using with a sail? In principle, any part could work if there were a lightweight material that is highly reflective at those wavelengths. For good reason, the range between 1 mm to around 30 cm stands out—microwaves. Why? Because we humans are exceptionally good at efficiently creating and using photons in the microwave region of the spectrum.

As with many other technologies, the human relationship with microwaves was a product of warfare. In the early 1940s, the magnetron tube, a device for generating microwaves, was discovered and then quickly developed and used as a way to detect German planes coming toward England on bombing runs—in a neat little invention called radar. There are now few regions of the world where radar is not scanning the skies,

tracking airplanes, ships at sea, satellites, and even space junk. We use microwaves to cook our food quickly, and we curse them after getting a speeding ticket. The best part is that we can create them efficiently, a full 65 percent or more of the input energy being emitted as microwaves. This compares with average laser efficiencies of 10–30 percent, dropping the input energy required for beaming by 50 percent right at the start. Currently, creating microwaves is also much less expensive, by a factor of ten, than creating lasers of similar power.[18] Can we make a microwave-beamed energy sail?

Yes, we can, and there are many different approaches to doing so. As in a solar or laser sail, the material used to make the sail needs to be highly reflective at the wavelength(s) used in the offboard-beamed energy source, in this case a microwave beamer. The wonderfully named Starwisp concept would use a large wire mesh sail (due to the wavelengths involved, a microwave sail need not be solid) as the reflector.[19] Robert Forward, the late progenitor of the concept, envisioned that the Starwisp sail would serve as both the propulsion system reflector and the home of the extremely low mass, small-volume instruments that would be used to study the target star upon arrival. Forward's initial Starwisp design called for a 1 km square mesh sail craft with wires spaced 3 mm apart and weighing only 29 g, including the instruments. Others have looked at the design and created variations, including the use of carbon fiber materials as the beam reflector instead of a wire mesh.

There have been experiments performed to actually show microwave beam levitation of small sail-like materials and how they can be made to remain centered on the beam during acceleration and not simply move out of the beam due to any asymmetries.[20] From a physics point of view, the concept is sound. But then there is the engineering . . .

Aside from the creativity that will be required to miniaturize an entire spacecraft and instruments to weigh less than 30 g, there is the required beamer size. Due to the nature of how microwave beams diverge and other physics constraints, the aperture of the microwave source for the 1 km Starwisp would be 50,000 kilometers, or four times the diameter of Earth, and would require 10 gigawatts of power.* As with most interstellar propulsion systems, size matters.

The solar wind, as described previously, is made from a continuous stream of ionized hydrogen (positively charged protons and negatively charged electrons that have too much energy to recombine easily into neutral hydrogen) and alpha particles (which is ionized helium, with its two protons and two neutrons but no electrons). Scientists refer to the solar wind as a plasma, which simply means it is filled with ionized atoms, in roughly equal measures positively charged particles and negatively charged ones. This solar wind plasma is streaming out from the sun at velocities 185–500 miles per second, which is what begins to make tapping into it most interesting. These solar wind particles have momentum, and, like light, that means a spacecraft should be able to absorb or reflect it to derive thrust.

Imagine deploying in space a large (perhaps hundreds of miles long), circular loop of superconducting wire carrying a large current. The wire is superconducting so that the current does not degrade over time. There are many materials that

*10 gigawatts is roughly the power output of ten nuclear power stations—a lot of power but not an unbelievable amount. But for the power required at the sail: taking into account all the inefficiencies between the power source and the sail, such as the transmission of the power to the beamer, the efficiency at which the beamer converts electricity into microwaves, and the power losses in the beam between the place at which it is generated and the sail, the input power required is likely to be much larger, perhaps as much as 50 gigawatts.

become lossless superconductors when cooled to temperatures comparable to those in deep space. The magnetic field is created by the current flowing through the wire loop. As the solar wind's charged particles enter the loop, they are deflected by the loop's magnetic field, imparting momentum to it. The solar wind contains several million protons and electrons per cubic meter and much of the momentum these particles carry can be transferred through the loop to the spacecraft that deployed it, theoretically accelerating it to speeds close to the speed of the solar wind itself. It should therefore be possible to use this propulsion system to send spacecraft rapidly to the edge of the solar system and beyond. Unfortunately, even this speed is too slow for taking a practical interstellar trip, reducing the trip time to the Centauri system to only 2,000–3,000 years. This is clearly better than rocket-based approaches, but not fast enough.

However, there is a possible use for this system on the other end of a true interstellar voyage—as a brake. In the discussion of propulsion systems, the focus has been on accelerating the ships to high speeds to make the trip time to another star as short as possible. Unless the craft is also able to lose a lot of velocity, it will pass through the target star system very rapidly and continue on its way into deep space for, well, forever. To slow down and stop, it will require propulsion of a scale equal to that which is used first to start it on its journey. What speeds up must slow down, and Newton tells us that the energy input requirements are the same. This makes the rocket equation much more tyrannical—recall that in addition to carrying the propellant needed to accelerate, the ship must carry at least that much more to decelerate, which means more propellant will be needed to accelerate it in the first place because now that "extra" deceleration propellant must be accelerated at the start of the mission also. Aargh!

Slowing down is where a magnetic sail gets potentially interesting. However the spacecraft accelerates on its journey (choose your favorite method), it could deploy a huge magnetic sail as it enters the destination star system and use its interaction with the outward-flowing stellar wind of the target star as a brake, helping to slow the ship without the use of propellant at all. Even for this approach, there are those pesky practical questions to resolve: the manufacturing, stowing, and deploying of a superconducting wire loop of hundreds to thousands of miles long, producing high currents to generate the needed magnetic fields, and so on.

Another way to use the solar wind is by taking advantage of a pithy science principle learned (and perhaps promptly forgotten) by most schoolchildren—"opposites attract" and "like repels like."

The electrostatic sail (E-sail) taps the momentum of solar wind particles for spacecraft propulsion with the help of long, positively charged wires. As the positively charged solar wind protons and alpha particles approach the positively charged wires, the wires and incoming particles repel each other via the interaction of their electric fields (like repels like), transferring much of their forward momentum in the process (figure 6.2). Negatively charged electrons are attracted to the positive wires and absorbed by them, producing a small current and acting as a drag, or slowing-down, force. A logical question: If there are roughly equal numbers of protons and electrons, won't the electrical forces cancel, producing no net thrust? That would be the case if protons and electrons were of equal mass, but they are not. Protons weigh 1,836 times more than electrons and carry much more momentum that they can and will impart to the E-sail system. The collected electrons are a problem because if the spacecraft doesn't get rid of them, then the wires will quickly

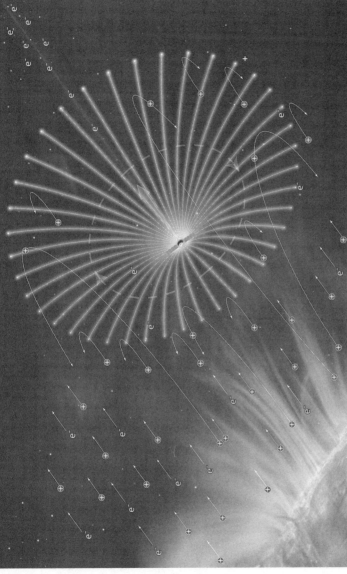

FIGURE 6.2. The Electric Sail. Like a solar sail, an E-sail reflects particles coming from the sun, in this case, positively charged solar wind ions. As these ions interact with the electric field surrounding each positively charged wire, they reflect from it, imparting momentum to the E-sail via the reflection. The nice thing about the physics of an E-sail is that the thrust provided by the solar wind does not drop as rapidly as it does from a solar sail, allowing it to provide measurable thrust farther into the outer solar system. Image courtesy of Finnish Meteorological Institute's Space and Earth Observation Centre © 2008 Antigravite / Alexandre Szames.

lose their net positive charge and become neutral, shutting off the proton repulsion and thrust. Spacecraft designers plan to use something called an electron gun to eject the collected electrons back into space and away from the spacecraft to prevent their accumulation and detrimental effects.

The solar wind, like sunlight, gets weaker with distance following the inverse square law, and one might be tempted to think that an E-sail would lose useful thrust following the same scaling as a solar sail (for a solar sail, doubling the distance from the sun results in a thrust only ¼ as strong as at the original distance), but, for an interesting reason, that is not the case. The E-sail's thrust drops off almost linearly with distance, meaning that at double the distance, the sail produces just under ½ the thrust that it did originally. This has a huge impact on the E-sail's ability to continue accelerating a spacecraft on its way out of the solar system. At Jupiter, instead of producing only 4 percent of its original thrust (like a solar sail), the E-sail will produce 15 percent of its original thrust, not dropping to the same level as a comparable solar sail until it reaches a place sixteen times farther out from where it began.

For missions to the outer solar system and into nearby interstellar space, the E-sail will perform far better than a solar sail due to this additional thrust. NASA assessed the relative performance of solar and E-sails and found that an E-sail could accelerate a spacecraft to enormous speeds—on the order of ~ 20–30 AU/year.[21] This is clearly too slow for a realistic mission to another star, but it might be useful for taking early steps in that direction (see chapter 2).

And, unfortunately, E-sails don't scale well to extremely large sizes, and there is no comparable beamed-energy approach to accelerating them after the solar wind gets too weak to provide additional thrust. It may be possible to build large, charged-particle beam projectors that would supplement the dwindling solar wind

in much the same way as a laser supplements the thrust of a solar sail, but the fundamental physics of charged particles may ultimately make this impossible. The "like repels like" aspect of charged particles generally causes the protons in such a charged particle beam to quickly diverge and become unfocused, unable to project across the enormous distances required. Relativistic beams, those traveling at near the speed of light, experience an inward-directed pinch due to the magnetic fields induced by the beam itself. By introducing a few particles in the beam of opposite charge (i.e., electrons), it may be possible to make a neutral particle beam that—in principle—doesn't spread as rapidly.[22]

It is worth noting that an E-sail, like a magnetic sail, could be deployed and used as a brake for a spaceship as it enters the destination star system, reducing some of the propellant needed to slow down.

Crossing the vast distances from Earth to the stars will require revolutionary advancements in spacecraft propulsion. As a means of assessing the applicability of known propulsion technologies, NASA scientists created a nice graphic (figure 6.3), which compares a propulsion system's efficiency (specific impulse) with its achievable acceleration (thrust-to-weight ratio). The range of capabilities for the various propulsion systems discussed so far are plotted to show their relative strengths and weaknesses. For example, the ideal propulsion system for a ship carrying humans, like the warp drive on the fictional *Enterprise* or the hyperdrive of the *Millennium Falcon*, would fall near the top right corner of the figure and operate with both high efficiency and high thrust to weight, allowing short trip times with minimal propellant expenditure. Unfortunately, nature has not yet revealed to us a space propulsion system with those characteristics, and we are stuck with systems that are highly efficient but low thrust, like solar, laser, and microwave sails that may be useful for sending rapid, small (hence,

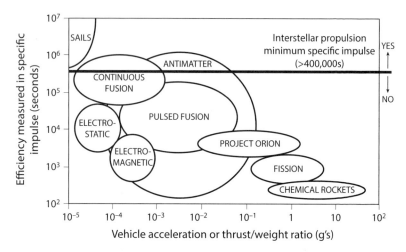

FIGURE 6.3. Propulsion Systems Comparison. Known space propulsion technologies are categorized according to the performance metrics of specific impulse (a measure of propellant utilization efficiency) and acceleration (or thrust-to-weight ratio). Interstellar missions will need both values to be as high as possible. The horizontal line at a specific impulse of 400,000 seconds represents the minimum value needed for interstellar propulsion at 0.1 c by concepts with onboard propellants. It should be noted that there are many fusion- and antimatter-based propulsion concepts, but only certain implementations are theoretically capable of achieving 0.1 c. The ideal propulsion system would be at the top-right corner with very high thrust and extremely high efficiency.

robotic) probes, and we currently have only two less-efficient rocket options, fusion and antimatter, which could be used for either robotic missions or for ships carrying humans. The horizontal line at a specific impulse of 400,000 seconds represents the minimum value needed for interstellar propulsion at 0.1 c by rocket-based technologies. Anything less efficient causes the rocket equation to rapidly exert its tyranny, making the propellant loading, or trip times, unacceptable and impractical, if not impossible.

With these limitations, where do we begin?

7

Designing Interstellar Starships

To be the first to enter the cosmos, to engage, single-handed, in an unprecedented duel with nature—could one dream of anything more?[1]

—YURI GAGARIN, RUSSIAN COSMONAUT AND
THE FIRST PERSON TO FLY IN SPACE

Building a ship that can go the distance and reach another star will not be easy. Yes, that is yet another understatement. In addition to propulsion, which is the first among many enabling technology challenges to be solved, there are myriad others begging for innovation, including power, communications, navigation, thermal management, and radiation protection. And if we are considering a ship populated by humans, then added to that list are life support (air, water, and waste management), food, redundancy, and, of course, *redundancy*. Other considerations worth mentioning for crewed starships are not technological but psychological, sociological, and political—which may end up being the toughest challenges of all.

Robotic interstellar exploration is inherently different from human exploration in many ways. First, of course, is that, though everyone funding, building, launching, and operating the mission wants it to be successful, the design can tolerate more risks than a mission where humans are the cargo. Second, instead of the human crew driving the requirement for size and trip time (due to the considerable amount of mass required to transport humans and what it takes to keep them alive), the scientific instruments being sent on the mission and their ability to call home with the collected data are what determine the overall size and scale of the mission. Robotic missions are therefore simpler, and we will tackle them first.

For purposes of this discussion, I am assuming the propulsion problem has been solved and that whatever propulsion system used will allow the spacecraft to reach its destination in less than about 150–250 years. Designing a spacecraft to operate ten to twenty times longer than those flying today require will be challenging enough; designing one to last over a thousand years would be an entirely different level of difficulty!

The masses of spacecraft and their scientific payloads have undergone a dramatic reduction in the last fifteen years, thanks to innovations seen most vividly in the commercial sector in our smartphones.* Engineers and scientists are now able to build lightweight instruments and accompanying command electronics as well as lower-mass sensors, flight computers, and other electronic-enabled hardware in virtually all spacecraft systems. Thanks to advances in materials science, lightweight

*The "phone" in my pocket has the same functionality that just a few decades ago (when many of our spacecraft were designed) would have required multiple, large electronic devices such as a video camera, stereo cassette player, AM/FM/shortwave radio, GPS receiver, television, computer, and, oh yes, a telephone.

carbon composite materials are replacing the heavy aluminum structures that have dominated spacecraft structures for the last several decades. Instruments that used to weigh many tens of pounds are now built weighing ten times less. Spacecraft structures have had their masses cut by 25 percent, with 50 percent reductions (or more) envisioned soon.

At a high level, the designers of a robotic mission must decide if their spacecraft needs power during the journey or only at the beginning and end. If there is no need to keep the spacecraft warm or functional while it crosses the light-years, then solving the power problem is quite easy. Just add solar panels and allow the spacecraft to go completely dormant during its journey, generating and using power only as it departs the solar system and enters its destination star system. While this option is certainly possible, it would assume that there would not be any mid-course trajectory maneuvers required to compensate for targeting errors at launch, that no scientific data would be collected during most of the flight, and that the ship reached its final velocity quickly, all before it left the influence (and power-providing range) of the sun. This approach would work well also if the ship were not meant to slow down or stop. Would those who spent a fortune building it over several years, perhaps decades, be content getting data for only a few hours as the ship flew by its destination at some sizable fraction of the speed of light? Waiting decades to a century for a few hours' worth of data would be a difficult thing to sell.

Some of the power options available for a precursor mission like those discussed in chapter 2 might be scalable for use on a true, full-distance interstellar mission, but most would not. Unless the criteria listed above are met, solar power is not an option in the eternal darkness of interstellar space. RTGs will have their radioactive heat source decay to uselessness long

before the destination might be reached, and no chemical battery would have a chance at being usable after so many years without recharging.

A fission reactor might work, especially for missions to a relatively close destination or one we can reach in under two hundred years (or so). The amount of nuclear fuel is manageable, and good design just might allow one to operate that long without failure, though over time the materials surrounding the reactor will decay from continuous neutron bombardment and from interaction with the other radioactive sources created from prolonged fission reactions.

It is conceivable that a network of beamed power stations could be established along the path to another star, each with the job of sending power to the spacecraft as it passes by on its journey. The infrastructure required would be significant and is difficult to envision for the first several spacecraft sent. After all, the amount of energy required to send a remote power station one-quarter of the distance to Alpha Centauri and having it stop there to await a transiting ship would be approximately half the power required to go ahead and send the power station itself all the way there. Doable, but not practical.

Nuclear fusion is another viable option worth considering. Like its fusion propulsion cousin (discussed in chapter 5), a shipboard fusion reactor would mimic the physical processes in the sun to produce heat energy that would then be converted into useful electrical power. In principle, a fusion reactor would require less fuel than its fission cousin and would produce fewer radioactive waste products. Fusion power should definitely be on the short list for viable options.

Communicating with a probe sent several hundred, or even a thousand, AU from Earth is challenging enough. Communication with one that is four light-years or more away is another

question entirely. And, as asked in the chapter on precursors, if a ship cannot send the data from its instruments home, then what is the point?*

Fortunately, there are options. Laser sail propulsion was described in chapter 6, and the phased array laser infrastructure used to propel the ship described there might also be used in reverse, as it were, for communications with the probe after it reaches its destination. Instead of using the optics to combine many individual lasers into a single, appropriately phased laser beam to propel the spacecraft, the optics would await the inevitably faint[†] laser optical signal from the starship and combine the weak signal into a readable one. A large optical receiver like this is directly analogous to the large-aperture radio receivers used by the NASA Deep Space Network to communicate with interplanetary spacecraft. Again, making this work is simply a matter of scale. The fundamental physics is sound—we just don't yet know how to engineer the hardware to do what the physics say is possible.

Mathematician and physicist Dr. Claudio Maccone came up with an ingenious method of providing low-power, high-bandwidth communication across interstellar distances that he calls the Galactic Internet.[2] In chapter 2, I described the Solar Gravity Lens interstellar precursor mission, in which a telescope

*Granted, some might ascribe to the notion of panspermia, making a one-way trip without communications a viable option. Panspermia is the idea that life is/was/ can be transmitted through space by natural or human-made objects. An example might be a meteorite that originated on Mars landing on Earth or vice versa. Perhaps we will decide to send uncrewed ships to other star systems with the expressed purpose of seeding the planets there with biological life from Earth, obviating the need for any of the ships ever to call home.

†The signal has to cross many light-years and suffer inverse square losses along the way.

placed over 550 AU from the sun can take advantage of the focusing of light due to the sun's bending of space-time in order to image distant exoplanets. Given that light and radio are both electromagnetic waves, though with different wavelengths and frequencies, both are affected by the bending of space-time, and both should have a region in deep space where weak source signals (light reflecting from a planet in the case of optical signals or radio waves being broadcast by our spacecraft in another star system) are focused, allowing them to be more easily collected. Therefore, if a modest-size radio antenna and receiver is placed at the sun's radio frequency gravity lens focus, and our interstellar starship at the target star's comparable focus, they should be able to talk to each other *using communications technologies available today.* Let that sink in for a moment. Through clever mission design, it ought to be possible to send a spacecraft to another star, have it take pictures and movies, collect scientific data, store the collected data onboard, and then have it make way to the star's gravity focus, where it turns on a simple radio transmitter and sends the data back home. Such a system can take advantage of the bent space-time to amplify the signal so that a receiving station at the sun's gravity focus can receive the data and then relay it back to Earth without having to develop the high-power, extremely large aperture systems described previously.

Navigating on Earth today is absurdly easy for the user, but not so much for the service provider. If you want to get to another city or a house on a rural mountaintop, it can be as simple as pulling out your smartphone, entering the address, and then following a series of step-by-step directions that your favorite remote assistant calls out to you. Making it easy for the user requires a network of physical cell phone towers crisscrossing the globe and access to precise timing data from Earth-orbiting

satellites.[3] Navigating in deep space is, as one might expect, a lot more difficult.

Today's spacecraft carry some onboard navigation hardware like sun sensors, which, as their name implies, tell the spacecraft its orientation relative to the sun. Since the stars are far away and their relative positions in the sky do not vary significantly from any terrestrial or near-terrestrial viewpoint, they can be used to help a spacecraft orient itself to know if it is pointing, or flying, in the correct direction. Devices that do this are known as star trackers. Any two stars have a unique angular separation between them—there are no pair of stars with exactly that same separation. Star trackers allow the spacecraft to look at the stars, find pairs that it recognizes, and orient itself accordingly. This does not necessarily allow the spacecraft to know where it is, but knowing how it is oriented is an essential step toward finding out. If you are familiar with the constellations and were to find yourself on the moon or Mars, they would look much the same as they would appear from Earth. The wandering planets would be at different locations in the sky, but that is because they are much closer than the stars, making their apparent changes in position immediately noticeable. The change in apparent location of the stars from this different viewpoint may not be discernible to the human eye, but our cameras are sensitive enough to notice that the angle with which some stars are viewed does change at each of these locations. Sun sensors and star trackers allow a spacecraft to know where it is relative to the sun and whether it is oriented correctly: for instance, up is where up should be, and the stars that should be on the right of the ship are in fact on the right and not the left. This is all well and good, but how then does a spacecraft know *where* it is?

Radio waves travel at the speed of light. By measuring the amount of time between when a signal is broadcast and when

it is received, it is possible to calculate precisely the distance to the source of the signal. By using two or more Earth ground stations that are far apart, there will be a measurably different arrival time for the incoming radio signal received by one station versus others. This difference, along with any measurable motion-induced frequency, or Doppler shift, can be used to calculate the slightly longer or shorter distances the signal traveled, allowing the laws of trigonometry to pinpoint the location of the spacecraft. This is similar to one of the methods used by surveyors in the pre-GPS era. Before and during flight, engineers determine the spacecraft's trajectory, map its flight path relative to the locations of the planets and their moons to understand the influence of their gravity on the path to be flown, and then routinely measure the amount of time it takes for signals to reach the craft and vice versa in order to make sure it is where it is supposed to be and to correct the trajectory if it is not. This works well enough to allow landing rovers on Mars, close approaches to the dwarf planet Pluto, and at its limit, knowing where the Voyager spacecraft are located. This is all well and good for navigating in the solar system where the large communication dishes are available, but not so helpful when our interstellar spacecraft is trying to remain on course autonomously, in deep space, trillions of miles from home.

Remember that just as our planet orbits the Sun, so do all the stars of the Milky Way orbit the center of the galaxy. If our instruments are sensitive enough, and if our spacecraft has a detailed catalog of stars and their relative speeds as observed from Earth, then it should be able to figure out roughly where it is by comparing the observed locations of the stars with how they appear at Earth.

And then there are pulsars, the distant, rapidly spinning, ultra-dense leftovers of exploded stars. Each known pulsar in

the galaxy has its own characteristic x-ray emission pattern, some sending forth a burst of x-rays every few thousandths of a second, forming their own unique fingerprints. Finding the location of these known pulsars in the sky and then combining that with the data coming in from the star trackers and radio signals from Earth (as long as that is possible) should allow a spacecraft to readily determine where it is located in relation to them and to Earth. Our future intrepid explorers will not be flying anywhere near the horrific radiation expelled by pulsars, but as cosmonaut Yuri Gagarin pointed out, nature will nonetheless try to kill them in every conceivable way as they journey through space to their new home—including through radiation exposure.

Who, other than a vampire, doesn't enjoy being outside on a glorious, cloud-free, and sunny day, particularly in the spring or fall? If you enjoy it too much and don't wear appropriate clothing or sunscreen, then you may pay the price for your overindulgence with a painful sunburn. Such is the adverse effect of too much exposure to the sun's ultraviolet light—a form of radiation exposure. So, too, can a spacecraft have serious, sometimes mission-ending encounters with radiation in space. There are many forms of radiation, and many ways it can adversely affect a spacecraft.

Solar ultraviolet light, like that which causes sunburn, also causes many materials made by humans to degrade. Its effect on polymers, long-chain (large) molecules that are quite common on our everyday lives such as plastic, silicone, and nylon, is profound—the UV light causes them to become brittle and more likely to break.

High-energy protons, electrons, and alpha particles, which are streaming out from the sun in the solar wind (see chapter 1), are particularly insidious, and especially in their effects on

electronics. The incoming particle radiation collides with an atom or atoms in our spacecraft, producing new particles with less energy, creating a cascade of secondary particle radiation. Each of these new particles then interacts with the material through which it is passing, producing yet more new, albeit lower energy, particles. Eventually the cascade stops as the products of each successive interaction have less energy and are more likely to be absorbed. It is this absorption that causes damage to electronics and our spacecraft. Some of the absorbed energy becomes heat, which, if left unmanaged, can cause changes in material properties such as strength and conductivity.

Some particles ionize materials with which they interact, producing a buildup of positive or negative ions, which can cause electrical discharges and damage to sensitive electronics. (Electronics, after all, is all about moving charged particles around.) This is called *ionizing* damage, and engineers look at the lifetime of electronics in terms of how well they can function in terms of the total ionizing dose, which is cumulative, before failure. Protons, electrons, and free neutrons, which can be part of the secondary particle cascade if the energy of the incoming particle is high enough, can also implant in electronics, producing defects and changing their material properties in a process called *displacement* damage. This is another form of damage that builds up over time.

Temporary damage can also be a problem. Consider single-event upsets, which are caused by a single charged particle passing through a semiconductor material. Digital data is composed of strings of binary data, zeros and ones, which are often encoded in electronic memory or signals as either the presence or absence of a single electric unit of charge. Your data string, or computer command, is a series of charge encoded information that might look roughly like this: ++——+–++—. In a single-event upset, a charged particle interacts with the material

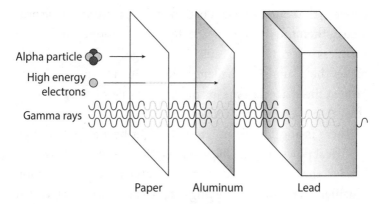

Alpha particle

High energy electrons

Gamma rays

Paper Aluminum Lead

FIGURE 7.1. Shielding from Cosmic Rays. To block radiation usually requires mass. The amount of mass is required depends upon the type of radiation to be blocked and its energy. The simplest to block are large, relatively heavy alpha particles (helium atoms) that can be stopped by a few sheets of paper. Next are beta particles (electrons), which can be efficiently stopped by a thin sheet of aluminum. Gamma rays, which are really just very energetic photons of light, can require extremely dense, therefore very heavy, blocks of lead. Adapted from "Protection against Gamma Radiation" by Nofit Amir (STEMRAD, https://stemrad.com/protection -from-radiation/). Image created by Danielle Magley.

where this string of charges is located and changes a + to a − (or vice versa), potentially changing the meaning of the data or the command. While there are mitigation techniques that can protect electronics from a few transient events without a significant impact, it is largely a game of probabilities. Given enough rolls of the dice—in this case enough protons interacting with the material—a bad outcome occurs that overcomes the mitigation approaches, causing a failure. With spacecraft exploring the solar system, there have been many instances of data errors, spacecraft resets, and outright mission failures.

The best way to protect materials and electronics from penetrating radiation like that encountered in the solar wind is to use inert mass as a shield (figure 7.1). If enough mass is placed

between the source of the radiation and the materials to be protected, then the incoming particles can be stopped and made harmless before they can cause any damage. Unfortunately, this makes the propulsion challenge more difficult—more mass to protect the spacecraft means more mass that must be accelerated. (Do not forget the rocket equation!)

There is another option, and it might be viable if enough electrical power is available—magnetic shielding. Closely related to the magnetic sail discussed in the propulsion section (chapter 6), magnetic shielding takes advantage of the fact that when a charged particle, any charged particle (electron, proton, ionized calcium ion, etc.) passes through a magnetic field, it experiences a force perpendicular to the direction in which it is moving and to the field with which it interacts. This means that a sufficiently powerful magnetic field should be able to deflect incoming cosmic rays so that they do not hit the ship and cause damage. To see this in action, consider Earth's magnetic field. Magnetic lines of force extend from the North to the South Pole and cover the entire planet in a protective blanket, diverting or trapping most of the solar wind away from the surface so that it doesn't bathe us in radiation, sterilizing the planet in the process. As solar wind ions interact with the field, some are simply reflected away, others entwine with the field's outermost reaches and stretch out behind the planet until they finally break free and continue their outward journey from the sun, and some become trapped in the field lines, bouncing back and forth between the planet's poles, producing the brilliant aurora borealis as they enter the lower atmosphere near the poles and ionize air molecules there. Unfortunately, there is a type of space particle radiation from which even the massive magnetic field of Earth cannot protect us—galactic cosmic rays (GCRs).

GCRs are highly energetic atoms that permeate space, most likely formed when stars elsewhere in the galaxy explode. Unlike solar radiation, which is primarily composed of hydrogen and helium atoms, a galactic cosmic ray can be formed of just about any element in the periodic table, and they move at incredibly high speeds, near the speed of light, allowing them to interact with and penetrate just about any shielding we can envision for a ship that has to watch its weight. Given their relatively higher masses, GCRs can do a lot more damage than a proton or alpha particle as they pass through. These are the ones to worry about in the long term, especially when the ship contains people, as will be discussed later.

To top it all off, when a spacecraft is traveling at 10 percent the speed of light and encounters a relatively slow-moving atom of hydrogen, helium, or any other element, the relative speed between the fast-moving ship and the slow-moving particle is still 10 percent the speed of light, making the hydrogen atom act as if it were traveling at 10 percent the speed of light relative to the ship, thereby becoming just another high-energy particle capable of doing the damage listed above. This adds to the total radiation problem that must be dealt with.

Finally, there is the challenge of building something that must continue operating for hundreds of years in what is likely to be the most hostile environment anyone will ever have to build a machine to operate in. The key to any machine's long-term operation lies in the inherent reliability of its parts and in redundancy. Parts and systems can be designed and manufactured for reliability, but there are few examples of machines operating continuously for over a hundred years without any sort of human intervention. It can be done, but it will likely be expensive. Since no system can be made foolproof and unable to fail, the critical spacecraft systems should be redundant. In

practice, this means either flying two copies of a system or component so that one is ready to activate should the primary experience a failure, or by having another, entirely different component or system that can assume the role of another that fails. Of course, incorporating redundancy likely adds mass, which exacerbates the propulsion problem.

Redundancy does not always mean flying two copies of something, though it often does. For example, Voyagers 1 and 2 were identical spacecraft, each capable of carrying out the mission independently of the other. If one of them failed, most of the scientific data would still have been returned by the other. Building two copies of each spacecraft can quickly become an expensive proposition. It is better to think of a redundant system as one that can do its job using multiple independent pathways. Redundant systems or components can be identical or similar, be activated automatically in the event the primary system fails, and be in different parts of the ship in case a catastrophic event damages one part and not another. When it can be afforded, spacecraft designers try to incorporate redundancy into a spacecraft to increase the likelihood of mission success, especially on ships carrying human crew. Studies show that this redundancy has saved the crew or extended their missions on almost every flight.[4] Consider Apollo 13. Without the redundant and available lunar module for the crew to occupy for part of their return flight from the moon after their catastrophic accident, the crew would likely have perished.

Sending to another star a relatively small, robotic spacecraft with a mass somewhere between that of a raisin and a large automobile is a big challenge; sending a 30,000,000 kg to 100,000,000 kg ship (not counting the propulsion system or its fuel) filled with settlers takes it to another level. Not to say that it cannot be accomplished—nature most emphatically says

that it can—but making it happen will just be that much more difficult.

First, a discussion of what the crewed starship, commonly called a worldship, might be like. No organization in the world has given more thought to the potential design of an interstellar worldship than the British Interplanetary Society, which has sponsored multiple symposia and devoted several issues of its peer-reviewed journal to the topic. In a recent paper published there, Andreas Hein and his coauthors established a useful categorization to describe the size of a worldship based on the performance of the available propulsion system.[5] I will adopt their nomenclature with slight modification and use it here. The first category of ships are called sprinters and would carry a crew of one thousand or fewer. The reasoning is clear: if a ship can travel extremely fast across interstellar space, faster than 10 percent the speed of light (0.1 c), then it would be safe to assume other ships could soon follow and a single ship would not have to assume the burden of taking everything needed to establish an extraterrestrial settlement, specifically thinking of the number of people who would have to be aboard to maintain genetic diversity as the founding population. A smaller crew translates into lower mass to keep them alive during the journey, less stringent ship design life requirements, and less redundancy—all making the propulsion problem (among others) much easier.

The next category, ships carrying between 1,000 and 100,000 people and traveling slower than 0.1 c, are called *colony ships*—a rather unfortunate term with considerable negative connotations in many parts of the world where entire peoples suffered under imperialism and colonialism. For this reason, I will refer to this class of starships as *settlement ships* and assume that the worlds to which the settlers are bound are uninhabited. Settlement ships

are much larger, take longer to reach their destination, and must carry much more mass (as supplies, spares, etc.). Given that they will likely also take longer than a human lifetime to reach their destination, there must be careful consideration given to the social, political, and economic systems in which the crew live out their lives.

Finally, there are the true *worldships* that take large populations (more than 100,000 people) and require centuries or millennia to cross the void between the stars. These behemoths could be constructs that resemble much larger versions of the sprinter and settlement ships or something that more closely resembles a planetary moon or an entire planet. They are, after all, called worldships for a reason—they would function as entire worlds and not necessarily resemble a ship of any kind.

Since this is a book about interstellar travel, not worldship design options, the discussion will primarily focus on settlement ships for one primary reason: the propulsion problem. There are not many options known to physics that will allow ships of any significant size to travel at speeds greater than 0.1 c. Since the logistics and solar system-wide commitment to building a true worldship seems, to be honest, science fictional, the middle category, settlement ships, seems the most reasonable and possible.

The technical challenges for building a crewed starship include all those that were required for robotic spacecraft (only on a much larger scale) plus all that will be required to keep rather fragile and squishy people alive and healthy.

Not all the propulsion systems available for robotic interstellar exploration scale well to ships of this size. For the first settlement ships, solar, laser, and microwave sails are unlikely options. First, photon pressure is small, and accelerating a 30,000,000 kg starship using it would require input power with so many zeros

after it as to make it nearly incomprehensible. Yes, future engineers might be able to build sails that are a single atomic layer thick, with diameters of the moon, and accelerate them with lasers or microwave beams that tap a significant fraction of the sun's radiant energy, so no one should ever say that it is impossible—physics certainly does not rule it out. Beamed energy, as promising as it is for robotic exploration, just does not pass the "reality test" for this class of starship.

If there is an efficient onboard power system, the photon drive would be an option. Granted, it has a worse problem than beamed energy propulsion because each photon produces only half as much thrust if it is simply emitted versus reflected, but the whole beamer and reflector problem goes away. The photon thruster and power system that drive it will be collocated on the ship.

Fusion propulsion has the energy density and scalability to enable this class of mission to nearby stars; it should be a matter simply of reactor size and available propellant. The propellant mass problem gets better if the Bussard ramjet can be made to work efficiently, since the ship would be able to supplement its onboard fuel supply as it traverses between the stars, scooping up errant hydrogen atoms along the way.

For a relatively fast trip to a nearby star, nuclear pulse propulsion makes a lot of sense. Given that the ship must already be large and massive enough to survive hundreds of nuclear detonations to propel it, envisioning a 30,000,000 kg starship being bumped to Alpha Centauri at 0.03 c is not that big a leap—it is this type of ship that an Orion propulsion system excels (at least in theory) in propelling. For traveling to stars farther away, the approximate upper limit velocity of 0.03 c becomes problematic, extending trip times.

Antimatter propulsion is probably most scalable given its efficiency and the universal availability of half of the mass

required to initiate a reaction—normal matter. The antimatter creation and storage problems are inherently no different than for a robotic ship, just a matter of scale. If anyone has an idea of how to increase global antimatter production from fractions of fractions of a gram to metric tons, then please let someone know!

The good news is that powering a larger ship for comparable periods of time is also mostly a matter of scale. Both fission and fusion power are inherently scalable, meaning that the same basic designs can be made larger and longer-lived, and can likely be designed to operate safely for the duration, provided there is enough nuclear fuel available. Having the energy density to propel a ship at high speeds is a vastly different thing from being able to continuously generate gigawatts of electrical power, with the latter being much easier than the former. Both should be considered.

Communication between the ship and Earth will be more demanding on a ship with crew than without. People aboard ship will inevitably want to remain in touch with loved ones and friends back home as they travel, so frequent, high-bandwidth communication available to thousands of people needs to be readily available. This will increase the onboard power requirements and the size of the apertures used. Neither should require breakthrough discoveries beyond what will be required to provide interstellar communication to our robotic probes.

For ships carrying people, there are no significant differences in the navigation requirements. The only difference between the robotic and crewed case is that the lives will rely on precise navigation in the latter.

Protecting human life from the effects of radiation for long periods of time will be a huge challenge. There is no magic bullet in physics for providing such protection and, so far at least,

mass seems to be the best approach. As discussed previously, not even a magnetic field as large as Earth's can stop galactic cosmic rays, but enough mass can. While perhaps untenable for the more mass constrained robotic probes, ships carrying people are already going to be massive, so why not pile on and add more?

Yes, some atoms provide better shielding than others, with hydrogen being among the best at it, but the differences are mere factors, not orders of magnitude. Hydrogen: the same hydrogen that our propulsion system might use as fuel, that our onboard fusion power system needs to operate, and that humans need for survival, because, when combined with oxygen, it forms water. Here nature may have given us a break. A starship fully stocked with hydrogen might be able to use the same hydrogen for many different applications during the journey. Big tanks of water could surround the ship to provide radiation protection and be drained along the way for use by the crew in drinking, eating, and cooking and then be recycled back into water by collecting the humidity the crew generates (through exhalation) and their waste, in much the same way the International Space Station (ISS) does now. The same water could be converted to its elemental constituents, hydrogen and oxygen, by passing an electrical current through it in a process known as electrolysis. The oxygen could be used to replenish the atmospheric oxygen required by the crew and the hydrogen channeled to the power or propulsion system, as the case may be. How much water would be needed to provide shielding? A lot. Perhaps as much as 90 percent of the entire habitat mass might need to be shielding to protect the crew.

The average human breathes in about 2 gallons of air each *minute*.[6] Multiply that by thousands of living, breathing settlers and you get an exceptionally large number. Then there's water.

The average American uses 300 gallons of water per day;[7] the average European 38 gallons;[8] the average astronaut aboard the ISS 3 gallons.[9] Again, do the math to see what will be required in water for our crew and passengers. How can this need be met?

Amazingly, this is one area in which our space technology has excelled. The ISS uses what is called an Environmental Control and Life Support System (ECLSS) that recycles nearly 100 percent of moisture in the air and 85 percent of the water in urine, resulting in a net overall water recovery efficiency of about 93 percent. Given the improvements that will be required in other technological areas, being 93 percent of the way there today sounds rather good. Air recycling has a bit farther to go. The ISS is less than 50 percent efficient in reusing consumed oxygen.

A great deal of effort has gone into improving agricultural efficiency on the ground, to feed the billions right here on planet Earth, and in space. While challenges remain, there don't appear to be any fundamental problems with plant growth in space, so the limiting factor may be, as it is on Earth, crop yield in the space allocated and with the use of available resources (air, water, nutrients, etc.).[10]

We will save the discussion of suspended animation and cryosleep, favorite tropes of science fiction, for chapter 8, "Scientific Speculation and Science Fiction."

People are not designed to live in low gravity, and its effects on space travelers are well documented. When many people first enter zero or micro-gravity, they experience dizziness, disorientation, nausea, and vomiting. The human body's neurovestibular system, coupled with our other senses such as sight and sound, help us maintain our balance, know "up" from "down," assess how fast we are traveling, and allow us to compete in

sports activities that require flawless integration of all these systems to excel such as tightrope walking, ballet, and ice skating. The vestibular system is a key part of this, and the lack of gravity in deep space messes with it in a big way. Within a person's inner ear are the otolith organs that contain small hairs and fluid. As your body accelerates or changes orientation, these hairs and the fluid that surrounds them move, sending information to your brain about what they are sensing and allowing you to perceive the motion and compensate for it as needed (by leaning forward, repositioning your head, etc.). Gravity acts to stabilize the otoliths—like a pendulum moves only in a prescribed arc, gravity keeps the otoliths oriented consistently. In space, they no longer have gravity and gravity-related inertia to stabilize them, and they begin "floating around," as does the overall body, sending rapidly conflicting sensory data to the brain, causing disorientation and, often, the inevitable nausea that accompanies it. Fortunately, over time, most people adapt to the changed sensory input and can function just fine. Some never quite get over it.* Fortunately, the effect is usually temporary.

While in space, gravity no longer acts to pull many of the body's fluids toward our feet, and the fluids redistribute themselves around the body, which is why many astronauts have noticeably puffy cheeks, like chipmunks, soon after arriving in space. This tricks the body into thinking that there is too much

*There is an apocryphal story in the space community that resulted in an unofficial and highly informal assessment tool, the Garn Scale, that describes the degree of space sickness an astronaut experiences, with a higher Garn number representing being more stricken. The scale was developed after US Senator Jake Garn flew on a Space Shuttle mission in 1985 and developed the worst case of space sickness ever recorded; subsequent cases are then measured as fractions of a Garn. Though Senator Garn no doubt hoped to be remembered for his achievements, I suspect this is one he did not envision.

fluid (why is all that fluid around my upper chest and neck?), and it acts to get rid of the (supposed) excess by, among other things, increasing urine output. This typically results in ~20 percent loss of blood volume. At the same time, the heart has to work less against gravity, and there is not as much return flow from the lower body. (When you walk, your leg muscles help pump blood from the legs back up to the heart. In space, there is no walking and therefore no extra pumping.) Taken together, this results in a weakening of the heart muscles. With less blood to pump, the muscles are exercised less, and blood pressure drops. The lower blood volume and pressure is mostly of concern when the person reenters gravity, which tends to pull body fluids, and blood in particular, generally toward the lower body and away from the head, which can cause dizziness and, worst case, fainting. This is *not* what you want happening to your pilot when flying back to Earth or toward the surface of another world.

Losses of bone strength and muscle mass are additional problems that are not so temporary and much more threatening. Astronauts tend to lose about 1 percent of their bone mass each month they spend without Earth-normal gravity. Bones need to be stressed to maintain their strength, which is closely correlated with the bone's mass. The required stress is easily achieved on Earth by simply walking, running, and the activities of daily life *in the presence of Earth gravity*. Without the gravity tugging your body back down with each step, which is really felt as a small impact that compresses the bone, the bone will lose mass and strength. My cell phone fitness tracker tells me that I usually get between 6,000 and 11,000 steps each day. That's 6,000–11,000 impact events, each helping to maintain my bones. Astronauts get none of this without carefully scripted exercise routines, using specially designed equipment, that still don't

quite mimic what is needed. When bones get weak, they are more likely to break—just ask any senior citizen who suffers from osteoporosis, a similar phenomenon that results from aging and lack of exercise and impact, not from lack of gravity.

So, too, astronauts lose muscle mass. This is easy to understand when you consider that though astronauts still have mass in space, they have no weight. Weight is the result of gravity acting on mass. In the absence of gravity, there is no weight. Again, looking at the average person's daily life, we use our muscles to lift weights all the time. The simple act of getting out of bed in the morning exercises our leg muscles. Brushing your teeth engages your arms and, unless you are sitting, your legs, as you take data from your vestibular system to maintain your posture. For that matter, lifting anything stresses and strengthens the muscles used to do so, with more massive—and on Earth therefore heavier—objects stressing them more. In space these common muscle stresses are largely absent and the muscles decay, with as much as 20 percent of muscle mass being lost in the first eleven or so days of space flight. Fortunately, maintaining muscle mass in zero gravity can be accomplished by means of rigorous exercise, and astronauts on the ISS exercise as much as 2.5 hours *each day* to mitigate the loss of mass.

Unmitigated and taken together, muscle mass loss and bone density/strength declines could be catastrophic to astronauts or our interstellar settlers when they first set foot on another world after decades or centuries of deep space flight. They would be more likely not only to clumsily fall as they begin to walk on the surface of an alien world due to muscle mass loss and neurovestibular adjustment to planetary gravity, but also to break a bone if they do fall. Ouch! Clearly, the design of a crewed ship must somehow mitigate these side effects of space travel.

If we "think big," which by now should be taken as a theme associated with interstellar travel in general, then there are solutions. Consider gravity and how you feel its effects. Now think about the last time you punched the gas pedal in your car, experienced an aircraft accelerating down the runway to take off, or rode in an elevator—in each case, the acceleration you experienced, except for its duration, felt just like gravity. That's because gravity is what we call the effects of being accelerated. On Earth, the acceleration we feel is caused by the planet's mass pulling on us. In the other examples, it is due to a change in velocity. The effects are the same. Once we realize this, then we can envision large, spinning habitats that mimic the acceleration of gravity through spin and allow the human body to experience the bone-compression forces needed to maintain bone strength and mass as well as the muscle engagement needed to move the objects that also have mass, and now weight.

There are bound to be other long-term effects that have yet to be uncovered due to the limited amount of time astronauts have been in space. To date, no one has spent more than 438 days in space, a record held by Russian cosmonaut Valery Polyako in 1995–96.[11]

Jim Beall, a former nuclear engineer with over forty-five years of experience in the nuclear industry, wrote a delightful tongue-in-cheek essay/short story on the topic of interstellar worldship reliability called "Our Worldship Broke."[12] In subsequent conversations with Jim and given the similarities between the design requirements of a nuclear power plant and a worldship (both must operate safely, with no failures, for exceedingly long periods of time), I asked him his number one recommendation regarding the construction of a worldship. His answer spoke volumes: "redundancy, redundancy, redundancy."

While this is certainly apropos, and brought a smile to my face, it poses challenges for a spaceship that is inherently mass limited. Adding multiple backup systems for nuclear plants on Earth where its overall size and mass is a secondary concern is quite different from a spaceship where every added pound in redundancy adds many extra pounds of propellant required to accelerate it. In addition to critical system redundancy, there has to be a better way.

Enter additive manufacturing, or 3D printing. Simply put, traditional manufacturing of complex hardware usually involves the separate construction of all its piece parts and components, each designed and manufactured with strict interface requirements so they will all fit together and function when assembled. This is traditionally how cars, refrigerators, computers, and even rocket engines are built. Each component has its own unique manufacturing facility, specifically designed to build that one part. When the industrial base—all the manufacturing plants making the various parts—is considered in total, it is enormous. It was (and the operative term is in the past tense) considered inevitable that long-duration human spaceflight would require carrying many spare parts for critical machinery. After all, if you are on your way to Mars and something breaks, you will not have access to the industrial base that made the part to get a replacement. This thinking has now changed because of the 3D printer.

A 3D printer uses a detailed computer model to join a diverse set of raw materials, layer upon layer, into whatever part might be needed. Like many new technologies, 3D printers came onto the scene in a simple and limited form, using easily malleable plastic (available in many colors!). They could make interesting baubles and nonfunctional models that helped engineers design parts for form and fit, not necessarily function. As the

technology matured, so did its sophistication. Much more complex systems are now being built additively, expanding their use to the point that some are predicting the demise of many big-box hardware retailers in favor of one-stop additive manufacturing sites that build from scratch whatever part is needed "while you wait." Most relevant to interstellar travel, NASA is embracing the technology to obviate the need for spares on the International Space Station (ISS) and future lunar and Mars bases. In 2014, NASA sent its first 3D printer to the ISS. When the history of the first self-sustaining off-Earth settlement is written, there will undoubtedly be two technologies credited with making it possible. The first will be the rocket. The second will be additive manufacturing. A future worldship will undoubtedly carry the technological descendant of our current 3D printers to fabricate or replace just about any part they might need during the voyage, using only the mass of raw materials carried aboard ship.

That's it.

We've discussed at a high level almost all of the major topics and technical requirements for travel to another star, limited only by our current understanding of physics and the creativity of the human mind in our (future) engineering. But what if we don't know as much as we think we do about how the universe works? In this case, there is no better place to consider "what if" than science fiction. Science fiction sometimes comes close to future reality, sometimes not. Let's now dream a little and see what might be possible should our theories turn out some way (or some day) to be real.

8

Scientific Speculation and Science Fiction

I don't think the human race will survive the next 1,000 years,
unless we spread into space. There are too many accidents that
can befall life on a single planet. But I'm an optimist. We will
reach out to the stars.

—STEPHEN HAWKING, FROM AN INTERVIEW
WITH THE *DAILY TELEGRAPH*

Since before the launch of Sputnik, heralding the beginning of
the Space Age, science fiction writers were speculating on how
humans might make the journey to another star and were not
shy about creating fictional star drives that were loosely based
on recent scientific breakthroughs (fiction based on real sci-
ence) or those that might, perhaps, become a reality in the
future (fictional science). Both permeate the genre we know as
science fiction, and it is difficult for the lay reader to distinguish
between the two. Boarding the Starship *Enterprise* and engaging

the antimatter-powered (possible) warp drive (probably not possible) to cross light-years in hours or days builds unrealistic expectations that such things are, or will soon be, possible. The pace of technological development and space exploration has not met public expectations, despite the tremendous progress that has been made and the significant achievements of space science and exploration accomplished in just over a half century of spaceflight. *Star Trek* is not alone in mixing reality with fanciful speculation; it is just among the most widely viewed and culturally well known representation.

As a physicist and a student of the history of science, I will not say that all the speculative physics found in science fiction and associated wishful thinking about bypassing the laws of nature are impossible or unscientific. Many well-meaning and highly accomplished scientists in past eras made similar assertions and were later proven incorrect by new theories, experiments, and observational data. Further, we currently have a standard model for the macroscopic world (general relativity) and a standard model for the microscopic world (quantum mechanics) that are considered incompatible—meaning there is likely an as-yet-to-be-discovered more generalized understanding of the natural world. Just as quantum mechanics and general relativity jointly gave us GPS so we can use our cell phones to navigate to a new destination, what technologies might a more complete understanding of nature provide? There is room for new ideas, but they must be articulated and grounded in the rigor and mathematics of physics. With that said, I will, however, provide an assessment of the reality of the various science fictional elements on a case-by-case basis based on our current understanding of nature.

Traveling Faster than Light
(Warping Space-time)

The warp drive on the Starship *Enterprise* is perhaps the most well known science fictional space drive in the world. When using it, the heroes gallivant across the known universe quickly and easily to visit strange new worlds and boldly go where no . . . You probably know the rest, and there will not be a discussion of which series is the best.* When engaging the warp drive, a ship does not leave the universe as it does in hyperdrive (discussed later), but rather uses tremendous energies to change the shape of space-time, allowing the ship to cross normal, albeit warped/compressed/expanded space very quickly. How quickly? To answer that question, the creators of the series have published several guidebooks for series writers to use so that the episodes and books set in the *Star Trek* universe are consistent. In one of the editions, the writers' guide explains that each warp factor (whole numbers, beginning with 1) is a multiple of the speed of light cubed. By this definition, warp 1 ($1 \times 1 \times 1 \times$ speed of light) is simply the speed of light, warp 2 is eight times the speed of light ($2 \times 2 \times 2 \times$ speed of light), warp 3 is twenty-seven times the speed of light ($3 \times 3 \times 3 \times$ speed of light), and so on. You get the idea. Pretty soon, you're crossing from star to star in not much time at all. Not leaving our normal universe to travel through it gets around the messy problem of creating new universes, while still leaving the elephant in the room—can it be

*Of course, I will express my opinion. The original *Star Trek* series was certainly the best and most influential. Countless peers of my generation who work in the aerospace field credit their interest in science, engineering, and space exploration to the exploits of Captain Kirk, Mr. Spock, and the rest of the original crew of the *Enterprise*.

done? The answer is a resounding "maybe," if you are willing to posit the existence of states of matter that have never been seen and may not exist. Enter the Alcubierre warp drive.

Physicist Miguel Alcubierre looked at Einstein's Theory of General Relativity and found another solution to the equations that works mathematically and would allow a starship to appear to be traveling faster than light, while not really doing so. In this theoretical model, the starship forces the space-time in front of the ship to contract while simultaneously expanding space-time behind it (figure 8.1) By shortening the distance to be covered (the contracted space-time in front of the ship), a slower-than-light ship could easily cross vast distances without ever exceeding the local speed of light. After the ship crosses the contracted space-time, it expands back to normal size behind the ship, leaving nature beautifully intact and space-time undisturbed, with the ship appearing to move much faster than light.[1] Pretty cool. So, what's the catch?

The catch is that mathematics is not physics. Yes, math can do a wonderful job describing the way the universe works. But there are many mathematical formulas that are completely self-consistent, logically correct in every way, and in no way correspond to how the universe actually works. Theoretical physicists postulate "what if?" theories all the time, and only after the theory is proven to predict how nature actually works, through experiment or observation, does it move from pure math into physics. In the case of the Alcubierre warp drive, the unproven creation is negative mass or "exotic" matter. What is negative mass? It is not antimatter, which is simply matter that, among other things, has an opposite charge from its normal matter cousin. Antimatter exists and was discussed previously. Negative mass would be mass whose fundamental measuring unit would be −1 kg. No one knows what that really means, nor has

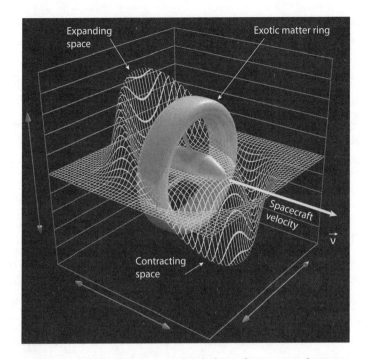

FIGURE 8.1. Alcubierre's Warp Drive. In the Alcubierre drive concept, the spacetime in front of the ship contracts while the spacetime behind expands, causing the spaceship to be simultaneously pushed (by the expanding spacetime behind) and pulled (by the contracting spacetime in front), allowing the ship to travel faster than the local speed of light. Image courtesy of Dr. Sonny White.

anyone ever found or created such mass. Remembering Einstein and the relationship between matter and energy, one could also look for negative energy and, if it were to be found, then it might be possible to convert it into analogous negative matter. Though there have been some interesting findings, negative energy has not yet been confirmed to exist either.[2]

As discussed in Alcubierre's seminal paper detailing the mathematics of how a warp drive might work, quantum mechanics (remember—the standard model for the microscopic

realm) provides a mechanism to manifest something known as negative vacuum energy density by means of the Casimir effect (more on that later). This negative vacuum energy density just so happens to have all the mathematical characteristics of exotic matter as described by general relativity (the standard model for the macroscopic realm). That said, there are still several other challenges/obstacles to address before the idea of a space warp could be considered possible in physical reality.

Traveling Faster than Light (Hyperspace)

The "other" superfamous star drive in science fiction is the hyperspace drive on the Millennium Falcon. Fortunately for us, the creators of *Star Wars* define how the hyperdrive works so we don't have to figure it out ourselves: "Hyperdrives allow starships to travel faster than the speed of light, crossing space through the alternate dimension of hyperspace. Large objects in normal space cast 'mass shadows' in hyperspace, so hyperspace jumps must be precisely calculated to avoid collisions."[3]

Are there alternate dimensions that we might someday access for such purposes? Scientists may not know much about "alternate" dimensions, but they do theorize that reality has more than the standard three (plus time) in which we live. The existence of additional dimensions is a significant part of string theory, one of the leading candidates for a Theory of Everything that physicists have been seeking since the time of Newton. In the many incarnations of string theory, most of these hypothetical dimensions are extremely small, smaller than the most fundamental particles known (smaller than quarks, electrons, and neutrinos). There is not simply one string theory; there are instead many, competing theories that use similar mathematical and theoretical constructs, and many of them hypothesize a

different number of space-time dimensions: M-theory requires eleven, superstring theory has ten, and bosonic theory has twenty-six. How small are these dimensions? Some are as small as 10^{-35} meters, called the Planck length. The small dimensions of string theory are not likely candidates to access if we want to cross vast interstellar distances.

On the upper end of the string theory scale, there is emerging a belief that our 3D+1 universe is a subset of a higher dimensional universe, in a way analogous to the 2D creatures in Edwin A. Abbott's *Flatland: A Romance of Many Dimensions*.* If one is willing to set aside the requirement for evidence, otherwise known as proof, that such a higher-dimensional universe exists, then speculatively tapping into it for our hyperspace travel is not outlandish. Of course, the mechanisms by which a starship accesses and traverses it are never described because no one knows or even has a clue.

The creative energy behind *Star Wars* uses hyperspace to solve another of the technical challenges of interstellar travel—communications. In the real universe, sending a radio message back to Earth from 100 light-years away would take, well, 100 years since the radio wave or laser signal is constrained to move at the speed of light. To allow the emperor to have real-time, back-and-forth chat with his minions a few hundred light-years away, hypertransceivers (also called a subspace radio, not to be confused with the radio of a similar name in the *Star Trek* universe) are used. The signals from the radio somehow go

*This is a delightful book published in 1884 that describes a 2D world occupied by geometric figures. Men are polygons of various kinds and women are line segments. Their simple, easily understandable world is suddenly rocked by the appearance (passing through) of a 3D sphere, and their attempts to understand it based on their ability to perceive only its 2D aspects are humorous and thought-provoking. I highly recommend the book.

from the universe in which we live through the higher-dimensional universe to their destination, then are brought back to the universe we know and love, where they can be heard. Other best-selling science fiction series use variations of travel through other dimensions to facilitate their plots. In author Larry Niven's Known Space series, which includes his novel *Ringworld*, ships access hyperspace where all objects move at rates faster than light at rates ranging from one light-year every three days to one light-year in seventy-five seconds. The Babylon 5 series created another variation of hyperspace travel that, at least initially, requires an external gate to provide access. Hyperspace, once entered, acts like other science-fictional versions in that it shortens the distance to be traveled, allowing the ship's normal-space propulsion system to cover vast normal-dimension distances much more quickly.

Traveling Faster than Light (Jump Drive)

The best faster-than-light drive is one that works to instantaneously transport someone or something from Point A to Point B, many light-years away, instantly, without any time lapse. Do you want to visit the star Wolf 359? *Click*, and you are there. This type of drive is used in many science fiction novels and series. My introduction to this type of space drive was with the German-language Perry Rhodan series that began publication in the early 1960s and was published in English by Ace Books. In the Perry Rhodan universe, not much effort is spent describing how it works, other than saying ships use a mysterious fifth dimension to manipulate the passage of time and allow the voyage to occur with zero measured time lag. Many notable movies and television shows use this approach, including *Battlestar*

Galactica. There really is not much of scientific connection to this approach; it is, at its core, wishful thinking.

Traveling Faster than Light
(Traversable Wormholes)

What respectable book about interstellar travel would be complete without mentioning black holes and their cousins, wormholes? Chapter 2 contains an introduction to the bending of space-time as described and successfully predicted by Einstein's General Theory of Relativity. A black hole is simply the extension of space-time bending taken to its logical extreme. Black holes form in regions of space-time where an object is massive enough to bend space-time so strongly that nothing, not even light, can escape. They form in many ways; a common one being after a massive star, much larger than our sun, runs out of nuclear fuel sufficient to keep its mass from pulling its constituent atoms closer and closer together, until finally they are packed so densely that their gravity bends space-time back on itself and forms the hole. Their event horizon is the boundary around its outer edge, past which light cannot escape. The inner region of a black hole, where the mass that created the bent space-time is located, is known as its singularity.

As if black holes were not jaw-droppingly interesting in their own right, some theoretical possibilities emerge in the math of the General Relativity equations that some say might enable future interstellar travelers to enter one in one region of the universe and emerge from either another black hole, or a white hole, somewhere else traversing through a "wormhole" that connects them (figure 8.2). White holes would have the opposite property of black holes in that they would emit energy and

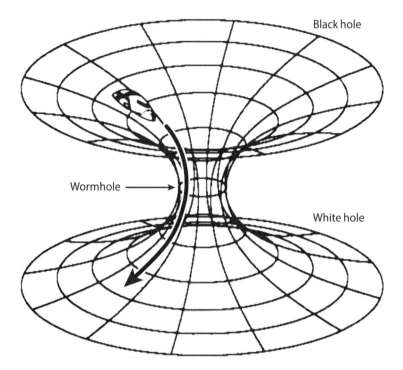

Black hole

Wormhole

White hole

FIGURE 8.2. Travel by Wormhole. This artist concept shows the simplicity (in theory!) of a traversable wormhole. A spacecraft simply enters a black hole at some point in space-time and emerges from a white hole someplace else, as the two are joined by a traversable wormhole tunneling through space-time from one location to the other. Image created by Danielle Magley.

allow nothing to enter. Do they exist? If so, then to have the properties required, they would have to be made of exotic matter like the negative mass required to enable an Alcubierre warp drive. The other theoretical method of wormhole creation was derived by none other than Albert Einstein and collaborator Nathan Rosen, who found that two black holes might connect to each other across space-time. These wormhole connections are often called Einstein-Rosen bridges in science fiction. Of course, if they exist, then there are the (more than) slight

problems of having your starship be ripped apart by the gravitational forces that would occur when entering the black hole to use the bridge. To find and enter such an Einstein-Rosen bridge would require a ship that can already travel interstellar distances, because there are no black holes anywhere near our solar system. But these quibbles don't deter the creators of science fiction.

In the *Stargate* universe of movies and television series, an ancient civilization created a network of traversable wormholes accessible through a portal, or stargate. Of course, to make this work, the ancient civilization would have had to be able to create, isolate, and sustain artificial black holes, which, of course, no one has any idea of how to do. Perhaps the most famous cinematic versions of traversable wormholes were in *Contact*, based on Carl Sagan's novel of the same name, and Christopher Nolan's movie *Interstellar*.

Traveling Slower than Light

Absent a revolution in our understanding of physics and fantastic subsequent technological advancement, reaching the stars with people will require traveling at speeds slower, in the case of crewed space travel, much slower than light. This is where depictions of worldships have prospered in science fiction, particularly in the literature.* Hearkening back to the discussion of crewed interstellar starships from chapter 7, a worldship would

*I suspect the reason we have not seen more on-screen depictions of worldships is the pacing of a story. Zipping from one world to the next, encountering this and that threat within the limited time available for onscreen viewing, albeit on television or at the movies, is much more suited for the medium than the one-day-at-a-time approach that would be necessary for a more realistic portrayal.

contain thousands of inhabitants, each living out their life in a world made to resemble the biosphere of Earth (or elements of it), probably loving, losing, crying, and celebrating life much as humans do on Earth but in an artificial construct roaming between the stars toward a new home somewhere else.

My personal conception of what a worldship might look like came from Arthur C. Clarke's *Rendezvous with Rama*, and it was not a ship filled with humans. Clarke told the story of a mysterious and huge (20 km × 50 km) cylindrical alien ship entering the solar system on a trajectory that would not allow it to be captured by the sun, so it would simply pass through the system rapidly—yet not so fast that enterprising humans on Earth could not launch a ship to rendezvous with it and explore. Once there, the humans find a totally alien world that appears to have been inert before entering the solar system and that is slowly coming to life as it nears the warmth of the sun. Clarke's description of what appear to be vast, empty alien cities within the ship haunts me to this day, forty years after I first read it. What about human-created worldships?

One of the most influential depictions of a worldship in science fiction came from Robert Heinlein in stories stitched together for his book *Orphans of the Sky*. Heinlein used the backdrop of a worldship in which the people aboard had mostly forgotten they were in an artificial construct and culturally evolved (devolved) into a sort of superstitious feudal culture, reminding the reader that when our technology is ripped away, we humans are not fundamentally different today than we were during the so-called Dark Ages, when superstition was universal and the scientific method unknown. Of course, the reader has to put up with a bit of ridiculous (in hindsight) radiation-created mutants and other science/engineering missed guesses that were not the author's fault—the contents of the book were

mostly written before we knew much at all about space travel and the real effects of radiation on living organisms.

One of the best modern depictions of life aboard a worldship came from Gene Wolfe in his Long Sun series. Once again, the protagonists are living in a worldship culture that has forgotten its origins, purpose, and destination. Aboard ship, mythologies have taken hold, and Wolfe does an excellent job creating not only another world but an entirely new culture that is both fascinating and sad.

While not a worldship, the starship (which was also not really a starship) in the SYFY Channel's *Ascension* is compelling and plausible. The first-layer story revolves around the crew of a smallish interstellar spacecraft that looks and feels like a spacecraft and not a worldship, with a crew much smaller than the >10,000 number discussed previously. The ship is bound for Proxima Centauri from Earth, having been launched at the height of the Cold War in the early 1960s. Using the Cold War-like Project Orion propulsion, the ship was ostensibly launched as a sort of ark to preserve the human species in case the Cold War turned hot. The true story of the ship and its crew is something else entirely, which I will not reveal here. The show realistically portrays what an interstellar voyage launched in 1963 might have been like from a modern-day perspective. My only quibble with the depiction is the lack of claustrophobia among the crew. Being locked in a hotel for a lifetime, not matter how nice it might be, would make me extremely claustrophobic, and it would have been nice for the show creators to find a creative way to convey that sense among the crew.

I really need to give a nod here to one of the most enjoyable big-screen depictions of interstellar travel in recent years—*Passengers*. To watch a movie about interstellar travel, I have to turn off the scientist part of the brain and convince myself that

I am there to be entertained, not educated. I could not enjoy any science fiction film if I did not have the ability to do this. Having consulted on a few, I understand why: directors, even those who desire to be as technically realistic as possible, tell their technical consultants that realism will always be sacrificed for the sake of story.* I am sure this happened many times in *Passengers*, and that's okay. The movie is a love story set on a hibernation ship bound for a star system over one hundred years of travel away from Earth. The crew and passengers of the ship are in hibernation, the kind where you don't age, and are supposed to remain that way for most of the journey so that they can awaken and have their day of arrival seem like the day after they went to sleep. Except something goes wrong and two passengers awaken far too early and, after saving the ship, fall in love. It works.

Finally, a shout-out to the *Alien* movie franchise. The ships and crews depicted in *Alien* are not settlers bound for a new world to settle; they are employees of an unscrupulous corporation and tricked into an extremely dangerous situation in the corporation's search for endless profits. The series has all the elements of potential and realistic future interstellar starships, including a slower-than-light drive, the need to monitor and ration limited onboard supplies, a nod to the complexity of the highly efficient recycling systems any such ships would need, hibernation, and a gritty realism that conveys the mechanical aspects of such journeys, their risks, and the unpredictable human element so wonderfully mirrored by the ship's humanlike

*I was the technical consultant for the movies *Lost in Space*, *Solis*, and *Europa Report*. In each case, when I objected to a scene that was simply unbelievable or physically impossible, the directors listened to my objections and then did what they wanted to do. Such is the life of a technical consultant.

android. And, of course, the thrill of the malevolent alien they encounter and fight.

Speculations on Space Drives

Where better than the science fiction section to discuss speculative science theories that sound like they are based on real science and have some of the mathematical rigors associated with real science, but are actually just conjecture? Some have already been discussed, like the Alcubierre, warp, hyperspace, and jump drives, but others have not, like the EmDrive and those that tap the "quantum energy of the vacuum," to name only two.

Most space propulsion schemes, however advanced they may be, typically consist of an onboard propellant source stored in a tank and the propellant being accelerated by some means through a propulsion system to impart momentum to the attached spacecraft. But what if one could generate a force on the spacecraft without using an onboard propellant? One must proceed carefully when thinking about this question, as there are some critical conservation laws (energy/momentum) to be mindful of when wading through the details—a number of space drive schemes have run afoul of these well-known laws and are closer to the magical world of *Harry Potter* than the physical world we inhabit. This is not to say that the idea of a space drive, or propellantless propulsion, is impossible. A pedestrian example is a solar sail—it does not carry any onboard propellant and is thus categorized as a propellantless propulsion scheme, but that does not mean that it is reactionless. We all know there are photons that hit and reflect off the solar sail, and in order to conserve momentum and energy, the sail must accelerate as a result of this physical process. The sail is using an

in situ reaction mass of photons provided by the sun (in most cases).

Are there other ways to produce spacecraft propulsion that don't require some sort of reaction mass? Think about an airplane—it uses a propeller to interact with the air medium that the plane is embedded within to generate a force and move the plane along. The plane does not have a tank of compressed air to shoot out of the back of the plane to generate a force. Yes, the plane has a tank of propellant, but this is the energy source used to spin the propeller. The reaction mass in this example is, of course, the surrounding air. Are there ways yet to be discovered to interact with the fabric of space-time to propel a spacecraft? Some think so.

The Em [interstellar propulsion] Drive is a reactionless drive that allegedly works by generating a microwave beam and then asymmetrically reflecting it internally, back and forth, many times to produce a net movement, or thrust (in space propulsion language). The key is the asymmetric reflection, which simply means that one of the reflectors is shaped differently from the other. The alleged breakthrough is that the drive would produce net thrust without the expenditure of propellant (like rockets) or the need for an external push (like photon and beamed energy sails). In other words, a space drive, once activated and operating, would continue to accelerate to velocities useful for interstellar travel and not mandate the massive power and propellant that all other known space drives require. It sounds too good to be true, and it is, mostly due to the fact that it violates the Law of Conservation of Momentum. This is another of Newton's laws, which states that within a system, the amount of momentum remains constant; momentum is neither created nor destroyed, but only changed through the action of forces. Conservation of momentum is what allows

rockets to work and a law that has been observed in nature for hundreds of years *without any known examples of it proven false.* Many laboratories around the world have built and tested variations of the EmDrive, under widely varying control conditions, and the most rigorous of the tests show that there is no propulsion effect.

Another popular power and propulsion idea that surfaces in the media every so often is "tapping the quantum energy of the vacuum." The name sounds technical and mysterious, due mainly to the seeming weirdness of quantum mechanics ("quantum energy") and the remote, isolated imagery invoked when one mentions a "vacuum." Physicists do talk about empty space as not being so empty when considered at the limits of the exceedingly small (in both physical size and time scale), where it is theorized that within space-time is a sea of virtual particles zipping into and out of existence, averaging nothing— hence creating, on average, a seemingly "empty" vacuum. Vacuum energy is real, and something called the Casimir effect has been experimentally verified showing that the energy contained within it is also real.

In previous chapters, we discussed how empty space is not so empty after all, averaging one atom per cubic centimeter in interstellar space with light from stars shining through in all directions, weak magnetic fields, and the odd piece of rock or dust. Aside from all this, we need to think about the vacuum of space itself—is there something that makes up the space in between these passersby? Revisiting our discussion of quantum mechanics and string theory, "empty space" appears to be made of electromagnetic waves of myriad wavelengths and amplitudes that cancel each other out, with the amplitude peaks of any single-wavelength wave being simultaneously canceled out by another of the same wavelength with its amplitude 180

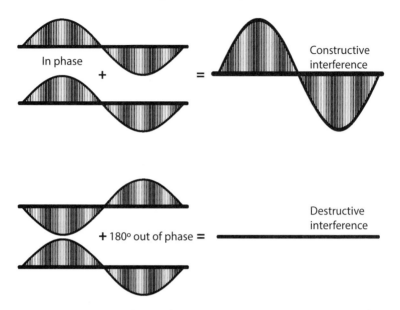

FIGURE 8.3. Wave Interference. If two identical waves meet, such that their peaks align, the amplitudes (heights) add together, creating a taller, more energetic wave. If the same two waves meet 180 degrees out of phase, then when their amplitudes add together, they cancel each other out, with the result appearing to contain no waves at all. If spacetime contains a nearly infinite number of electromagnetic waves rapidly coming into and out of existence (due to quantum mechanics), then their average amplitude should average out to zero. Image created by Danielle Magley.

degrees out of phase (figure 8.3). When these two are added together, the resulting wave has zero amplitude and does not manifest itself in any way we can readily detect.

This is where the Casimir effect comes in. Any good physics experiment usually results from someone asking "What if?" In this case, physicist Hendrick Casimir asked what would happen in a vacuum if finely tuned mirrors were placed facing each other and very, very close together—but not touching. The result would be that within the space between the two mirrors, only spontaneously appearing and disappearing quantum

waves of short wavelengths could fit. The longer wavelengths would be excluded by the plates' spacing being too small to contain them. By excluding some of these waves, the energy contained in the vacuum on the outside of the two plates would be higher than in the vacuum between them because the outer vacuum allows waves of longer wavelength to materialize/dematerialize. This difference in energy would result in an external pressure that would drive the two plates together. When Casimir asked the question in 1948, there was no way to build mirrors small enough, nor instruments sensitive enough, to measure the forces predicted to cause the effect. That changed in 1996, when scientists at Los Alamos National Laboratory successfully measured the forces and found the Casimir effect to be real. Now that it has been measured, there is another problem—the theory that says that all possible wavelengths are simultaneously coming into existence and being canceled throughout the vacuum of space-time. This should be good news—it means that infinite energy exists all around us just waiting to be tapped. Unfortunately, we also know that this cannot possibly be true. If this energy is truly infinite, then, according to the Theory of Relativity, space-time should be infinitely curved and, well, it isn't. Clearly something in our understanding of vacuum energy is incomplete. In fact, based on the observed nature of space-time, it appears that the total energy in the vacuum is vanishingly small, perhaps too small to be a plausible source of energy for space travel, and even if it were more energetic, there are no known ways to readily make use of it.[4]

Those looking for quick and easy solutions to the space propulsion problems (mostly problems of scale) should hark back to TANSTAAFL. In the science fiction community, this easily pronounced but kludgy-looking acronym is used to describe situations that appear to be too good to be true: There Ain't No

Such Thing as a Free Lunch can be applied to just about every aspect of life, including space physics and engineering. TANSTAAFL was popularized by Robert Heinlein in his classic novel *The Moon Is a Harsh Mistress*, published in 1966. Both the EM Drive and using the quantum vacuum energy may be so categorized.

Speculations on Suspended Animation

A favorite trope in science fictional worldships, one that sounds plausible but at this time is also mere conjecture, is suspended animation.* The colonists get on board for their journey, for which there is no alternative to decades or hundreds of years voyaging, and they are put into supercold coffins,† where their bodily functions (aging) stops until they are awakened upon arrival centuries later, with the virile male characters not having much more than some modest facial hair growth to show the passage of time. Suspended animation is famously used in Stanley Kubrick's *2001: A Space Odyssey*, as the doomed crew of the *Discovery* makes the journey to Jupiter only to be killed by the malevolent and mysterious AI, HAL, before they reach their destination. Similar-looking suspended animation is used in *Alien* and its sequels and prequels, allowing Sigourney Weaver to awaken and titillate adolescent male audiences despite her being in suspended animation for decades or more. More recent examples include Christopher Nolan's *Interstellar* and

*Suspended animation certainly predates modern science fiction: consider Sleeping Beauty's hundred-year slumber awaiting Prince Charming, or the story of Rip Van Winkle.

†The suspended animation chambers in science fiction books and movies are not always cold; some are filled with mysterious chemicals that slow or stop the aging process, and others don't even bother to explain how they might work. They just do.

Morten Tyldum's *Passengers*, spanning the storytelling space from a big, mind-expanding idea film (*Interstellar*) all the way to the interstellar ark serving as a convenient setting for a love story (*Passengers*). The list goes on, and it would be impossible to list comprehensively all the books and films that make use of this convenient medical capability. But is suspended animation complete fiction or based on science?

The answer is, it combines elements of both. Many animals hibernate in the winter (or, much more rarely, estivate in the summer), in a state of torpor for extended periods of time, slowing their body processes dramatically, allowing them to live on nutrients stored in their bodies while they slumber away, sometimes for an entire season. Well-known examples of mammals that hibernate include many rodents, squirrels, and, of course, bears. While artificially induced hibernation for short periods of time on a deep-space voyage may make sense from a logistics point of view, since sleeping people don't consume as much air, water, or food, it unfortunately will not stop the aging process. Bears still grow older while they sleep and, unless scientists find a way to separately stop the aging process, so will sleeping humans.

Humans don't naturally hibernate, but data from accidental and intentionally induced hypothermia suggest it might be possible, at least in the short term. There are well-documented cases of people surviving prolonged submersion in cold water and not suffering any brain or other organ damage, as well as of doctors forcing similar conditions to save the lives of people suffering certain kinds of heart attacks and strokes.[5] NASA and other space agencies are studying the possibility of inducing hibernation in crew bound for Mars to alleviate the issues that arise with being awake for the nearly one-year-long journey.

Hibernation during the journey to another star does not seem like it will be a realistic option. What about simultaneously slowing or stopping the aging process? Slowing it may not be as far-fetched as it seems; stopping it is not likely. Researchers at the University of Michigan's Glenn Center for Aging Research cite peer-reviewed, published medical research papers that describe how some drug treatments have been shown to increase the average life span of mice by 15–20 percent, or more.[6] Other studies show that by dramatically reducing caloric intake, the mice's life spans increased by as much as 40 percent. So, if our intrepid explorers are willing to be injected with clinically proven medications and put to sleep on a near-starvation diet, they might actually be able to sleep for a few years without necessarily losing productive years after being awakened. They would still age but not suffer from some of the side effects of aging. For this to be viable on an interstellar journey, future medical breakthroughs would have to both increase the extended life span beyond an additional 40 percent to perhaps an additional 140 percent or more, given the long trip times involved.

Life at the Destination

Science fiction often paints a rosy portrait of what life might be like at the endpoint of an interstellar voyage. After all, Captain Kirk, Mr. Spock, and Dr. McCoy visited one Earth-like planet after the other as their adventures saving the Federation thrilled viewers every week. The tradition continued two decades later with Captain Picard and Counselor Troi, and for more seasons. They occasionally encountered planets with conditions inhospitable to human life, but that was a rarity. On *Battlestar Galactica*, there were the twelve Colonies of Man, all Earth-like and

all filled with humans flourishing on these serendipitously compatible worlds. *Star Wars* did essentially the same with Coruscant, Dagobah, and Luke's home world, Tatooine.

In written fiction, these human-friendly worlds are also quite common, including Asimov's galactic empire in his Foundation series, in which millions of planets are settled by humans, including Trantor, the empire's capital. David Weber's Honorverse series has numerous human compatible worlds, most notably Manticore and Haven. Such worlds are extremely unlikely to exist in the real world—or the real galaxy.

According to our current understanding of astronomy and planetology, the environment on Earth is a product of a series of historical events, spanning billions of years, that are extremely unlikely to be replicated anywhere else. That's not to say that there may not be planets out there that are hospitable to life, just probably not ready-made and compatible with Earth life. Earth today would be radically different if just one significant event in its history had not happened, occurred slightly differently, or occurred at another time. If Earth's orbit were closer to the sun, then we might be more like Venus; farther away, more like Mars. If we didn't have a powerful magnetic field and UV-filtering ozone layer, then life as we know it might not exist due to the resulting continual irradiation of the planet's surface. If the planet did not have as much water, then there might not be enough photosynthetic plants, algae, and bacteria to produce the oxygen we need to survive. The list goes on.

When we travel to worlds circling other stars, even solar systems that look like they have planets in their habitable zones, we might arrive and find out that they are not at all suitable for human or Earth life. There will almost certainly be no worlds where Earth life can simply get out of the spaceship, breathe the air, establish roots, and begin to thrive and grow. Most of these

new worlds will instead be toxic, with unbreathable air or none at all, soil that has none of the nutrients required to nourish terrestrial plants, and so on. In other words, our settlers will have to confine themselves to living out the rest of their lives in various artificial constructs they erect there until they do one of two things: terraform or adapt.

Making another planet like Earth, terraforming it, will be a centuries-long process with uncertain outcomes. Serious scientific papers have been written on the topic, which involve the deliberate modification of a planet's (or moon's) atmospheric composition and temperature, and eventually its ecology, modifying one that exists or creating one from scratch. Though not a new idea, the name of this process, terraforming, is widely used, originating in science fiction, with the publication of the story "Collision Orbit" by Jack Williamson in 1942. Since then, it has appeared in many science fiction stories, with varying degrees of believability, such as Robert Heinlein's *Farmer in the Sky*, Arthur C. Clarke's *The Sands of Mars*, and Kim Stanley Robinson's Mars series, but not so much in movies and film. Aside from a few episodes of *Star Trek* and *Dr. Who* and minor movies such as *The Arrival*, the grand vision of modifying planetary biospheres is largely a theme left to novels. Is terraforming possible?

Elon Musk seems to think so. The founder of SpaceX has publicly discussed a notional plan that would involve detonating thousands of nuclear weapons high above the frozen volatiles at the Martian poles, which are mostly carbon dioxide and water, in order to evaporate and release them into the atmosphere. Presumably, the high-altitude detonations would limit the amount of radiation released into what he hopes could one day become an Earth-like environment. Other ideas, ones that do not include large numbers of nuclear weapons, look to

proven approaches to terraforming such as the unfortunate experiment we are running here on Earth through our uncontrolled release of carbon dioxide into the atmosphere and the ensuing climate modification. Yes, we are performing an uncontrolled terraforming (or terra unforming) of our own planet. An intriguing idea, published in the journal *Nature Astronomy*, would use aerogels similar to those used to help keep spacecraft warm, to retain heat in parts of the Martian surface and release the trapped volatiles therein. Silica aerogels are transparent to visible light, letting the energy from sunlight pass through, and can be made to be opaque in the infrared, trapping the heat energy created when the visible light is absorbed by the frozen soil underneath the aerogel, allowing it to warm and evaporate whatever gases are frozen within it.[7] Creative people can come up with creative ideas. Is this plausible? In principle, yes. But it depends on the amount of carbon dioxide that is trapped and could be released, and there are conflicting data on that in the literature.[8] Be aware that the task of transforming another planet will require efforts on a scale similar to what will be required to launch a mission to get there in the first place. Planets are extremely large and have complicated atmospheric physics,* and each one will be unique when it comes to determining the steps required to take it from its current state to the desired goal—Earth 2.

If modifying an entire world is too daunting, perhaps the settlers can instead create a habitable world from a much smaller moon. Keep in mind that humans do not need the full area of Earth to house our burgeoning population now numbering in the billions. Earth's surface is about 70 percent water, leaving roughly 150 million square kilometers of dry land,

*How accurate is your local weather forecast?

one-third of which is considered desert. For comparison, the surface of the moon, on which there is no significant water, is about 37 million square kilometers—plenty of room for a crew of ten thousand or so to call home. There are problems with this, of course, not the least of which is that the surface gravity of most moons would be substantially lower than that on Earth or Mars, allowing whatever atmosphere is created to then slowly leak away into space once it is created or released. Enter "shell worlds."

Proposed by engineer Ken Roy, a shell world is just such a small moon, but it is encased in a protective shell made of graphene or something as simple as Kevlar and steel. Within the shell, an Earth-like atmosphere and biosphere could be created and maintained. Roy's calculations show that a Mars-size shell world would only require about 7 percent of the mass of Earth's atmosphere, provide protection from ultraviolet and solar radiation, and require much less in the way of raw materials and time to create. It would still be a massive engineering challenge but a much more manageable one—relatively speaking.[9]

If modifying the planet to make it suitable for humans is too difficult or not possible, then what about the other way around? Can we modify humans to allow them to survive in whatever environment awaits them at the end of their journey? Again, a resounding "maybe." With the success of the Human Genome Project, we now know more about the code that programs our cells to be "human" versus, say, "cat" or "dog." We are getting a better idea of what genes contribute to diseases like breast cancer, type 1 diabetes, and others. For example, a common cause of hereditary breast cancer is a mutation in the BRCA1 or BRCA2 gene. Normally, these genes help make proteins that repair damaged DNA, but known mutated versions can lead to abnormal cell growth and cancer.[10] The link is so well known

that many women with this specific inherited genetic abnormality choose to have preemptive surgery rather than risk developing cancer. Scientists are working to better understand the links between certain genes and diseases, like cancer, as well as seeking ways to repair mutations or stop the mutation from happening in the first place.

Since the invention of agriculture, humans have been modifying the genome of plants through crop selection and hybridization, leading to high-yield varieties of many foods that are staples of our diets: corn, wheat, soybeans, and bananas, to name a few. After gene sequencing became possible, it was only a matter of time before someone figured out how to intentionally edit, or change, these genes, and genetically modified crops were among the first results. Consider Bt corn. *Bacillus thuringiensis* (*Bt*) is a bacterium that produces toxins fatal to some insects. Inserting genes from *Bt* into corn makes it less susceptible to being eaten by insects before it reaches the dinner table or the animal feed lot. Much of the corn consumed in the US is *Bt* corn, like it or not. As with most technologies, improved and more efficient processes have come along, such as CRISPR,* that greatly simplify what used to be a much more cumbersome and time-consuming process. Thanks to CRISPR, gene editing research is happening in research laboratories across the globe, big and small. It was inevitable that someone would begin to use gene editing on humans, and not just by changing an existing gene in a living person but by changing a gene in that person before they became a person, enabling the changed gene to potentially become a permanent part of that person's genome, which in turn would allow whatever traits it was designed to

*CRISPR stands for "clusters of regularly interspaced short palindromic repeats." (You can see why it is referred to by its acronym.)

modify to be (potentially) passed on to future generations in the normal reproductive manner.

The scientific world was rocked in 2018 when a Chinese scientist announced that he had genetically modified human embryos in just such a fashion.[11] The ethical and moral firestorm that ensued cost the scientist his job and likely destroyed his professional career. And, in my opinion, for good reason. The field is too new, and the long-term effects of such tinkering are not well understood. The potential for causing harm is simply too great for the new technology to leap from the laboratory to the human population at this time. That said, if there were a foolproof method to eliminate many serious, life-limiting birth defects in future generations, perhaps it should be a legal, viable option—in the future. And, in the future, when settlers arrive to a new, habitable, but not Earth-like world, this technology might be proven and available—allowing them to modify themselves and future generations to live in the new environment. Is the atmospheric oxygen content too low? Modify the genome to compensate. Is the gravity too low to prevent premature osteoporosis? Edit the genes to adjust the compression needed in bones to maintain calcium uptake and good bone density. The list goes on.

There are many science fiction novels that explore this idea quite well. Among them are Lois McMaster Bujold's *Falling Free*, David Brin's *Startide Rising*, and Octavia E. Butler's *Dawn*.

Science fiction also provides a few cautionary notes that we should carefully consider. *Gattaca* is one of the most profound yet thoroughly depressing movies I have ever seen. In the all-too-plausible future envisioned by *Gattaca*, the wealthy have their children genetically modified to be nearly perfect in every way—looks, athletic ability, intelligence, visual acuity, and so on, thereby fulfilling some of the ideas of Margaret Sanger[12] and

other eugenicists in a dystopic future. The story centers on a nonmodified individual and the lengths he must go to achieve his lifelong dreams. It is a future in which I do not want to live. Like many technologies—guns and atom bombs come to mind—the ethics of genetic engineering use must be carefully considered by societies and individuals. To create a *Gattaca* future is one thing; using the technology to eliminate type 1 diabetes is another—and using it to adapt a shipful of Earth humans to life on another world might just be another example of acceptable use.

Alien Life at the Destination

Then there is the question of alien life. In science fiction, the universe is filled not only with primitive life, microbes, and the like, but also with intelligent, tool-using creatures much like us. The depiction of this life is quite different in books and short stories than it is on television or in the movies. Until recent breakthroughs in green screen technology and computer enhancement, creating a truly *alien* alien on a screen was a practical impossibility. That's why most television aliens are humanoid. It is no coincidence that the aliens in *Star Wars* are mostly humans from other planets and occasional bipeds that look like people dressed up in funny clothes—because that is all they could do within their special effects and costume budgets to create aliens. In the *Star Trek* universe, the writers created a history of the galaxy to explain the convenient fact that most of the aliens encountered looked human. With modern technology supporting, some serious science fiction films have done an outstanding job depicting truly alien life. Consider 2016's *Arrival*. In it, aliens arrive on Earth and they bear absolutely no resemblance to humans in appearance, actions, or methods of

communication. The hero, Louise Banks, finally unravels the secret to communicating with them, finding that their language reshapes the way the speaker's brain works, altering perception and the physical world in ways never before imagined or imaginable. Based on a short story by Ted Chiang, *Arrival* is probably one of the most realistic depictions in film of first contact; its realism is not because of the specific alien characteristics portrayed but because of the sense of "differentness" the movie evokes.

In the world of science fiction literature, there is a lot more room to be creative because your mind creates the visual and is not limited by cinematic special effects. In Murray Leinster's 1946 story "First Contact," an interstellar Earth ship encounters an alien ship with roughly the same technological capabilities, forcing the two to find a peaceful way to interact in a potentially hostile universe. In *The Sparrow* by Mary Doria Russell, first contact with an almost-human but totally alien species provides the fodder for an emotional roller-coaster story of a man who was part of a first contact team and came away severely physically and emotionally damaged. Russell carefully crafted an unsettling and thought-provoking page-turner. However, if you are looking for a realistic portrayal of the ship and technologies that enabled the encounter to happen, you will be disappointed. *The Sparrow* is all about the people, not the hardware. *The Mote in God's Eye*, a 1974 collaboration between Larry Niven and Jerry Pournelle, depicts a first contact, with much more believable technologies, that at first appears peaceful but ends up being hostile as it becomes clear that the alien "Moties" are actually on a mission of conquest. Hostile encounters between humans and aliens are common in the literature, likely for two reasons. The first is that in our own history, first contact between different human cultures so often ends in conflict. The

second is that conflict in a story tends to make it an interesting read.

If there is a habitable, or close to habitable, world out there, then there may also be extant, non-Earth life.* Believe it or not, there is an entire academic field of study today—astrobiology—focused on alien life, even though we have yet to encounter any. Do not let the lack of specimens to study make you believe astrobiologists have nothing to do! Far from it. They are now involved in the planning of many space missions, particularly those going to Mars, and in the overall exoplanet field. Key to understanding alien life—and to helping understand which exoplanets merit additional study—is understanding the environments in which life can develop and thrive.

The discussion of life beyond Earth inevitably leads to the question of there being other intelligent beings "out there" and whether we might encounter them. With more than 400 billion stars in our galaxy and at least that many planets, the seemingly weekly discovery of another planet in its star's habitable zone, and the fact that the universe is about 13 billion years old, make it seem unlikely that in our galaxy no one else is home. And don't forget that our galaxy is but one out of billions that make up the known universe, making the likelihood even greater that someone else is out there, looking at the stars, and wondering if they, too, are alone. Yet, despite our best efforts, we have seen no sign that life, intelligent or not, exists anywhere beyond right here. Under the guise of the search for

*It is difficult to imagine a habitable world that does not have life. Earth's habitability is due, in large part, to the cumulative effects caused by life on it for the past few billion years. That said, it is certainly possible that future explorers will find a planet with oceans, dry land, and that it be utterly devoid of life—but it would almost certainly not be suitable for Earth's life.

extraterrestrial intelligence (SETI), many radio telescopes have been scanning the skies for alien radio transmissions for well over half a century and come up with nothing concrete.[13] While not changing the search methods (yet), Dr. Jill Tarter, the Emeritus Chair for SETI Research at SETI Institute, now advocates that researchers begin thinking of SETI as a way to find not intelligence but rather the technological signatures that might accompany the presence of intelligence. After all, there may be extraterrestrial intelligent species out there that do not ever develop technology, and we would therefore likely never detect them.

Why have we not detected anything? Humans have had a technological civilization for only a few hundred years, and we could, if we wanted to, set up a radio beacon announcing our presence that could be detected to distances of many tens to hundreds of light-years. Given our rate of scientific and technological progress, and assuming we continue to advance at the same or a similar rate, then it is likely we will have explored and settled our solar system within the next two hundred years and be taking our first steps toward the stars shortly thereafter. Being conservative and assuming that building the ships and technologies described in this book is more difficult than anticipated, let's assume that we do not launch our first crewed ships on an interstellar voyage until the year 3000. Continuing that conservatism, we shall assume that each ship requires about five hundred years to reach its destination. This means that we will have settled many nearby star systems by the year 10,000—eight thousand years in the future. From a human perspective, that is a long time, but not much from an astronomical perspective.

The universe is over 13 billion years old. Our star and Earth have been here for over 4 billion years. A billion years is 1,000 million years. The long-term human expansion to nearby stars

taking ten thousand years from the time our modern calendars began counting is a mere blink of an eye in galactic history. If any intelligent, tool-using, and curious creatures are out there among the stars, and their rate of technological progress is similar to our own, then not only should we have heard their beacons but should also have seen them here and in or around nearly every star in the galaxy. Yet we do not.

This seemingly logical contradiction is known as the Fermi paradox, named after the famous Italian physicist Enrico Fermi, who is credited with creating the world's first nuclear reactor, among many other contributions to physics. There are entire books written about the Fermi paradox that contain theory after theory trying to explain the stunning silence we hear when we look outward into what appears to be a lonely and quiet universe. For this work, we shall leave it as one of the great unanswered questions in science—yet one with profound implications for any future human interstellar explorers.

It is at this point that some readers might ask, "But what about the flying saucers?" Scientists are a skeptical lot. When science is conducted properly (which, admittedly, is not always the case), evidence is presented that can be questioned, examined, and dissected in every imaginable way before a theory of its origin/behavior/purpose can be proffered. Mysterious lights in the sky or oddly behaving aircraft captured on film and perhaps even radar does not mean we are being visited by extraterrestrials. There are many possible explanations that do not involve aliens from other worlds. Setting aside the Fermi paradox for a moment, when discussing flying saucers, it might be instructive to look a simple thought experiment in probabilities. In other words, what are the odds?

Let's assume that the prevailing understanding about the origin of biological life on Earth is correct and that we evolved

over billions of years, through the tug-of-war of survival of the fittest, through the many mass extinctions and accidents of history such as the asteroid that apparently wiped out the dinosaurs some 65 million years ago, to arrive as a species, humans, who are intelligent, sentient, and can use tools. That took about 3.5 to 4 billion years, of which the human species has existed for only about 100,000 years. It's been only a little more than five hundred years that we have had a civilization that understands its place in the universe, conducts astronomy, and uses its tools to build machines capable of traveling around our planet. And spaceflight has been possible for less than one hundred years— out of 4,000,000,000. Now, let's also assume that some other, nonhuman species similarly evolved on a planet surrounding another star somewhere out there among the billions that make up the Milky Way Galaxy, and that they found a way to cross the vast distances between the stars to reach here—which, since we are near the end of this book means that you, the reader, know how incredibly difficult this challenge really is. What is the likelihood that these extraterrestrial beings, using technologies that we can even recognize as such (most alleged flying saucer sightings involve craft that look like something we might be able to build in the not too distant future), would arrive on Earth within the very hundred-year timespan that we also began to contemplate spaceflight? One hundred years out of the 4,000,000,000 years of Earth's development? The dinosaurs are estimated to have reigned over the planet for more than 65,000,000 years. Isn't it far more likely that aliens in flying saucers, if they exist, visited Earth during the time of the dinosaurs? The likelihood that they are here, now, with technologies that are, at most, perhaps a thousand years more advanced than ours, is vanishingly small. So small as to be zero in practical terms.

Until someone comes forward with a solid body of evidence that flying saucers are aliens from another world, it would be best to file these sightings away as something interesting but not as proof that we are being visited by aliens. For a more detailed discussion of the likelihood of alien life visiting us on Earth, please see my online essay, "The Aliens Are Not among Us."[14]

Science Fiction: Useful and Essential Speculation

While science fiction may raise unrealistic expectations for the progress of our exploration of space and the time frame in which we might attain interstellar travel, it has been incredibly useful, dare I say essential, in getting us to where we are today in our current space exploration capabilities. In *From the Earth to the Moon* (1865), author Jules Verne described a crew of three taking a trip to the moon in a ballistic (fired by a gun) projectile launched from Florida who, upon their return, land safely in the ocean after using parachutes to slow down. Does this sound familiar? Apollo 11 took a crew of three men to the moon in a rocket launched from Florida who then returned to Earth in a capsule that landed in the ocean after using parachutes to help slow down. Many science fiction stories written before Apollo accurately captured what real space travel would be like, but many, probably most, missed the mark entirely. And that is okay—good science fiction does not have to be 100 percent accurate. First and foremost, science fiction needs to be engaging, thought-provoking, and entertaining. Since Apollo, there have been many excellent, technically sound science fiction novels depicting the next giant leap in space exploration—human Mars exploration. Among the best are *Mars* (Ben Bova), *Red*

Mars (Kim Stanley Robinson), and, of course, *The Martian* (Andy Weir).* Many stories, movies, and television series trying to depict realistic interstellar exploration have already been mentioned.

Besides entertainment, science fiction has contributed to the future of space exploration in two other impactful ways: preparing the culture for what is to come and inspiring the next generation of scientists and engineers. There is no doubt that the science fiction of the early twentieth century inspired visionaries like Wernher von Braun, the German rocket scientist who gave the world the horror of the V-2 rocket during World War II as well as the awesome and inspiring Saturn V that carried astronauts to the moon. The current generation of senior scientists and engineers working on space exploration will unashamedly admit that science fiction, coupled with the successes of the early space program, inspired them. I am among them. I was seven years old when Neil Armstrong walked on the moon, eleven when I discovered the writings of Robert Heinlein, Arthur C. Clarke, and Isaac Asimov, and about thirteen when I decided I wanted to study physics so that I could work for NASA. And I am not alone.

In about 2010, NASA's leadership in Washington, DC, wanted to learn more about what inspired its workforce to choose careers in science and engineering and to work for NASA. They commissioned a private consulting firm to identify innovators from around NASA, interview them, ask them to complete a battery of personality inventories, and otherwise find out what motivated them to be creative and contribute to the nation's space program. I was honored to be among the few

*Shameless self-promotion: you should also read my novel about Mars exploration, *Rescue Mode*, which I coauthored with the late Ben Bova.

nominated to participate. There were about thirty of us selected from a workforce that numbers in the thousands across the USA. After completing the interviews, questionnaires, and background surveys, we were invited for a two-day workshop at NASA headquarters in Washington to review the results and discuss how to motivate and inspire others. During the two-day event, the consulting team gave a presentation that described the demographics of the group. It contained the usual break-downs of age, ethnicity, education level, geographic origins, and so on. The interesting part came when they showed a cloud chart with the words they noticed we, as a group of individuals, used in describing what motived us to study science. (A cloud chart shows data, in this case words, that are used most frequently, with the font size proportional to the frequency with which a particular word is used. The more a word is used, the larger the font size.) As one would expect, words like *discovery*, *exploration*, *science*, and *Apollo* were on the chart. But in the middle was a large blank space that took up about 30 percent of the page. The presenters built suspense by telling us that there were two words that were mentioned by nearly everyone as being a motivating factor in our decisions to study science and engineering and then to work for NASA. Two words that were mentioned far more times than any other. What were those two words?

Star Trek.

The ages of those present spanned decades, and the pre-senter informed us that the inspiration of *Star Trek* crossed the generational divides in its various incarnations. For the older among us, it was the classic *Star Trek* with Captain Kirk and Mr. Spock. For those slightly younger, it was *Star Trek: The Next Generation* with Captain Picard and Counselor Troi. For others, it was *Star Trek: Voyager*'s Captain Janeway or *Deep Space Nine*'s

Sisko. We were generations motivated to choose our educational path and careers based on the positive, technology-enabled future that is the *Star Trek* universe. As we work on the technologies that may one day take us to the stars, it is important to remember that developing them will require an inspired and motivated team of people from varied disciplines, including many who are not scientists and engineers (such as *Star Trek*'s creator, Gene Roddenberry, and the many talented writers who wrote the scripts for the television show). Going to the stars will not happen unless people have a vision to make it happen, and science fiction may be as important to making it a reality as the development of all the systems and technologies described in this book.

Epilogue

Crossing the gulf between the stars will require technologies that are clearly beyond anything available today, but that doesn't mean it is too early to begin planning. The technological ancestors of the first ships to make these audacious journeys are being developed today as we expand our presence beyond Earth and into the solar system. The rise of commercial space with companies such as SpaceX, Blue Origin, and Virgin Galactic is making access to space more affordable, potentially enabling the creation of the viable in-space infrastructure that will be needed. The technologies required to make nuclear rockets are available today and may soon be demonstrated in space as we prepare to take our first crewed journeys to Mars and beyond. Solar sails have flown successfully in space and larger, more capable ones are soon to fly. The lasers required to boost sails to higher speeds are being tested and miniaturized, laying the groundwork for their use in space. Fusion power research appears close to a breakthrough that will allow it to become a viable terrestrial power source—miniaturizing it for use in space will be the next logical step. The technological pieces of the puzzle are being matured.

As we learn more about the myriad exoplanets in our galactic neighborhood, many will ask, "Can we go visit them?" The answer is, "Yes—but . . ." Before we or our machines can make the

trip, we need to become good stewards of a truly interplanetary civilization, tapping the energies of the sun and the atom. Interstellar travel is clearly possible, and making it happen will be extremely difficult—but it can be done!

GLOSSARY

100 Year Starship: a joint US Defense Advanced Research Projects Agency (DARPA) and National Aeronautics and Space Administration (NASA) program that offered grants to private entities. The goal of the main study grant was to create a business plan that fosters the research and technology needed for interstellar travel within a 100-year time frame.

aerogel: a light, highly porous solid formed by replacement of liquid in a gel with a gas so that the resulting solid is the same size as the original.

Aerospace Corporation: an American nonprofit corporation that operates a federally funded research and development center in El Segundo, California. The corporation provides technical guidance and advice on all aspects of space missions to military, civil, and commercial customers.

alpha particle: a positively charged nuclear particle identical with the nucleus of a helium atom that consists of two protons and two neutrons.

antimatter: a subatomic particle identical to another subatomic particle in mass but opposite to it in electric and magnetic properties (such as positive or negative charge). When brought together with its counterpart, the mutual annihilation releases energy.

aperture: the diameter of the objective lens or mirror of a telescope.

astrobiology: a branch of biology concerned with the search for life outside the earth and the effects of extraterrestrial environments on living organisms.

biosphere: the part of the world in which life can exist.

Breakthrough Initiatives: a science-based program founded in 2015 and funded by Julia and Yuri Milner. The program is divided into multiple projects, including Breakthrough Starshot, which aims to send a swarm of probes to the nearest star at about 20 percent the speed of light.

cosmic ray: a stream of atomic nuclei traveling through space at a speed approaching that of light.

diffraction: a modification that light undergoes, especially when passing by the edges of opaque bodies or through narrow openings, causing the rays to appear to be deflected.

dwarf planet: a celestial body that orbits the sun and has a spherical shape but is not large enough to disturb other objects from their orbits.

electric propulsion: propulsion of a body by the forces resulting from the rearward discharge of a stream of ionized particles.

electrolysis: a process that produces chemical changes by passage of an electric current through an electrolyte, often water to produce hydrogen and oxygen.

electron gun: an electron-emitting device for directing, controlling, and focusing a beam of electrons.

event horizon: the boundary of a black hole beyond which nothing can escape from within it.

extravehicular activities: any activities performed by astronauts outside a space-craft when it is beyond the Earth's appreciable atmosphere.

gamma ray: a photon of higher energy than that of an x-ray.

general relativity: the geometric theory of gravitation published by Albert Einstein in 1915, which serves as the current description of gravitation in modern physics.

genetic inheritance: the passing on of traits from parents to their offspring.

genome: the genetic material of an organism.

gluon: a hypothetical neutral massless particle binding together quarks to form hadrons.

heliosphere: the region in space influenced by the sun or solar wind.

hypothermia: subnormal temperature of the body.

in situ: in the natural or original position or place.

kick stage: propulsive rocket segment.

kinetic energy: energy associated with motion.

Limitless Space Institute: a registered US nonprofit organization, established in 2019 to advance human exploration beyond our solar system.

link margin: the difference between the minimum expected power received at the receiver's end, and the receiver's sensitivity (i.e., the received power at which the receiver will stop working).

Low Earth Orbit (LEO): a usually circular orbit from about 90–600 miles (140–970 kilometers) above Earth.

metamaterial: any material engineered to have a property that is not found in natu-rally occurring materials.

neurovestibular system: of, relating to, or affecting the perception of body position and movement.

neutrino: an uncharged elementary particle believed to have a very small mass; it can take one of three forms and interacts only rarely with other particles.

neutron star: a dense celestial object that consists primarily of closely packed neutrons.

nuclear fission: the splitting of an atomic nucleus, resulting in the release of large amounts of energy.

nuclear fusion: the union of atomic nuclei to form heavier nuclei, resulting in the release of enormous quantities of energy when certain light elements unite.

particle zoo: in physics, describes the relatively extensive list of known "elementary particles" by comparison to the variety of species in a zoo.

Planck length: a unit of length in the system of Planck units that was originally proposed by physicist Max Planck, equal to $1.616255(18)\times10^{-35}$ m.

plenary: fully attended or constituted by all entitled to be present.

quantum mechanics: a theory of matter based on the concept of elementary particles possessing wave properties, thus allowing a mathematical interpretation of the structure and interactions of matter on the basis of these properties, which incorporates within it quantum theory and the uncertainty principle.

radar: a device or system used especially for detecting and locating objects, consisting usually of a synchronized radio transmitter and receiver that emits radio waves and processes their reflections for display.

radial: extending uniformly outward from a central axis.

secondary particle cascade: a stream of particles produced as the result of a high-energy particle interacting with dense matter.

solar array: an arrangement of several components, including solar panels to absorb and convert sunlight into electricity.

solar sail: a propulsive device for a spacecraft that consists of a flat material (such as aluminized plastic) designed to derive thrust by reflecting sunlight.

space tether propulsion: a means of propelling spacecraft around a planet with a strong magnetic field. An electrical current is made to flow through a long conducting wire (tether). The electrons that make up the current are negatively charged and therefore experience a force as they move through the wire in the presence of the planetary magnetic field. Since the electrons are constrained in the wire, the induced force acts to push on the wire and anything attached to it, like a spacecraft.

string theory: in physics, a theory that all elementary particles are manifestations of the vibrations of one-dimensional strings.

superconductor: a substance that exhibits no electrical resistance.

Theory of Everything: a hypothetical, singular, all-encompassing, coherent theoretical framework of physics that fully explains and links together all physical aspects of the universe.

vacuum energy density: an underlying background energy that exists in space throughout the entire universe.

volatiles: substances that are readily vaporizable at relatively low temperatures.

white paper: a detailed or authoritative report.

x-ray: any of the electromagnetic radiations that have an extremely short wavelength of less than 100 angstroms.

NOTES

Chapter 1: The Universe Awaits

1. A. Wolszczan and D. Frail, "A Planetary System around the Millisecond Pulsar PSR1257 + 12," *Nature* 355 (1992): 145–47, https://doi.org/10.1038/355145a0.

2. "Exoplanet Exploration: Planets beyond Our Solar System," NASA website, December 17, 2015, https://exoplanets.nasa.gov/; L. Kaltenegger, J. Pepper, P. M. Christodoulou, et al., "Around Which Stars Can TESS Detect Earth-like Planets? The Revised TESS Habitable Zone Catalog," *The Astronomical Journal* 161, no. 5 (2021): 233, https://iopscience.iop.org/article/10.3847/1538-3881/abe5a9.

3. Habitable Exoplanets Catalog, Planetary Habitability Laboratory at UPR Arecibo, http://phl.upr.edu/projects/habitable-exoplanets-catalog, accessed October 9, 2020; Steve Bryson, Michelle Kunimoto, Ravi Kopparapu, et al., "The Occurrence of Rocky Habitable-Zone Planets around Solar-like Stars from Kepler Data," *The Astronomical Journal* 161, no. 1 (2020): 36, https://doi.org/10.3847/1538-3881/abc.

4. E. A. Petigura, A. W. Howard, and G. W. Marcy, "Prevalence of Earth-size Planets Orbiting Sun-like Stars," *Proceedings of the National Academy of Sciences* 110, no. 48 (2013): 19273–78, https://doi.org/10.1073/pnas.1319909110.

5. Stephen James O'Meara, *Deep-Sky Companions: The Messier Objects* (Cambridge University Press, 2014).

6. Steven J. Dick, "Discovering a New Realm of the Universe: Hubble, Galaxies, and Classification," *Space, Time, and Aliens*, 2020, 611–25, https://doi.org/10.1007/978-3-030-41614-0_36.

7. Rod Pyle, "Farthest Galaxy Detected," California Institute of Technology, September 3, 2015, https://www.caltech.edu/about/news/farthest-galaxy-detected-47761.

8. J. A. M. MacDonnell, *Cosmic Dust* (Chichester: Wiley, 1978).

9. NASA SP-4008, *Astronautics and Aeronautics* (1967): 270–71.

10. J. T. Gosling, J. R. Asbridge, S. J. Bame, and W. C. Feldman, "Solar Wind Speed Variations: 1962–1974," *Journal of Geophysical Research* 81, no. 28 (1976): 5061–70.

11. "Did You Know . . . ," NASA website, June 7, 2013, https://www.nasa.gov
/mission_pages/ibex/IBEXDidYouKnow.html.

12. M. Opher, F. Alouani Bibi, G. Toth, et al., "A Strong, Highly-Tilted Interstellar
Magnetic Field near the Solar System," *Nature* 462, no. 7276 (2009): 1036–38, https://
doi.org/10.1038/nature08567.

Chapter 2: Interstellar Precursors

1. Elizabeth Howell, "To All the Rockets We Lost in 2020 and What We Learned
from Them," *Space* (December 29, 2020), https://www.space.com/rocket-launch
-failures-of-2020.

2. Walter Dornberger, *Peenemünde (Dokumentation)* (Berlin: Moewig, 1984).

3. Robin Biesbroek and Guy Janin, "Ways to the Moon," *ESA Bulletin* 103 (2000):
92–99.

4. Ashton Graybiel, Joseph H. McNinch, and Robert H. Holmes, "Observations
on Small Primates in Space Flight," *Xth International Astronautical Congress London
1959–1960*, 394–401, https://doi.org/10.1007/978-3-662-39914-9_35.

5. David R. Williams, "Explorer 9." NASA Space Science Data Coordinated Ar-
chive, https://nssdc.gsfc.nasa.gov/nmc/spacecraft/display.action?id=1959-004A
(accessed December 4, 2020).

6. Yuri Gagarin, *Road to the Stars* (University Press of the Pacific, 2002).

7. "The Pioneer Missions," NASA website, March 3, 2015, https://www.nasa.gov
/centers/ames/missions/archive/pioneer.html.

8. Jonathan Scott, *The Vinyl Frontier: The Story of NASA's Interstellar Mixtape*
(Bloomsbury Publishing, 2019).

9. Aymeric Spiga, Sebastien Lebonnois, Thierry Fouchet, et al., "Global Climate
Modeling of Saturn's Troposphere and Stratosphere, with Applications to Jupiter,"
July 2018. 42nd COSPAR Scientific Assembly. Held July 14–22, 2018, in Pasadena,
California, USA, Abstract id. B5.2-33-18; 2018cosp . . . 42E3216S.

10. B. Johnson, T. Bowling, A. J. Trowbridge, and A. M. Freed, "Formation of the
Sputnik Planum Basin and the Thickness of Pluto's Subsurface Ocean," *Geophysical
Research Letters* 43, no. 19 (2016): 10,068–77.

11. "Voyager," NASA / Jet Propulsion Laboratory, California Institute of Technol-
ogy, https://voyager.jpl.nasa.gov/ (accessed March 20, 2020).

12. "Interstellar Probe: Humanity's Journey to Interstellar Space," NASA / Johns
Hopkins Applied Physics Laboratory, http://interstellarprobe.jhuapl.edu/ (accessed
October 17, 2020).

13. Ralph L. McNutt, Robert F. Wimmer-Schweingruber, Mike Gruntman, et al.,
"Near-Term Interstellar Probe: First Step," *Acta Astronautica* 162 (2019): 284–99,
https://doi.org/10.1016/j.actaastro.2019.06.013.

14. Lyman Spitzer, "The Beginnings and Future of Space Astronomy," *American Scientist* 50, no. 3 (1962): 473–84.

15. Slava G.Turyshev, Michael Shao, Viktor T. Toth, et al., "Direct Multipixel Imaging and Spectroscopy of an Exoplanet with a Solar Gravity Lens Mission," Cornell University (2020). https://arxiv.org/abs/2002.11871.

16. John A. Hamley, Thomas J. Sutliff, Carl E. Sandifer, and June F. Zakrajsek, "NASA RPS Program Overview: A Focus on RPS Users" (2016), https://ntrs.nasa.gov/citations/20160009220.

17. Patrick R. McClure, David I. Poston, Marc A. Gibson, et al., "Kilopower Project: The KRUSTY Fission Power Experiment and Potential Missions," *Nuclear Technology* 206, supp. 1 (2020): 1–12.

18. National Research Council, Division on Engineering and Physical Sciences, Space Studies Board, et al., "Solar and Space Physics: A Science for a Technological Society," A Science for a Technological Society | The National Academies Press (August 15, 201), https://doi.org/10.17226/13060.

Chapter 3: Putting Interstellar Travel into Context

1. Wells, H. G., *The Discovery of the Future*. London: T. Fisher Unwin, 1902.

2. Nicolas Kemper, "Building a Cathedral," *The Prepared* (April 28, 2019), https://theprepared.org/features/2019/4/28/building-a-cathedral.

3. The Dorothy Jemison Foundation website, https://jemisonfoundation.org/100-yss/ (accessed September 23, 2021).

4. Michael J. Benton, *When Life Nearly Died: The Greatest Mass Extinction of All Time* (Thames & Hudson, 2003).

Chapter 4: Send the Robots, People, or Both?

1. Phillip Dick, "The Android and the Human," speech delivered at the Vancouver Science Fiction Convention, University of British Columbia, December 1972.

2. Malcolm Gladwell, *Blink: The Power of Thinking without Thinking* (Back Bay Books, 2007).

3. Andreas M. Hein, Cameron Smith, Frédéric Marin, and Kai Staats, "World Ships: Feasibility and Rationale," *Acta Futura* 12 (April 2020):75–104, https://arxiv.org/abs/2005.04100.

4. Mike Massa, *Securing the Stars: The Security Implications of Human Culture during Interstellar Flight*, ed. Les Johnson and Robert E. Hampson (Baen Books, 2019).

Chapter 5: Getting There with Rockets

1. Chris Hadfield, *An Astronaut's Guide to Life on Earth* (Pan MacMillan, 2013).
2. "The Space Shuttle and Its Operations," NASA, https://www.nasa.gov/centers/johnson/pdf/584722main_Wings-ch3a-pgs53-73.pdf (accessed December 30, 2021).
3. Les Johnson and Joseph E. Meany, *Graphene: The Superstrong, Superthin, and Superversatile Material That Will Revolutionize the World* (Prometheus Books, 2018).
4. A. Boxberger, A. Behnke, and G. Herdrich, "Current Advances in Optimization of Operative Regimes of Steady State Applied Field MPD Thrusters," In *Proceedings of the 36th International Electric Propulsion Conference, Vienna, Austria*, pp. 15–20 (2019).
5. "Whatever Happened to Photon Rockets?" *Astronotes* (December 5, 2013). https://armaghplanet.com/whatever-happened-to-photon-rockets.html.
6. "Advantages of Fusion," ITER, https://www.iter.org/sci/Fusion#:~:text=Abundant%20energy%3A%20Fusing%20atoms%20together,reactions%20(at%20equal%20mass) (accessed October 28, 2020).
7. Michael Martin Nieto, Michael H. Holzscheiter, and Slava G. Turyshev, "Controlled Antihydrogen Propulsion for NASA's Future in Very Deep Space" (2004), https://arxiv.org/abs/astro-ph/0410511.
8. Paul E. Bierly III and J-C Spender, "Culture and High Reliability Organizations: The Case of the Nuclear Submarine," *Journal of Management* 21, no. 4 (1995): 639–56.
9. Raul Colon, "Flying on Nuclear: The American Effort to Built a Nuclear Powered Bomber," (August 6, 2007), http://www.aviation-history.com/articles/nuke-american.htm.
10. Lyle Benjamin Borst, "The Atomic Locomotive," *Life Magazine* 36, no. 25 (June 21, 1954): 78–79.
11. Daniel Patrascu, "Nuclear Powered Cars of a Future That Never Was," *Autoevolution* (August 26, 2018), https://www.autoevolution.com/news/nuclear-powered-cars-of-a-future-that-never-was-128147.html.
12. George Dyson, *Project Orion: The Atomic Spaceship, 1957–1965* (Allen Lane, 2002).
13. Robert Wickramatunga, "United Nations Office for Outer Space Affairs," The Outer Space Treaty, https://www.unoosa.org/oosa/en/ourwork/spacelaw/treaties/introouterspacetreaty.html (accessed December 4, 2020).

Chapter 6: Getting There with Light

1. "A Brief History of Solar Sails," NASA website, July 31, 2008, https://science.nasa.gov/science-news/science-at-nasa/2008/31jul_solarsails#:~:text=Almost%20400%20years%20ago%2C%20German,fashioned%22%20to%20glide%20through%20space.

2. Gregory L. Matloff, "Graphene, the Ultimate Interstellar Solar Sail Material," *Journal of the British Interplanetary Society* 65 (2012): 378–81.

3. Les Johnson, Mark Whorton, et al., "NanoSail-D: A Solar Sail Demonstration Mission," *Acta Astronautica* 68 (2011): 571–75.

4. Justin Mansell, David A. Spencer, Barbara Plante, et al., "Orbit and Attitude Performance of the LightSail 2 Solar Sail Spacecraft," in *AIAA Scitech 2020 Forum* (2020): 2177.

5. Yuichi Tsuda, Osamu Mori, Ryu Funase, et al., "Achievement of IKAROS— Japanese Deep Space Solar Sail Demonstration Mission," *Acta Astronautica* 82, no. 2 (2013): 183–88.

6. Les Johnson, Julie Castillo-Rogez, and Tiffany Lockett, "Near Earth Asteroid Scout: Exploring Asteroid 1991VG Using A Smallsat," 70th International Astronautical Congress, Washington, DC, 2019.

7. Les Johnson, Frank M. Curran, Richard W. Dissly, and Andrew F. Heaton, "The Solar Cruiser Mission—Demonstrating Large Solar Sails for Deep Space Missions," 70th International Astronautical Congress, Washington, DC, 2019.

8. Mario Bertolotti, *The History of the Laser* (CRC Press, 2004).

9. Yasunobu Arikawa, Sadaoki Kojima, Alessio Morace, et al. "Ultrahigh-Contrast Kilojoule-class Petawatt LFEX Laser Using a Plasma Mirror," *Applied Optics* 55, no. 25 (2016): 6850–57.

10. Nancy Jones-Bonbrest, "Scaling Up: Army Advances 300kW-Class Laser Prototype," https://www.army.mil/article/233346/scaling_up_army_advances _300kw_class_laser_prototype (accessed December 4, 2020).

11. Edward E. Montgomery IV, "Power Beamed Photon Sails: New Capabilities Resulting from Recent Maturation of Key Solar Sail and High Power Laser Technologies," in *AIP Conference Proceedings* 1230, no. 1 (2010): 3–9.

12. Neeraj Kulkarni, Philip Lubin, and Qicheng Zhang, "Relativistic Spacecraft Propelled by Directed Energy," *The Astronomical Journal* 155, no. 4 (2018): 155; Young K. Bae, "Prospective of Photon Propulsion for Interstellar Flight," *Physics Procedia* 38 (2012): 253–79.

13. Robert L. Forward, "Roundtrip Interstellar Travel Using Laser-pushed Lightsails," *Journal of Spacecraft and Rockets* 21, no. 2 (1984): 187–95.

14. Patricia Daukantas. "Breakthrough Starshot," *Optics and Photonics News* 28, no. 5 (2017): 26–33.

15. Kevin L. G. Parkin, "The Breakthrough Starshot System Model," *Acta Astronautica* 152 (2018): 370–84.

16. Gregory Benford and James Benford, "An Aero-Spacecraft for the Far Upper Atmosphere Supported by Microwaves," *Acta Astronautica* 56, no. 5 (2005): 529–35.

17. "Breakthrough Initiatives," https://breakthroughinitiatives.org/ (accessed November 2, 2020).

18. Jordin T. Kare, and Kevin L. G. Parkin, "A Comparison of Laser and Microwave Approaches to CW Beamed Energy Launch," in *AIP Conference Proceedings* 830, no. 1 (2006): 388–99.

19. Robert L. Forward, "Starwisp—An Ultra-light Interstellar Probe," *Journal of Spacecraft and Rockets* 22, no. 3 (1985): 345–50.

20. Gregory Benford and James Benford, "Flight of Microwave-driven Sails: Experiments and Applications," in *AIP Conference Proceedings* 664, no. 1 (2003): 303–12.

21. Bruce M. Wiegmann, "The Heliopause Electrostatic Rapid Transit System (HERTS)-Design, Trades, and Analyses Performed in a Two Year NASA Investigation of Electric Sail Propulsion Systems," in *53rd AIAA/SAE/ASEE Joint Propulsion Conference* (2017): 4712.

22. Andre A. Gsponer, "Physics of High-intensity High-energy Particle Beam Propagation in Open Air and Outer-space Plasmas" (September 2004), https://arxiv.org/abs/physics/0409157.

Chapter 7: Designing Interstellar Starships

1. Jennifer Rosenberg, "Biography of Yuri Gagarin, First Man in Space," ThoughtCo (February 16, 2021), https://www.thoughtco.com/yuri-gagarin-first-man-in-space-1779362.

2. Claudio Maccone, "Galactic Internet Made Possible by Star Gravitational Lensing," *Acta Astronautica* 82, no. 2 (February 2013): 246–50, https://doi.org/10.1016/j.actaastro.2012.07.015.

3. "Human Needs: Sustaining Life During Exploration," NASA website, https://www.nasa.gov/vision/earth/everydaylife/jamestown-needs-fs.html (accessed November 20, 2020).

4. Robert P. Ocampo, "Limitations of Spacecraft Redundancy: A Case Study Analysis," in *44th International Conference on Environmental Systems*, 2014.

5. Andreas M. Hein, Cameron Smith, Frédéric Marin, and Kai Staats, "World Ships: Feasibility and Rationale," *Acta Futura* 12 (April 2020):75–104, https://arxiv.org/abs/2005.04100.

6. J. Stocks and P. H. Quanjer, "Reference Values for Residual Volume, Functional Residual Capacity and Total Lung Capacity: ATS Workshop on Lung Volume Measurements; Official Statement of The European Respiratory Society," *European Respiratory Journal* 8, no. 3 (1995): 492–506; and "Lung Volumes and Vital Capacity—Cardio-Respiratory System—Eduqas—GCSE Physical Education Revision—Eduqas—BBC Bitesize," *BBC News*, https://www.bbc.co.uk/bitesize/guides/z3xq6fr/revision/2 (accessed November 20, 2020).

7. "Gallons Used per Person per Day," City of Philadelphia, https://www.phila
.gov/water/educationoutreach/Documents/Homewateruse_IG5.pdf (accessed
November 20, 2020).

8. "Water Use in Europe—Quantity and Quality Face Big Challenges," European
Environment Agency (August 30, 2018), https://www.eea.europa.eu/signals/signals
-2018-content-list/articles/water-use-in-europe-2014#:~:text=On%20average%2C%20
144%20litres%20of,supplied%20to%20households%20in%20Europe.

9. "Human Needs," https://www.nasa.gov/vision/earth/everydaylife
/jamestown-needs-fs.html.

10. Petronia Carillo, Biagio Morrone, Giovanna Marta Fusco, et al., "Challenges
for a Sustainable Food Production System on Board of the International Space Sta-
tion: A Technical Review," *Agronomy* 10, no. 5 (2020): 687, https://doi.org/10.3390
/agronomy10050687.

11. Mike Wall, "The Most Extreme Human Spaceflight Records," *Space* (April 23,
2019), https://www.space.com/11337-human-spaceflight-records-50th-anniversary
.html.

12. Les Johnson and Robert Hampson, *Stellaris: People of the Stars* (Baen Books,
2019).

Chapter 8: Speculation and Science Fiction

1. Miguel Alcubierre, "The Warp Drive: Hyper-fast Travel within General Relativ-
ity," *Classical and Quantum Gravity* 11, no. 5 (n.d.), https://doi.org/10.1088/0264-9381
/11/5/001; and Brandon Mattingly, Abinash Kar, Matthew Gorban, et al., "Curvature
Invariants for the Alcubierre and Natário Warp Drives," *Universe* 7, no. 2 (2021): 21.

2. G. J. Maclay and E. W. Davis, "Testing a Quantum Inequality with a Meta-
analysis of Data for Squeezed Light," *Foundations of Physics* 49, 797–815 (2019),
https://doi.org/10.1007/s10701-019-00286-8.

3. "Hyperdrive," StarWars.com. https://www.starwars.com/databank/hyper
drive#:~:text=Hyperdrives%20allow%20starships%20to%20travel,precisely%20
calculated%20to%20avoid%20collisions (accessed November 24, 2020).

4. Matt Viser, "FOLLOW-UP: What Is the 'Zero-point Energy' (or 'Vacuum
Energy') in Quantum Physics? Is It Really Possible that We Could Harness This
Energy?" *Scientific American Online* (August 18, 1997), https://www.scientificamerican
.com/article/follow-up-what-is-the-zer/ (accessed November 25, 2020).

5. Lecia Bushak, "Induced Hypothermia: How Freezing People After Heart At-
tacks Could Save Lives," *Newsweek* (December 20, 2014), https://www.newsweek
.com/2015/01/02/induced-hypothermia-how-freezing-people-after-heart-attacks
-could-save-lives-293598.html.

6. Claudia Capos, "A New Drug Slows Aging in Mice. What About Us?" *Michigan Health Lab*, University of Michigan (January 17, 2020), https://labblog.uofmhealth.org/lab-report/a-new-drug-slows-aging-mice-what-about-us.

7. R. Wordsworth, L. Kerber, and C. Cockell, "Enabling Martian Habitability with Silica Aerogel via the Solid-state Greenhouse Effect," *Nature Astronomy* 3 (2019): 898–903, https://doi.org/10.1038/s41550-019-0813-0.

8. B. Jakosky and C. Edwards, "Inventory of CO_2 Available for Terraforming Mars," *Nature Astronomy* 2 (2018): 634–39.

9. Kenneth I. Roy, Robert G. Kennedy III, and David E. Fields, "Shell Worlds," *Acta Astronautica* 82, no. 2 (2013): 238–45.

10. "BRCA Gene Mutations: Cancer Risk and Genetic Testing Fact Sheet," National Cancer Institute, https://www.cancer.gov/about-cancer/causes-prevention/genetics/brca-fact-sheet (accessed December 20, 2020).

11. Dennis Normile, "Chinese Scientist Who Produced Genetically Altered Babies Sentenced to 3 Years in Jail," *Science* (December 30, 2019), https://www.sciencemag.org/news/2019/12/chinese-scientist-who-produced-genetically-altered-babies-sentenced-3-years-jail.

12. Margaret Sanger, "My Way to Peace," speech delivered January 17, 1932, http://www.nyu.edu/projects/sanger/webedition/app/documents/show.php?sangerDoc=129037.xml.

13. J. C. Tarter, A. Agrawal, R. Ackermann, et al., "SETI Turns 50: Five Decades of Progress in the Search for Extraterrestrial Intelligence," in *Instruments, Methods, and Missions for Astrobiology XIII: Proceedings of the SPIE*, ed. Richard B. Hoover, Gobert V. Levin, Alexei Y. Rozanov, and Paul C. W. Davies, Vol. 7819 (2010), pp. 781902-13.

14. Les Johnson, "The Aliens Are Not among Us" (Baen Books Science Fiction & Fantasy, 2011), https://baen.com/aliens.

REFERENCES

Adams, Douglas. *The Hitchhiker's Guide to the Galaxy*. New York: Harmony Books, 1979.

"Advantages of Fusion." ITER. https://www.iter.org/sci/Fusion#:~:text =Abundant%20energy%3A%20Fusing%20atoms%20together,reactions%20 (at%20equal%20mass). Accessed October 28, 2020.

Alcubierre, Miguel. "The Warp Drive: Hyper-fast Travel within General Relativity." *Classical and Quantum Gravity* 11, no. 5 (n.d.). https://doi.org/10.1088/0264 -9381/11/5/001.

Arikawa, Yasunobu, Sadaoki Kojima, Alessio Morace, Shohei Sakata, Takayuki Gawa, Yuki Taguchi, Yuki Abe, et al. "Ultrahigh-contrast Kilojoule-class Petawatt LFEX Laser Using a Plasma Mirror." *Applied Optics* 55, no. 25 (2016): 6850–57.

Bae, Young K. "Prospective of Photon Propulsion for Interstellar Flight." *Physics Procedia* 38 (2012): 253–79.

Benford, Gregory, and James Benford. "An Aero-Spacecraft for the Far Upper Atmosphere Supported by Microwaves." *Acta Astronautica* 56, no. 5 (2005): 529–35.

———. "Flight of Microwave-driven Sails: Experiments and Applications." In *AIP Conference Proceedings* 664, no. 1 (2003): 303–12.

Benton, Michael J. *When Life Nearly Died: The Greatest Mass Extinction of All Time*. Thames & Hudson, 2003.

Bertolotti, Mario. *The History of the Laser*. CRC Press, 2004.

Bierly III, Paul E., and J-C. Spender. "Culture and High Reliability Organizations: The Case of the Nuclear Submarine." *Journal of Management* 21, no. 4 (1995): 639–56.

Biesbroek, Robin, and Guy Janin. "Ways to the Moon." *ESA Bulletin* 103 (2000): 92–99.

Borst, Lyle Benjamin. "The Atomic Locomotive." *Life Magazine* 36, no. 25 (June 21, 1954): 78–79.

Boxberger, A., A. Behnke, and G. Herdrich. "Current Advances in Optimization of Operative Regimes of Steady State Applied Field MPD Thrusters." In *Proceedings of the 36th International Electric Propulsion Conference, Vienna, Austria*, pp. 15–20. 2019.

"BRCA Gene Mutations: Cancer Risk and Genetic Testing Fact Sheet." National Cancer Institute. https://www.cancer.gov/about-cancer/causes-prevention /genetics/brca-fact-sheet. Accessed December 20, 2020.

"Breakthrough Initiatives." https://breakthroughinitiatives.org/. Accessed November 2, 2020.

"A Brief History of Solar Sails." NASA website. July 31, 2008. https://science.nasa.gov /science-news/science-at-nasa/2008/31jul_solarsails#:~:text=Almost%20 400%20years%20ago%2C%20German,fashioned%22%20to%20glide%20 through%20space.

Bryson, Steve, Michelle Kunimoto, Ravi K. Kopparapu, Jeffrey L. Coughlin, William J. Borucki, David Koch, Victor Silva Aguirre, et al. "The Occurrence of Rocky Habitable-Zone Planets around Solar-like Stars from Kepler Data." *The Astronomical Journal* 161, no. 1 (2020): 36. https://doi.org/10.3847/1538-3881 /abc418.

Bushak, Lecia. "Induced Hypothermia: How Freezing People after Heart Attacks Could Save Lives." *Newsweek*. December 20, 2014. https://www.newsweek.com /2015/01/02/induced-hypothermia-how-freezing-people-after-heart-attacks -could-save-lives-293598.html.

Capos, Claudia. "A New Drug Slows Aging in Mice. What about Us?" *Michigan Health Lab*, University of Michigan. January 17, 2020. https://labblog.uofmhealth .org/lab-report/a-new-drug-slows-aging-mice-what-about-us.

Carillo, Petronia, Biagio Morrone, Giovanna Marta Fusco, Stefania De Pascale, and Youssef Rouphael. "Challenges for a Sustainable Food Production System on Board of the International Space Station: A Technical Review." *Agronomy* 10, no. 5 (2020): 687. https://doi.org/10.3390/agronomy10050687.

Colon, Raul. "Flying on Nuclear: The American Effort to Built a Nuclear Powered Bomber." August 6, 2007. http://www.aviation-history.com/articles/nuke -american.htm.

Daukantas, Patricia. "Breakthrough Starshot." *Optics and Photonics News* 28, no. 5 (2017): 26–33.

Dick, Phillip. "The Android and the Human." Speech delivered at the Vancouver Science Fiction Convention, University of British Columbia, December 1972.

Dick, Steven J. "Discovering a New Realm of the Universe: Hubble, Galaxies, and Classification." *Space, Time, and Aliens* (2020): 611–25. https://doi.org/10.1007 /978-3-030-41614-0_36.

"Did You Know . . ." NASA website. June 7, 2013. https://www.nasa.gov/mission _pages/ibex/IBEXDidYouKnow.html.

Dyson, George. *Project Orion: The Atomic Spaceship, 1957–1965*. Allen Lane, 2002.

"Exoplanet Exploration: Planets beyond Our Solar System." NASA website. December 17, 2015. https://exoplanets.nasa.gov/.

Forward, Robert L. "Roundtrip Interstellar Travel Using Laser-pushed Lightsails." *Journal of Spacecraft and Rockets* 21, no. 2 (1984): 187–95.

———. "Starwisp—An Ultra-Light Interstellar Probe." *Journal of Spacecraft and Rockets* 22, no. 3 (1985): 345–50.

Gagarin, Yuri. *Road to the Stars.* University Press of the Pacific, 2002.

"Gallons Used per Person per Day." City of Philadelphia. https://www.phila.gov/water/educationoutreach/Documents/Homewateruse_IG5.pdf. Accessed November 20, 2020.

Gladwell, Malcolm. *Blink: The Power of Thinking without Thinking.* Back Bay Books, 2007.

Gosling, J. T., J. R. Asbridge, S. J. Bame, and W. C. Feldman. "Solar Wind Speed Variations: 1962–1974." *Journal of Geophysical Research* 81, no. 28 (1976): 5061–70.

Graybiel, Ashton, Joseph H. McNinch, and Robert H. Holmes. "Observations on Small Primates in Space Flight." *Xth International Astronautical Congress London 1959–1960*, 394–401. https://doi.org/10.1007/978-3-662-39914-9_35.

Gsponer, Andre. "Physics of High-Intensity High-energy Particle Beam Propagation in Open Air and Outer-space Plasmas." September 2004. https://arxiv.org/abs/physics/0409157.

Habitable Exoplanets Catalog. Planetary Habitability Laboratory at UPR Arecibo. http://phl.upr.edu/projects/habitable-exoplanets-catalog. Accessed October 9, 2020.

Hadfield, Chris. *An Astronaut's Guide to Life on Earth.* Pan Macmillan, 2013.

Hamley, John A., Thomas J. Sutliff, Carl E. Sandifer, and June F. Zakrajsek. "NASA RPS Program Overview: A Focus on RPS Users." (2016). https://ntrs.nasa.gov/citations/20160009220.

Hein, Andreas M., Cameron Smith, Frédéric Marin, and Kai Staats. "World Ships: Feasibility and Rationale." *Acta Futura* 12 (April 2020):75–104. https://arxiv.org/abs/2005.04100.

Howell, Elizabeth. "To All the Rockets We Lost in 2020 and What We Learned from Them." Space.com. *Space* (December 29, 2020). https://www.space.com/rocket-launch-failures-of-2020.

"Human Needs: Sustaining Life During Exploration." NASA website. https://www.nasa.gov/vision/earth/everydaylife/jamestown-needs-fs.html. Accessed November 20, 2020.

"Hyperdrive." StarWars.com. https://www.starwars.com/databank/hyperdrive#:~:text=Hyperdrives%20allow%20starships%20to%20travel,precisely%20calculated%20to%20avoid%20collisions. Accessed November 24, 2020.

"Interstellar Probe: Humanity's Journey to Interstellar Space." NASA / Johns Hopkins Applied Physics Laboratory. http://interstellarprobe.jhuapl.edu/. Accessed October 17, 2020.

Jakosky, B., and C. Edwards. "Inventory of CO_2 Available for Terraforming Mars." *Nature Astronomy* 2 (2018): 634–39.

Johnson, B., T. Bowling, A. J. Trowbridge, and A. M. Freed. "Formation of the Sputnik Planum Basin and the Thickness of Pluto's Subsurface Ocean." *Geophysical Research Letters* 43, no. 19 (2016): 10,068–77.

Johnson, Les. "The Aliens Are Not among Us." Baen Books Science Fiction & Fantasy, 2011. https://baen.com/aliens.

———, and Joseph E. Meany. *Graphene: The Superstrong, Superthin, and Superversatile Material That Will Revolutionize the World.* Prometheus Books, 2018.

———, Frank M. Curran, Richard W. Dissly, and Andrew F. Heaton. "The Solar Cruiser Mission—Demonstrating Large Solar Sails for Deep Space Missions." 70th International Astronautical Congress, Washington, DC, 2019.

———, Julie Castillo-Rogez, and Tiffany Lockett. "Near Earth Asteroid Scout: Exploring Asteroid 1991VG Using A Smallsat." 70th International Astronautical Congress, Washington, DC, 2019.

———, Mark Whorton, et al. "NanoSail-D: A Solar Sail Demonstration Mission." *Acta Astronautica* 68 (2011): 571–75.

———, and Robert Hampson. *Stellaris: People of the Stars.* Baen Books, 2019.

Jones-Bonbrest, Nancy. "Scaling Up: Army Advances 300kW-Class Laser Prototype." https://www.army.mil/article/233346/scaling_up_army_advances_300kw_class_laser_prototype. Accessed December 4, 2020.

Kare, Jordin T., and Kevin L. G. Parkin. "A Comparison of Laser and Microwave Approaches to CW Beamed Energy Launch." In *AIP Conference Proceedings* 830, no. 1 (2006): 388–99.

Kemper, Nicolas. "Building a Cathedral." *The Prepared.* April 28, 2019. https://theprepared.org/features/2019/4/28/building-a-cathedral.

Kulkarni, Neeraj, Philip Lubin, and Qicheng Zhang. "Relativistic Spacecraft Propelled by Directed Energy." *The Astronomical Journal* 155, no. 4 (2018): 155.

Lasue, Jeremie, Nicolas Mangold, Ernst Hauber, Steve Clifford, William Feldman, Olivier Gasnault, Cyril Grima, Sylvestre Maurice, and Olivier Mousis. "Quantitative Assessments of the Martian Hydrosphere." *Space Science Reviews* 174, no. 1–4 (2013): 155–212.

"Lung Volumes and Vital Capacity—Cardio-Respiratory System—Eduqas—GCSE Physical Education Revision—Eduqas—BBC Bitesize." *BBC News.* https://www.bbc.co.uk/bitesize/guides/z3xq6fr/revision/2. Accessed November 20, 2020.

Maccone, Claudio. "Galactic Internet Made Possible by Star Gravitational Lensing." *Acta Astronautica* 82, no. 2 (February 2013): 246–50. https://doi.org/10.1016/j.actaastro.2012.07.015.

MacDonnell, J. A. M. *Cosmic Dust.* Chichester: Wiley, 1978.

Maclay, G. J., and E. W. Davis. "Testing a Quantum Inequality with a Meta-analysis of Data for Squeezed Light." *Foundations of Physics* 49, 797–815 (2019). https://doi.org/10.1007/s10701-019-00286-8.

Mansell, Justin, David A. Spencer, Barbara Plante, Alex Diaz, Michael Fernandez, John Bellardo, Bruce Betts, and Bill Nye. "Orbit and Attitude Performance of the LightSail 2 Solar Sail Spacecraft." In *AIAA Scitech 2020 Forum* (2020): 2177.

Massa, Mike. *Securing the Stars: The Security Implications of Human Culture during Interstellar Flight.* Edited by Les Johnson and Robert E. Hampson. Baen Books, 2019.

Matloff, Gregory L. "Graphene, the Ultimate Interstellar Solar Sail Material." *Journal of the British Interplanetary Society* 65 (2012): 378–81.

Mattingly, Brandon, Abinash Kar, Matthew Gorban, William Julius, Cooper K. Watson, M. D. Ali, Andrew Baas, et al. "Curvature Invariants for the Alcubierre and Natário Warp Drives." *Universe* 7, no. 2 (2021): 21.

McClure, Patrick R., David I. Poston, Marc A. Gibson, Lee S. Mason, and R. Chris Robinson. "Kilopower Project: The KRUSTY Fission Power Experiment and Potential Missions." *Nuclear Technology* 206, supp. 1 (2020): 1–12.

McNutt, Ralph L., Robert F. Wimmer-Schweingruber, Mike Gruntman, Stamatios M. Krimigis, Edmond C. Roelof, Pontus C. Brandt, Steven R. Vernon, et al. "Near-Term Interstellar Probe: First Step." *Acta Astronautica* 162 (2019): 284–99. https://doi.org/10.1016/j.actaastro.2019.06.013.

Montgomery IV, Edward E. "Power Beamed Photon Sails: New Capabilities Resulting from Recent Maturation of Key Solar Sail and High Power Laser Technologies." In *AIP Conference Proceedings* 1230, no. 1 (2010): 3–9.

National Research Council; Division on Engineering and Physical Sciences; Space Studies Board; Aeronautics and Space Engineering Board; Committee on a Decadal Strategy for Solar and Space Physics (Heliophysics). "Solar and Space Physics: A Science for a Technological Society." A Science for a Technological Society | The National Academies Press, August 15, 2012. https://doi.org/10.17226/13060.

Nieto, Michael Martin, Michael H. Holzscheiter, and Slava G. Turyshev. "Controlled Antihydrogen Propulsion for NASA's Future in Very Deep Space." 2004. https://arxiv.org/abs/astro-ph/0410511.

Normile, Dennis. "Chinese Scientist Who Produced Genetically Altered Babies Sentenced to 3 Years in Jail." *Science* (December 30, 2019). https://www.sciencemag.org/news/2019/12/chinese-scientist-who-produced-genetically-altered-babies-sentenced-3-years-jail.

O'Meara, Stephen James. *Deep-Sky Companions: The Messier Objects.* Cambridge University Press, 2014.

Ocampo, Robert P. "Limitations of Spacecraft Redundancy: A Case Study Analysis." In *44th International Conference on Environmental Systems*. 2014.

Opher, M., F. Alouani Bibi, G. Toth, J. D. Richardson, V. V. Izmodenov, and T. I. Gombosi. "A Strong, Highly-Tilted Interstellar Magnetic Field near the Solar System." *Nature* 462, no. 7276 (2009): 1036–38. https://doi.org/10.1038/nature08567.

Parkin, Kevin L. G. "The Breakthrough Starshot System Model." *Acta Astronautica* 152 (2018): 370–84.

Patrascu, Daniel. "Nuclear Powered Cars of a Future That Never Was." *Autoevolution* (August 26, 2018). https://www.autoevolution.com/news/nuclear-powered-cars-of-a-future-that-never-was-128147.html.

Petigura, E. A., A. W. Howard, and G. W. Marcy. "Prevalence of Earth-Size Planets Orbiting Sun-like Stars." *Proceedings of the National Academy of Sciences* 110, no. 48 (2013): 19273–78. https://doi.org/10.1073/pnas.1319909110.

"The Pioneer Missions." NASA website. March 3, 2015. https://www.nasa.gov/centers/ames/missions/archive/pioneer.html.

Pyle, Rod. "Farthest Galaxy Detected," California Institute of Technology. September 3, 2015. https://www.caltech.edu/about/news/farthest-galaxy-detected-47761.

Roy, Kenneth I., Robert G. Kennedy III, and David E. Fields. "Shell Worlds." *Acta Astronautica* 82, no. 2 (2013): 238–45.

Sanger, Margaret. "My Way to Peace." Speech delivered January 17, 1932. http://www.nyu.edu/projects/sanger/webedition/app/documents/show.php?sangerDoc=129037.xml.

Scott, Jonathan. *The Vinyl Frontier: The Story of NASA's Interstellar Mixtape.* United Kingdom: Bloomsbury Publishing, 2019.

"The Space Shuttle and Its Operations." NASA website. https://www.nasa.gov/centers/johnson/pdf/584722main_Wings-ch3a-pgs53-73.pdf. Accessed December 30, 2021.

Spiga, Aymeric, Sebastien Lebonnois, Thierry Fouchet, Ehouarn Millour, Sandrine Guerlet, Simon Cabanes, Alexandre Boissinot, Thomas Dubos, and Jérémy Leconte. "Global Climate Modeling of Saturn's Troposphere and Stratosphere, with Applications to Jupiter." July 2018. 42nd COSPAR Scientific Assembly. Held July 14–22, 2018, in Pasadena, California, USA, Abstract id. B5.2-33-18; 2018cosp . . . 42E3216S.

Spitzer, Lyman. "The Beginnings and Future of Space Astronomy." *American Scientist* 50, no. 3 (1962): 473–84.

Stocks, J., and P. H. Quanjer. "Reference Values for Residual Volume, Functional Residual Capacity and Total Lung Capacity: ATS Workshop on Lung Volume

Measurements; Official Statement of The European Respiratory Society." *European Respiratory Journal* 8, no. 3 (1995): 492–506.

Tsuda, Yuichi, Osamu Mori, Ryu Funase, Hirotaka Sawada, Takayuki Yamamoto, Takanao Saiki, Tatsuya Endo, Katsuhide Yonekura, Hirokazu Hoshino, and Jun'ichiro Kawaguchi. "Achievement of IKAROS—Japanese Deep Space Solar Sail Demonstration Mission." *Acta Astronautica* 82, no. 2 (2013): 183–88.

Turyshev, Slava G., Michael Shao, Viktor T. Toth, Louis D. Friedman, Leon Alkalai, Dmitri Mawet, Janice Shen, et al. "Direct Multipixel Imaging and Spectroscopy of an Exoplanet with a Solar Gravity Lens Mission." Cornell University. 2020. https://arxiv.org/abs/2002.11871.

Viser, Matt. "FOLLOW-UP: What Is the 'Zero-point Energy' (or 'Vacuum Energy') in Quantum Physics? Is It Really Possible that We Could Harness This Energy?" *Scientific American Online* (August 18, 1997). https://www.scientificamerican.com/article/follow-up-what-is-the-zer/. Accessed November 25, 2020.

"Voyager." NASA / Jet Propulsion Laboratory, California Institute of Technology. https://voyager.jpl.nasa.gov/. Accessed March 20, 2020.

Wall, Mike. "The Most Extreme Human Spaceflight Records." *Space* (April 23, 2019). https://www.space.com/11337-human-spaceflight-records-50th-anniversary.html.

"Water Use in Europe—Quantity and Quality Face Big Challenges." European Environment Agency. August 30, 2018. https://www.eea.europa.eu/signals/signals-2018-content-list/articles/water-use-in-europe-2014#:~:text=On%20average%2C%20144%20litres%20of,supplied%20to%20households%20in%20Europe.

"Whatever Happened to Photon Rockets?" *Astronotes.* December 5, 2013. https://armaghplanet.com/whatever-happened-to-photon-rockets.html.

Wells, Herbert George. *The Discovery of the Future.* London: T. Fisher Unwin, 1902.

Wickramatunga, Robert. "United Nations Office for Outer Space Affairs." The Outer Space Treaty. https://www.unoosa.org/oosa/en/ourwork/spacelaw/treaties/introouterspacetreaty.html. Accessed December 4, 2020.

Wiegmann, Bruce M. "The Heliopause Electrostatic Rapid Transit System (HERTS)-Design, Trades, and Analyses Performed in a Two Year NASA Investigation of Electric Sail Propulsion Systems." In *53rd AIAA/SAE/ASEE Joint Propulsion Conference*, p. 4712. 2017.

Williams, David R. "Explorer 9." NASA Space Science Data Coordinated Archive. https://nssdc.gsfc.nasa.gov/nmc/spacecraft/display.action?id=1959-004A. Accessed December 4, 2020.

Wolszczan, A., and D. Frail. "A Planetary System around the Millisecond Pulsar PSR1257 + 12." *Nature* 355 (1992): 145–47. https://doi.org/10.1038/355145a0.

Wordsworth, R., L. Kerber, and C. Cockell. "Enabling Martian Habitability with Silica Aerogel via the Solid-state Greenhouse Effect." *Nature Astronomy* 3 (2019): 898–903. https://doi.org/10.1038/s41550-019-0813-0.

Zitrin, Adi, Ivo Labbé, Sirio Belli, Rychard Bouwens, Richard S. Ellis, Guido Roberts-Borsani, Daniel P. Stark, Pascal A. Oesch, and Renske Smit. "Lyα Emission from a Luminous z= 8.68 Galaxy: Implications for Galaxies as Tracers of Cosmic Reionization." *The Astrophysical Journal Letters* 810, no. 1 (2015): L12 (September 3, 2015).

INDEX

3D printing. *See* additive manufacturing
100 Year Starship Organization, 59
100 Year Starship Study. *See* 100 Year Starship Organization

Abbot, Edwin A., 161
Adams, Douglas, 5
additive manufacturing, 153–54
Advanced Space Transportation Program (ASTP), 32–33
Alcubierre, Miguel. *See* Alcubierre warp drive
Alcubierre warp drive, 158–60, 164, 169
Aldrin, Buzz, 24, 66–67
Alpha Centauri, 15, 89, 112, 120, 132, 145; A and B, 9–12, 58
alpha particles, 43n2, 44, 122, 124, 137, 139
Andromeda Galaxy, 10–12
antimatter, 2, 98–103, 106, 128, 145–46, 155–56, 158; particles of, 101
Apollo missions, 23–24, 60, 70, 189, 191; Apollo 8, 24; Apollo 10, 24; Apollo 11, 189; Apollo 13, 142; Apollo 17, 70–71
Armstrong, Neil, 24, 67, 190

Arrokoth, 26, 31; (486958) 2014 MU69, 26
astronomical unit (AU), 1–2, 12

Bae, Young. *See* photon recycling
Beall, Jim, 152–53
black holes, 163–65; inner region of, 163. *See also* Einstein-Rosen Bridges; wormholes
Bova, Ben, 189, 190n
Breakthrough Starshot, 117–20
British Interplanetary Society, 143
Bussard, Robert. *See* Bussard ramjet
Bussard ramjet, 90–91, 97–98, 145

Cash, Webster, 37
Casimir, Hendrick. *See* Casimir effect
Casimir effect, 160, 171–73
Cassini spacecraft, 29
Ceres, 13, 94. *See also* Dawn mission; Vesta
CERN (Conseil Européen pour la Recherche Nucléaire), 92–93, 101
chemical rockets, 32–33, 82, 93, 128; limit of performance with, 36, 85; propellant of, 84, 86, 94. *See also* Falcon 9; Saturn V; Space Shuttle

218 INDEX

Messier, Charles. *See* Messier Objects
Messier Objects, 10
meteoroids, 13–16, 119
meteors, 16. *See also* meteoroids
microwave sail, 120–21, 127–28, 144
Milky Way Galaxy, 5, 8, 10–11, 18, 62,
 136, 188
motion-induced frequency. *See* Doppler
 shift

NanoSail-D, 112, 113
NASA (National Aeronautics and
 Space Administration), 22, 34, 48,
 60, 69, 126–27, 154, 190–91
Near Earth Asteroid (NEA) Scout,
 112, 113
negative vacuum energy density, 159–60
neutron stars, 6
New Horizons, 24, 26–27, 29, 30–31, 42
Newton, Isaac, 83–84, 109, 118, 123, 170–71
nuclear fission, 86, 97, 106
nuclear fusion, 2, 87–90, 106, 132
nuclear thermal rocket, 86, 95, 104

Oberth, Herman. *See* Oberth Maneuver
Oberth Maneuver, 35–36
optical communication, 50–51

particle physics, 99
Pathfinder, 68–69
perihelion, 35
Permian Extinction, 63
phased array, 115–16, 133. *See also* laser
photoelectric effect, 114. *See also*
 Einstein, Albert
photon recycling, 115
photon rocket, 97–98, 102–3, 106,
 108–9
Pioneer 10, 24–25, 27
Pioneer 11. *See* Pioneer 10

plasma, 122
plasma rockets. *See* electric rockets
Pluto, 7, 13, 26, 29–31, 42, 86, 136
Pournelle, Jerry, 184–85
power beaming, 45–47
Project Orion, 85, 104–5, 128, 145,
 167
propellantless propulsion. *See* space
 drive
Proxima Centauri, 1, 2, 26, 167;
 Proxima Centauri B, 76
pulsars, 6, 136–37

quantum vacuum energy, 174

radar. *See* magnetron tube
Radioisotope Power Systems (RPS), 43
Radio Thermoelectric Generators
 (RTGs), 42–43, 44, 45, 131–32
Ranger series, 67
Robinson, Kim Stanley, 178, 189–90
rocket equation, 79–80, 87, 89–90, 105,
 123, 128
Roddenberry, Gene, 192
Rosen, Nathan, 164. *See also* Einstein-
 Rosen bridges
Roy, Ken. *See* shell worlds
Russell, Mary Doria, 184

Saturn V, 82, 190
Seager, Sara, 37
SETI (search for extraterrestrial
 intelligence), 185–86
settlement ship, 143–44. *See also*
 worldship
Schmitt, Harrison, 70–71
shell worlds, 180
Solar Cruiser, 112–13
Solar Gravity Lens (SGL), 15, 37, 40n,
 41, 44, 133–34

solar magnetic field, 18

solar sails, 108–10, 112–13, 119, 169. See also IKAROS; LightSail 1 & 2; NanoSail-D; Solar Cruiser

solar storm, 17

solar wind, 17–18, 122–23, 137, 140

space drive, 169–170; See also Alcubierre warp drive; EmDrive; hyperdrive; jump drive; vacuum energy; warp drive

Space Launch System (SLS), 35–36

Space Shuttle, 82–83. 84, 97n

space-time, 38–40, 41, 157–58, 163–64, 173

specific impulse (I_{sp}), 83–85, 87, 107, 127, 128

speed of light (c), 1, 37–38, 58, 70, 88, 96, 135, 143, 157–61

sprinters, 143. See also worldship

Starshot, 118–20. See also Breakthrough Starshot

star trackers, 135

Star Trek, 64, 156–57, 161, 178, 183, 191–92

Star Wars, 160–61, 176–77, 183

Starwisp, 121–22. See also Forward, Robert

string theory, 160–61, 171–72

sun sensors, 135

suspended animation, 148, 174–176. See also hibernation

TANSTAAFL (There Ain't No Such Thing as a Free Lunch), 173–74. See also Heinlein, Robert

Tarter, Jill, 186

"Tau Zero: In the Cockpit of a Bussard Ramjet" (Blatter and Greber), 90–91. See also Bussard ramjet

Taylor, Ted. See Project Orion

Tereshkova, Valentina, 67

terraforming, 178–79

Theory of Everything, 160

Theory of Special Relativity, 37–38

Townes, Charles, 114. See also laser transit method, 7

Tsiolkovsky, Konstantin E., 63

Turyshev, Slava, 40, 41

Tyldum, Morten, 174–75

University of Michigan's Glenn Center for Aging Research, 176

vacuum, 9, 13, 17, 102, 169, 171–73

vacuum energy, 171–73. See also Casimir effect

Van Allen Radiation Belts, 29

VASIMR (variable specific impulse magnetoplasma rocket), 95

Verne, Jules, 189

Vesta, 94

Viking spacecraft, 68–69

von Braun, Wernher, 190. See also Saturn V

Voyager spacecraft, 1, 29, 32, 43, 47, 48, 50, 118; Voyager 1, 2, 31; Voyager 1 & Voyager 2, 14, 24–27, 142

warp drive, 127, 155–57

Weir, Andy, 190

Wells, H. G., 53

white hole, 163, 164. See also wormholes

Williamson, Jack. See terraforming

worldship, 71–74, 76n, 143–45, 152, 154, 165–67, 174

wormholes, 163–65. See also black holes